P9-EGC-979

GREAT HOUSES ON A BUDGET

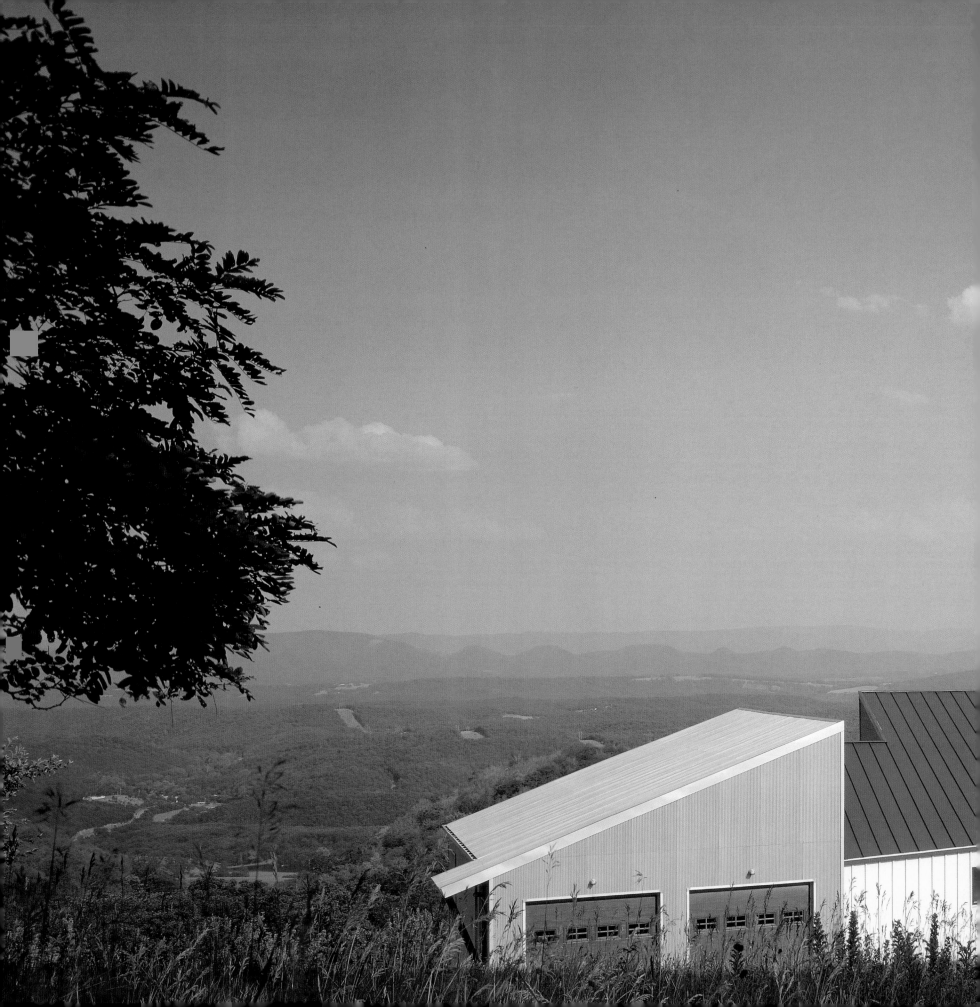

GREAT HOUSES
ON A BUDGET

JAMES GRAYSON TRULOVE

HARPER
DESIGN

An Imprint of HarperCollins*Publishers*

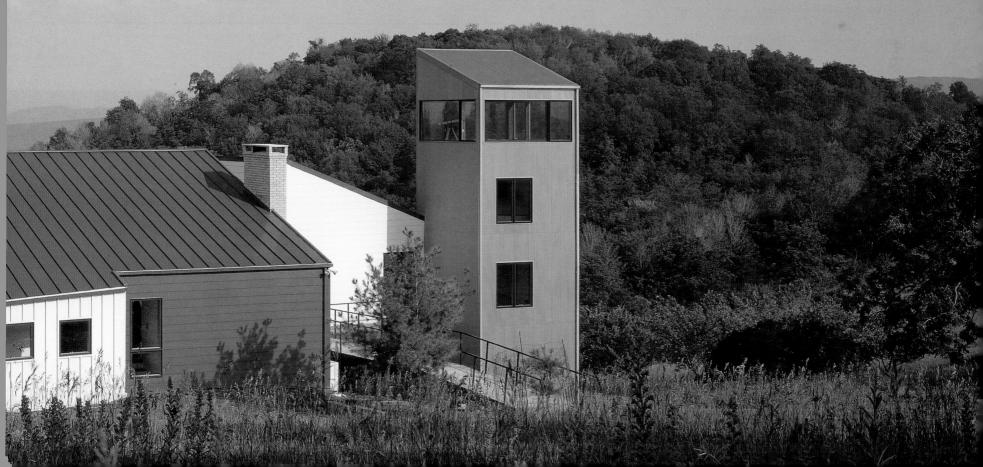

GREAT HOUSES ON A BUDGET
Copyright 2005 © by JAMES GRAYSON TRULOVE and HARPER DESIGN

Published in 2005 by
Harper Design
An Imprint of HarperCollins*Publishers*
10 East 53rd Street
New York, NY 10022
Tel: (212) 207-7000
Fax: (212) 207-7654
HarperDesign@harpercollins.com
www.harpercollins.com

Distributed throughout the world by:
HarperCollins International
10 East 53rd Street
New York, NY 10022
Fax: (212) 207-7654

HarperCollins books may be purchased for educational, business, or sales promotional use.
For information, please write: Special Markets Department,
HarperCollins Publishers Inc., 10 East 53rd Street, New York, NY 10022.

Packaged by:
Grayson Publishing, LLC
James G. Trulove, Publisher
1250 28th Street NW
Washington, DC 20007
Tel: (202) 337-1380
jtrulove@aol.com
Graphic Design by: Agnieszka Stachowicz

Library of Congress Control Number: 2005921186

ISBN: 0-06-077993-4

All rights reserved. No part of this book may be used or reproduced in any manner whatsoever
without written permission except in the case of brief quotations embodied in critical articles and reviews.
For information, address Harper Design, 10 East 53rd Street, New York, NY 10022.

Manufactured in China
First printing, 2005
1 2 3 4 5 6 7 8 9 / 08 07 06 05

CONTENTS

FOREWORD
Good Design Does Not Mean High Costs

Everyone knows that housing prices have soared during the last several years to the point that the value of one's house is now standard cocktail conversation. Affordable housing, especially for young families just starting out, has become an equally pressing issue. To many, finding a cheaply constructed, cookie-cutter-designed home in a townhouse community may seem like the only option. This book offers examples of homes that were built on budgets that might not be sufficient for a down payment on an existing home.

At the time of construction, costs for the houses in this book ranged from a low of $70-per-square-foot to a high of around $250-per-square-foot, minus the price of the land. Of course construction costs are subject to countless variables from the obvious, such as the region of the country or the types of building materials used, to the less obvious, such as weather conditions, availability of materials and labor, and subtle population shifts. A house in a particular region that cost $100 per square foot to build a year ago could just as easily cost $125 or more today. The point of this book however is to demonstrate that good design does not have to take a back seat when the budget is tight. Indeed, as many of the projects featured illustrate, budget constraints can challenge the architect as well as the client to think more creatively both in terms of the design as well as in the selection of building materials.

Often the first challenge is finding a piece of land on which to build. Creative thinking is in order here. Many projects in this book were built on lots that had sat around for years because they were thought to be unbuildable. This is especially true in older, inner-city neighborhoods that are essentially built out but where a few of these lots may exist. Another option is to find a house ready for demolition, salvage the parts that can be salvaged, such as the foundation and basement, and go from there, as architect Stephen Chung did for his own home.

These principals of good design, careful planning, and creative thinking when building a home apply equally to a small 1,000-square-foot hideaway as to a 4,000-square-foot primary residence. The 16 projects that follow provide ample proof of this.

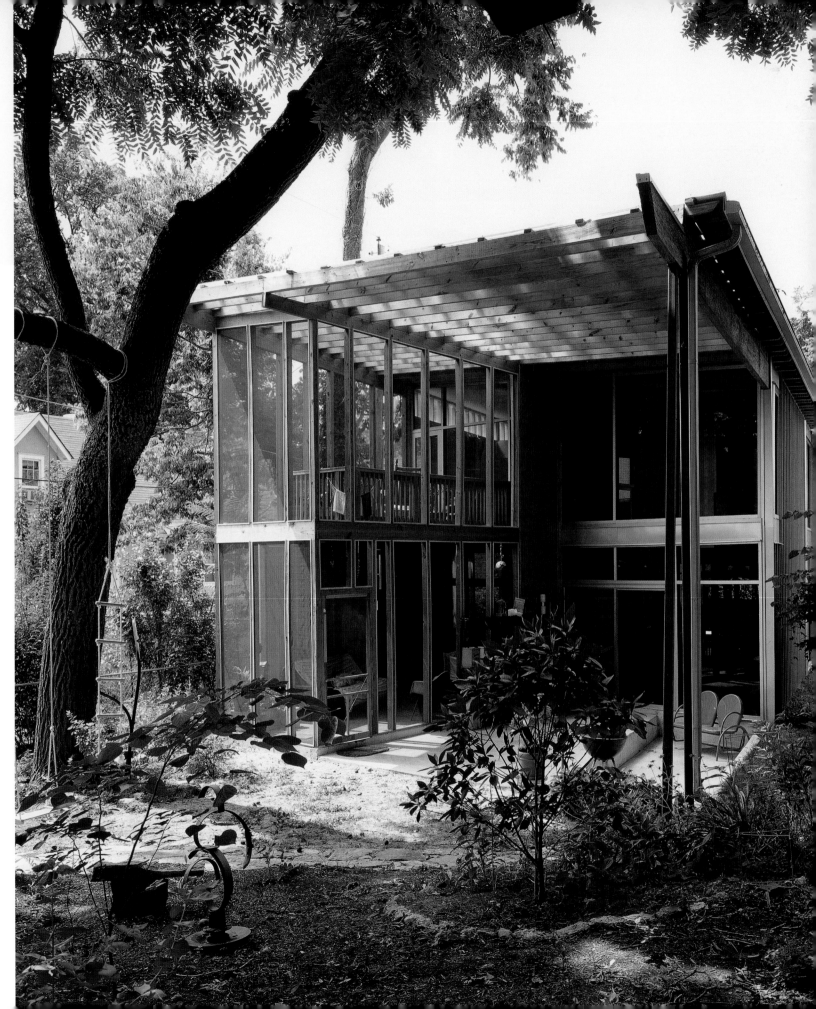

Right: For this house, the architect utilized materials that are of common size and that are durable and inexpensive. Standard insulated glass was used in an economical aluminum-framed wall system.
Architect: Building Studio
Photo: Tim Hursley

Left: This house is framed with wood, with very simple finishes and surfaces that were selected to minimize labor and expense while maintaining a very clean and modern aesthetic with no interior trim.
Architect: E. Cobb Architects
Photo: Steve Keating

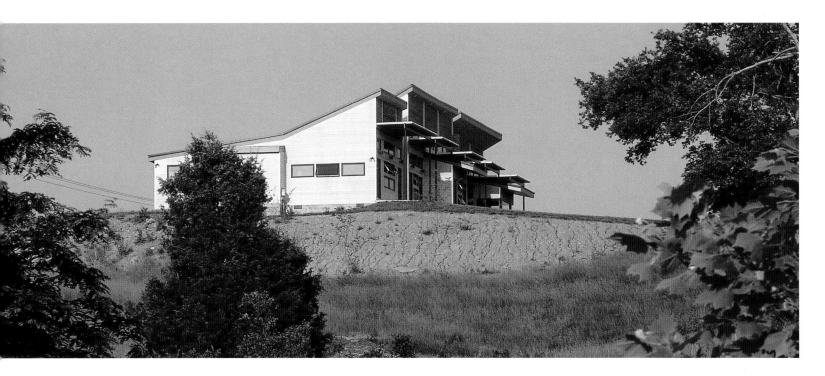

Above: Energy efficiency and the low maintenance requirements for the outside cladding were dominant themes in the design and construction of this home in Kentucky.
Architect: Guyon Architects
Photo: Scott Guyon

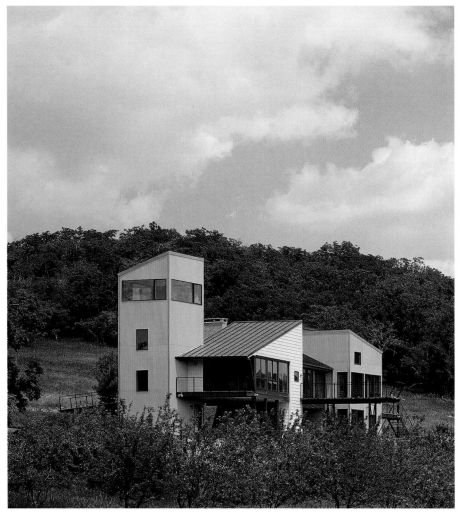

Left: Rethinking an existing house and nearly doubling its size while creatively using colorful, inexpensive cladding kept the budget in check for this 4,200-square-foot house.
Architect: Robert M. Gurney
Photo: Hoachlander Davis Photography

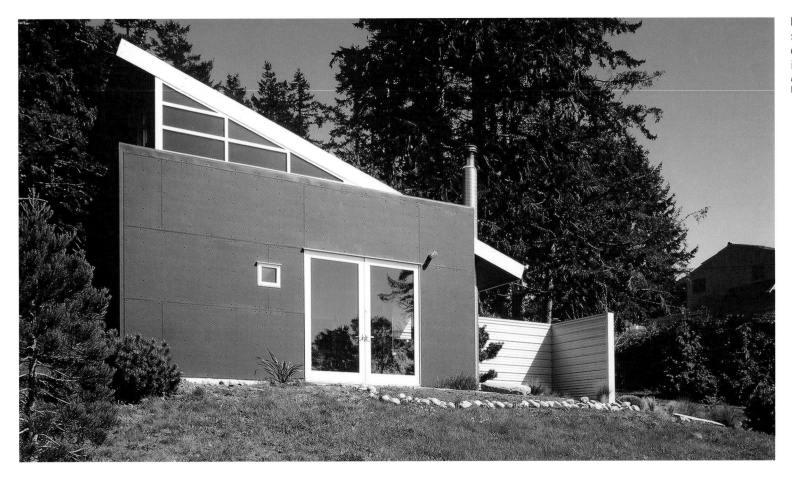

Left: A simple 4-foot module scheme allowed this house to be constructed and finished by its owners.
Architect: Vandeventer+Carlander
Photo: Steve Keating

Right: The architect acted as his own general contractor for this house for himself and his family.
Architect: Stephen Chung
Photo: Bob O'Connor

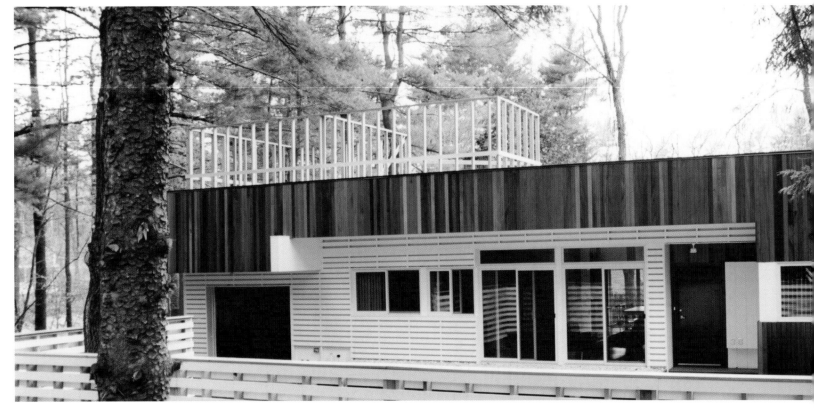

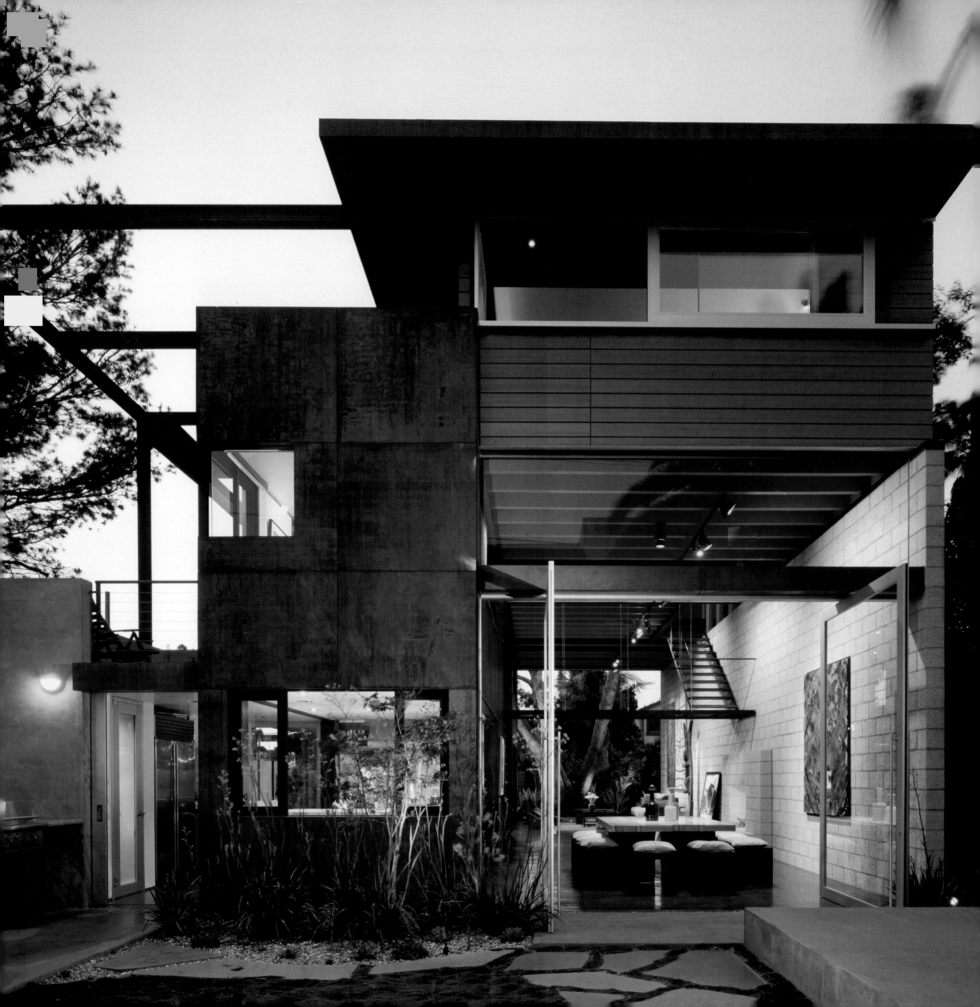

Left: Raw, honest materials and a focus on energy conservation helped the architect contain costs for this project.
Architect: Steven Ehrlich Architects
Photo: Ehrhard Pfeiffer

Right: To keep costs low, the architects developed a very straightforward plan. Utilizing a central circulation core, all rooms radiated from the core, eliminating needless circulation space and interior partitions.
Architect: Vandeventer+Carlander
Photo: Michael Moore

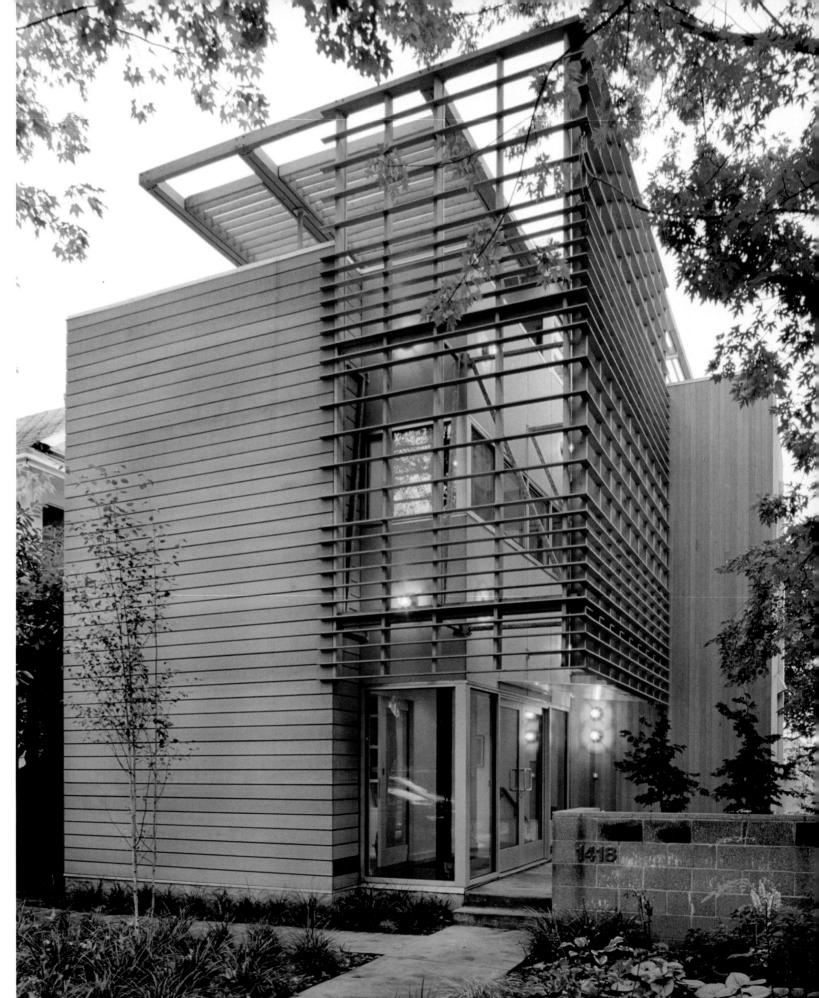

PROJECTS

MADRONA

On the Ground and Up in the Trees

place: **SEATTLE, WASHINGTON** | architects: **VANDEVENTER + CARLANDER ARCHITECTS**

photography: **MICHAEL MOORE**

PROJECT DESCRIPTION

A narrow lot, 35 feet by 35 feet, influenced the long, rectangular design of this 3,000-square-foot house for a Seattle couple who wanted a rooftop terrace and a garden on level with the house. Abundant natural light as well as privacy on this tight urban lot were important considerations as well. The design solution provides for public spaces on the ground level adjacent to the front and back gardens; bedrooms on the second floor, and a rooftop retreat located on the third. The kitchen is pulled out from the rectangle to provide privacy to the outdoor spaces. The wood-framed structure was kept nearly solid on three sides, with extensive glazing on the south side. A wood screen located 4 feet beyond the south window wall was developed to provide sun protection in the summer while maintaining a sense of privacy. Between the house and the screen, metal grated terraces were created off the upper floor bedrooms. A secondary staircase from the master bedroom to the roof was inserted between the screen and house.

KEEPING COSTS DOWN

To keep costs low, the architects developed a very straightforward plan. Utilizing a central circulation core, all rooms radiated from the core, thereby eliminating needless circulation space and interior partitions. Openings were kept to a minimum in the exterior walls, allowing for quick construction. Window areas were large expanses on the south side. Aside from the rain screen technology of the primary block, the siding materials used are common and were detailed in the customary fashion used in the region. Finishes on the interior are minimal, thereby eliminating the detail associated with the use of many materials.

PRIMARY BUILDING MATERIALS

Western red cedar was used for all exterior siding and for the screen. Fiber cement panels were used on the south side as infill panels between the continuous glazed areas on all floors. Inside, maple-strip flooring was used on all floors, with the exception of glass mosaic tiles in the two upper-floor bathrooms, and steel sheet was used at the entry. Gypsum wall board was used on all interior walls. The cabinetry is maple plywood.

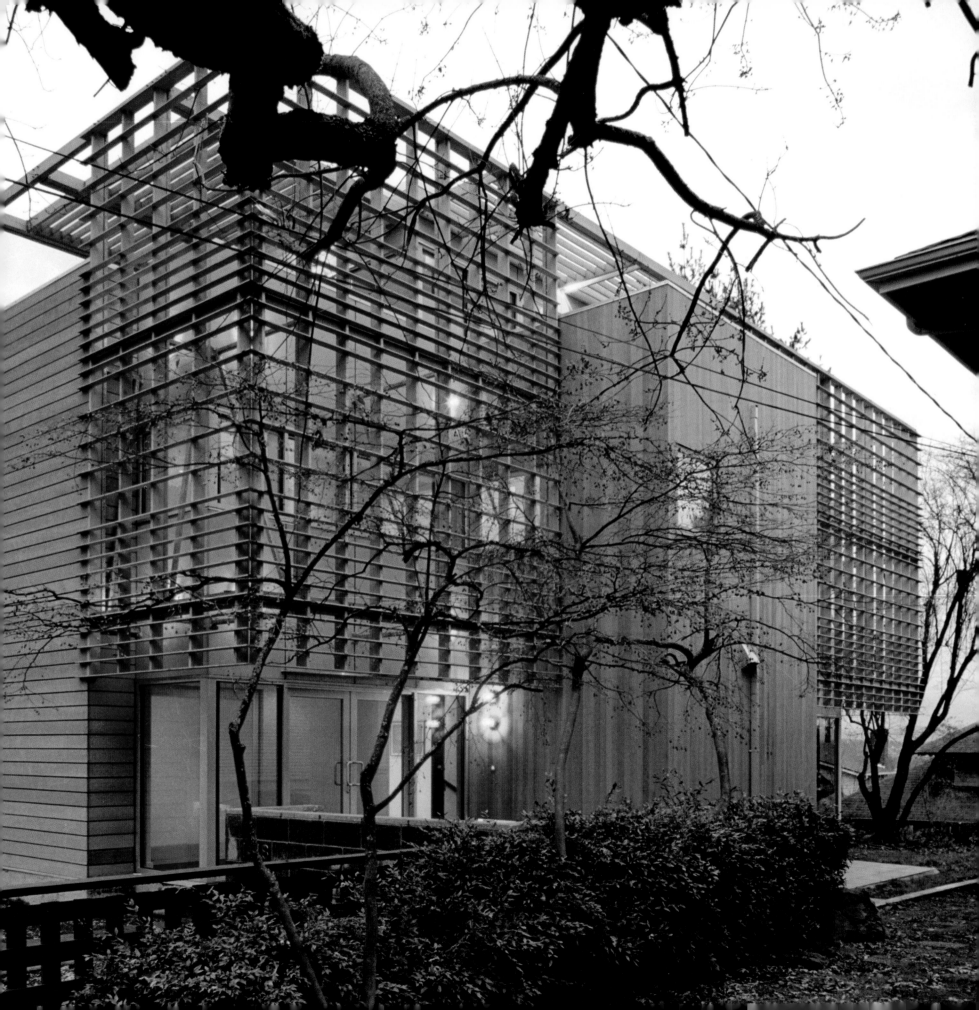

Third-floor Plan

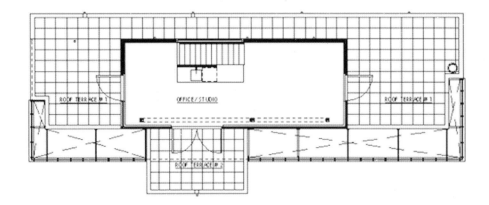

Second-floor Plan

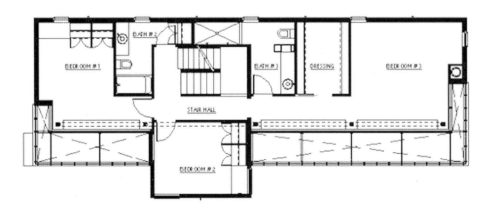

First-floor Plan

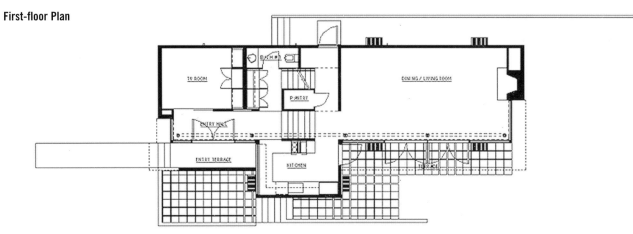

Basement Plan

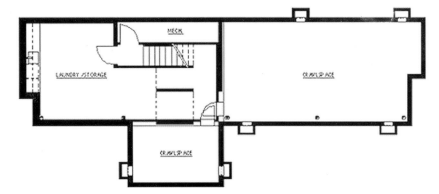

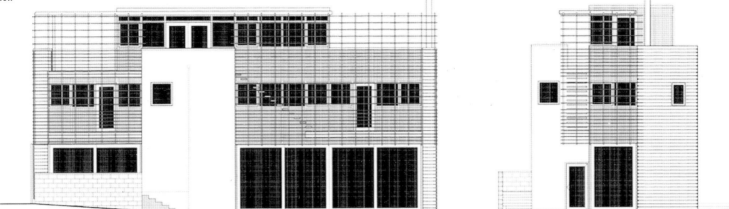

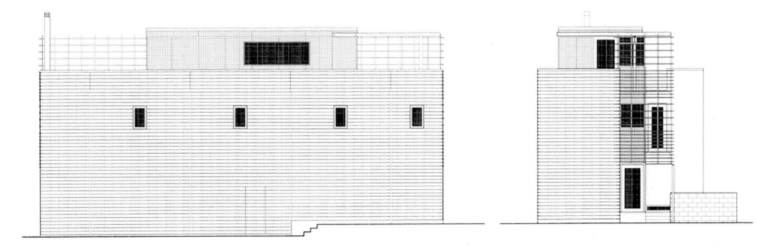

Sections

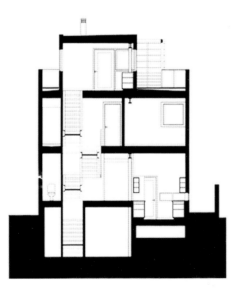

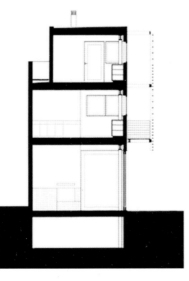

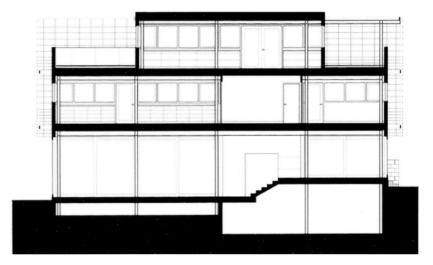

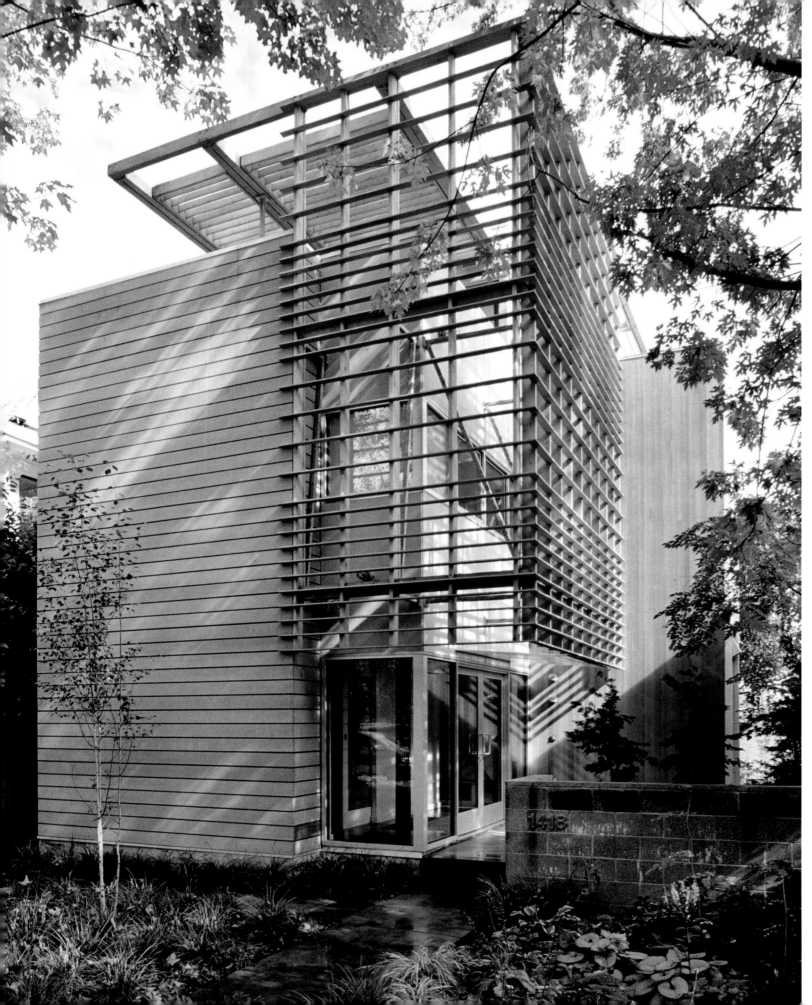

Left and Right: Views of the entry from the street show the roof terrace and sun screen that wraps around from the south facade to the front.

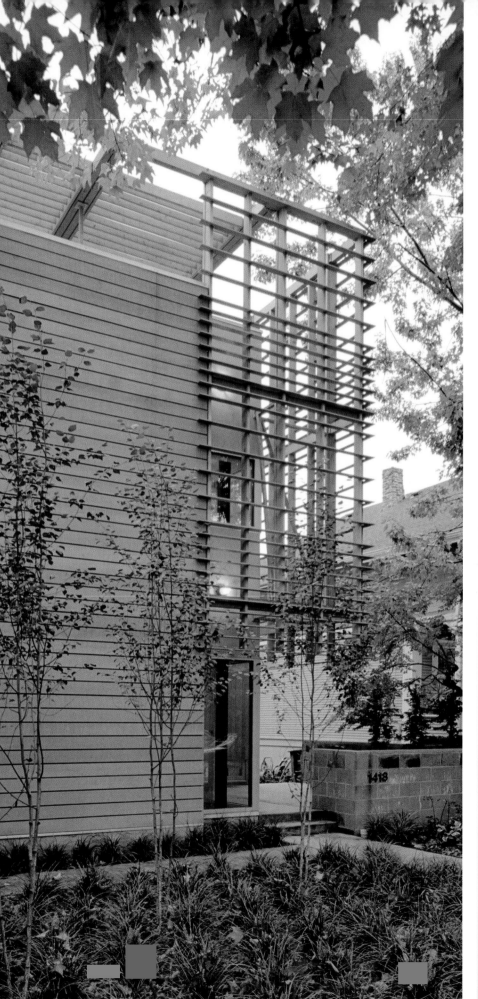
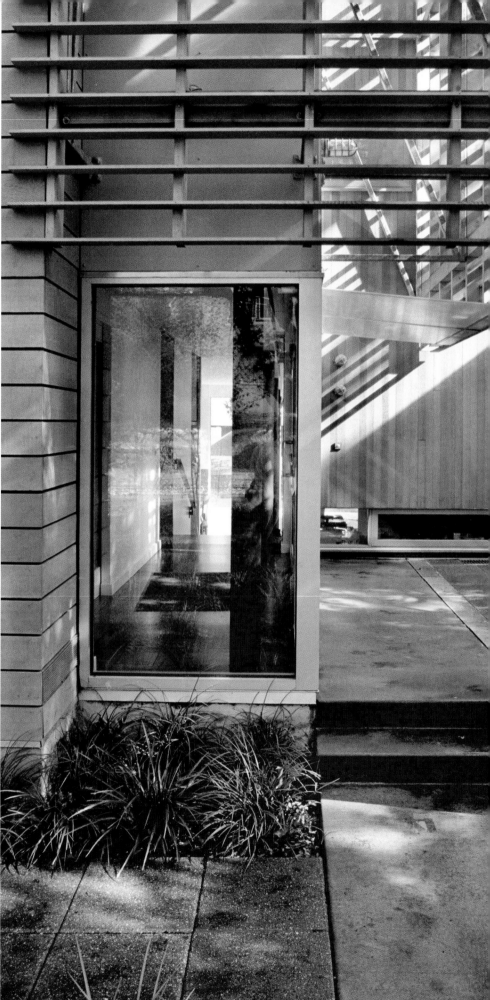

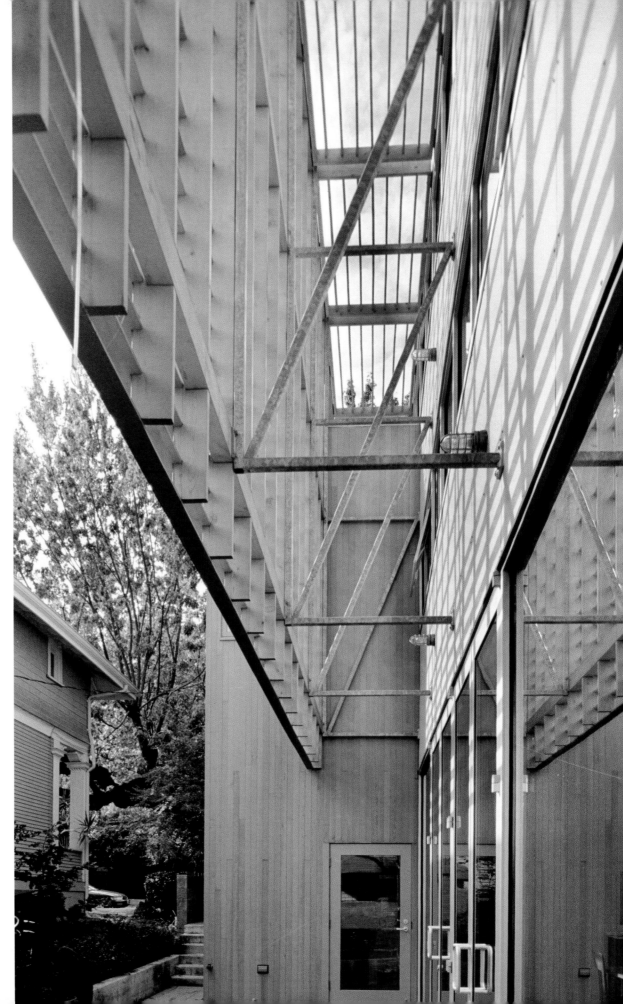

Right: The western red cedar sunscreen is positioned 4 feet from the house. It provides protection from the summer sun while giving a sense of privacy to the second-floor bedrooms.

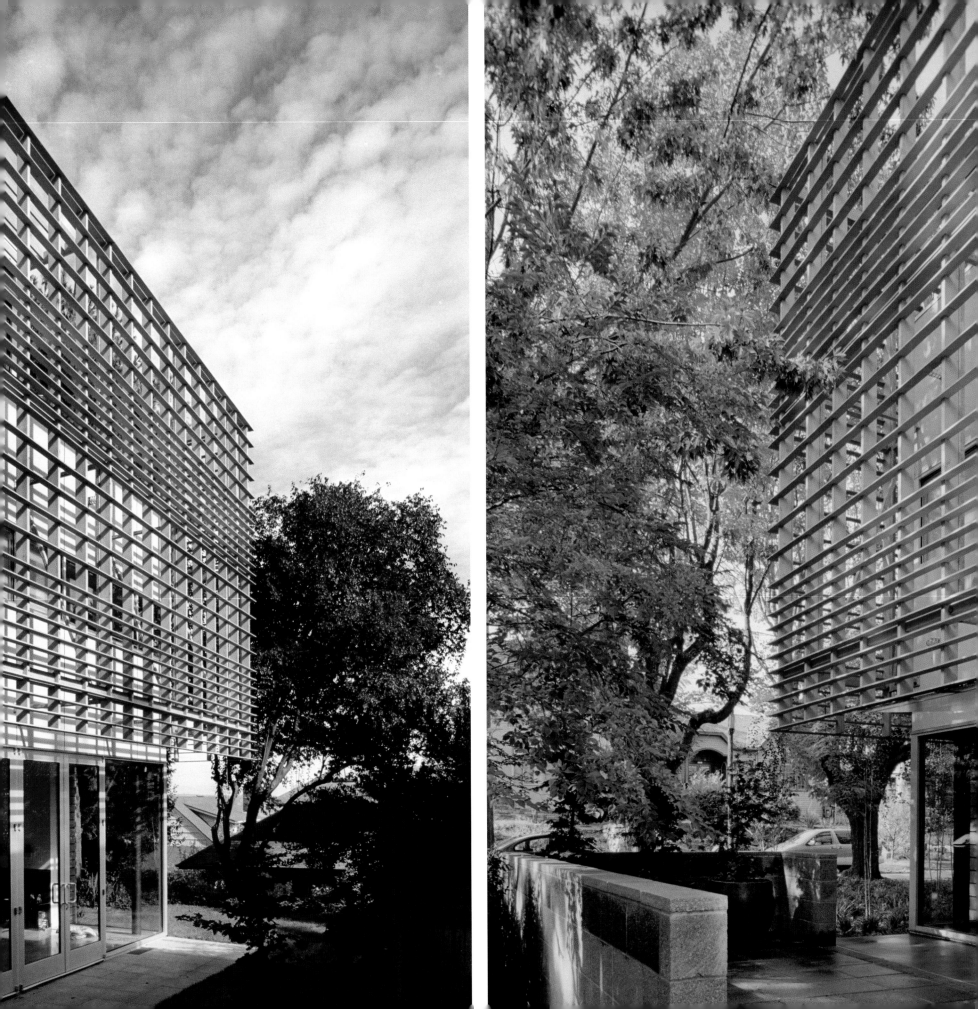

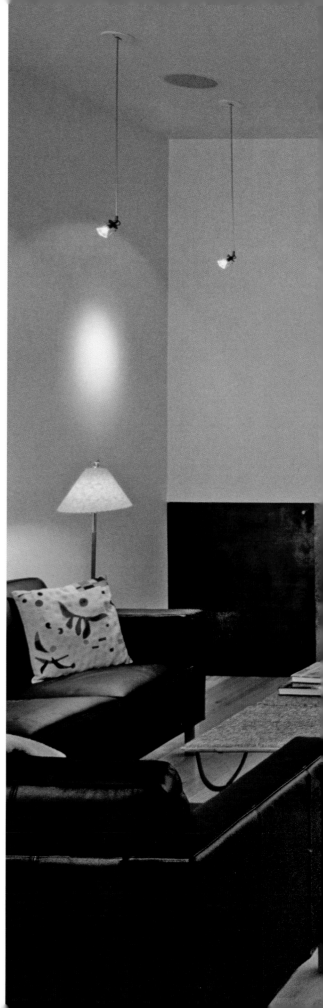

Left: The entry is at counter level to the kitchen and then steps down to the living area that is at grade.

Right: On the first floor, all room are on level with the gardens.

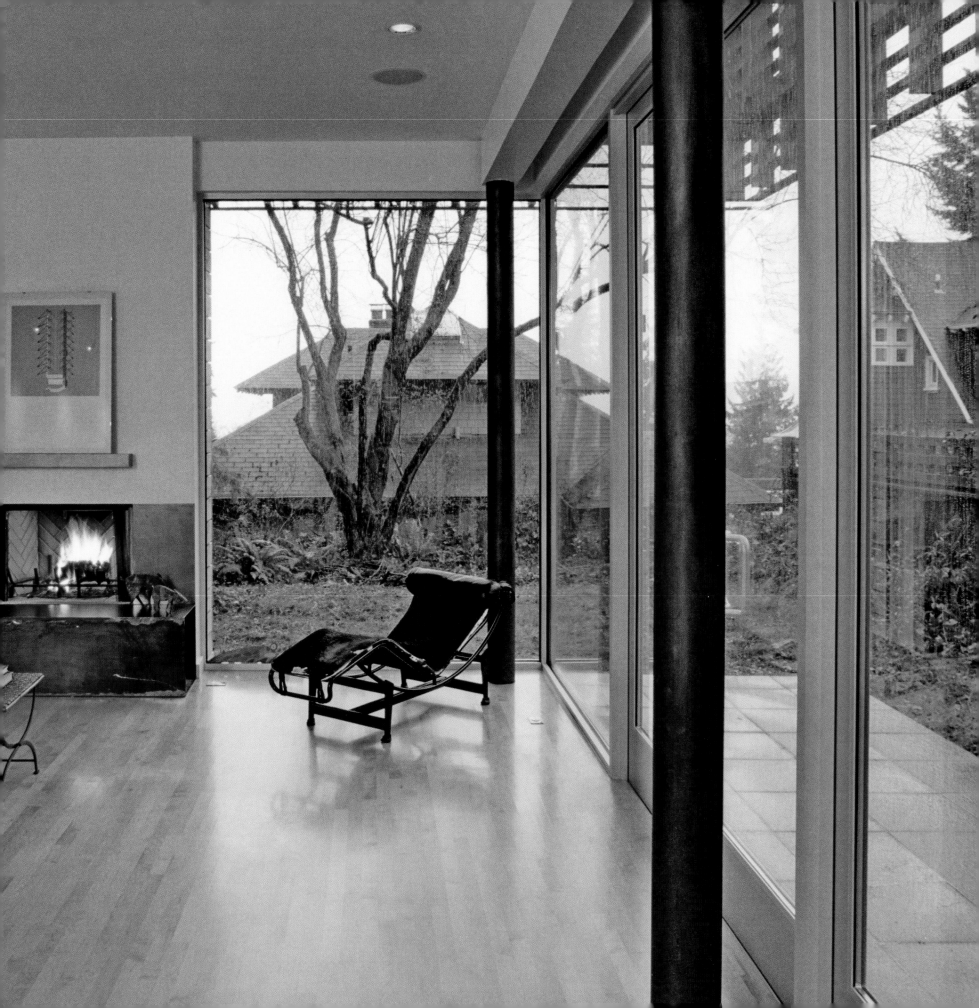

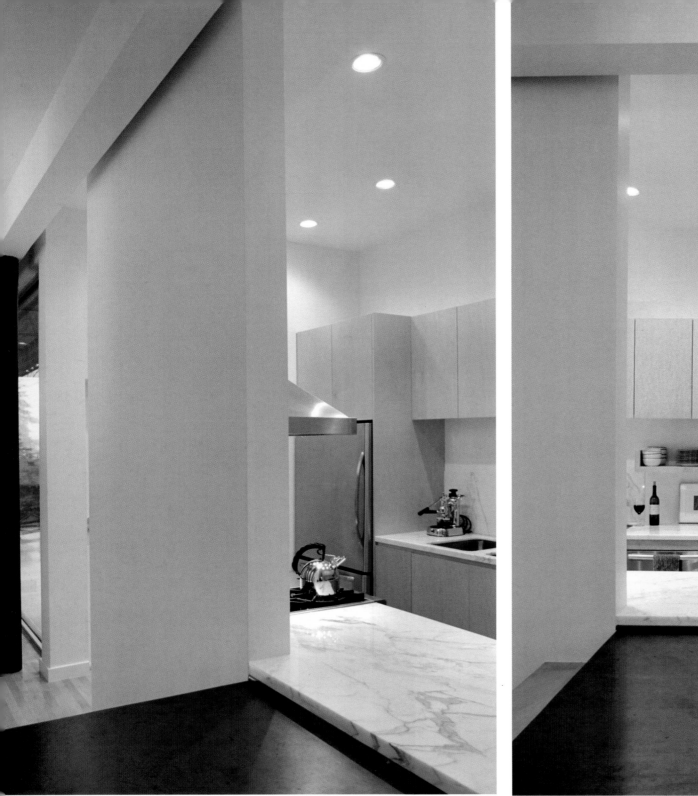

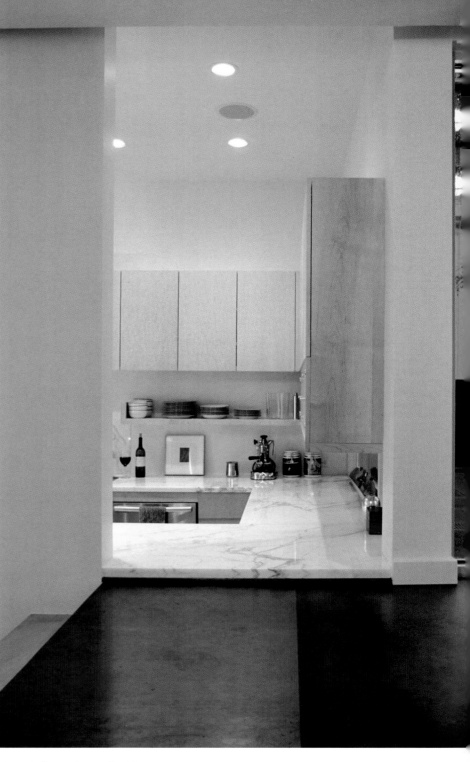

Above Left and Above: The kitchen, as seen from the entry corridor where the floor is steel sheet

Right: The kitchen cabinets are maple plywood.

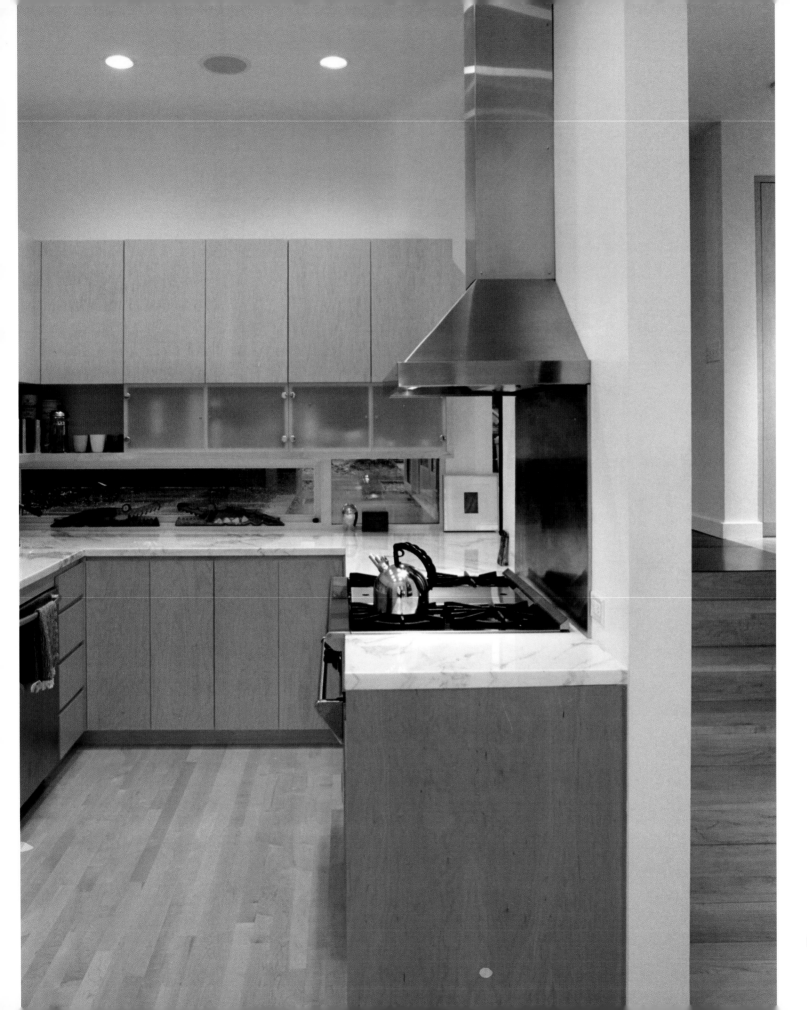

Above: Stairs to the second-floor bedrooms

Right: The master bedroom

KOGAN
Economical and Modern

place: **SEATTLE, WASHINGTON** | architects: **E. COBB ARCHITECTS**

photography: **STEVE KEATING**

PROJECT DESCRIPTION

The Kogan House was intended to create a very compact, economical, and modern house for a retired couple. With their daughter's family one block away in a larger house, the Kogan House functions as a comfortable guest house, without the burden of multiple bedrooms and accommodations for large gatherings. The house used an existing foundation and was cantilevered 4 feet beyond one wall to gain an additional 70 square feet of area.

KEEPING COSTS DOWN

The house is wood framed, with very simple finishes and surfaces that were selected to minimize labor and expense while maintaining a very clean and modern aesthetic with no interior trim. Costs were further minimized by making the house as small as possible. The construction documents were created to allow for alternatives that may be suggested by subcontractors to reduce costs while achieving a comparable aesthetic. The existing foundation was reused, but the new first floor was lifted to create more usable storage space in the basement. A free-standing gas fireplace minimized installation complexity and costs.

PRIMARY BUILDING MATERIALS

The interior wood flooring consists of baltic birch plywood, which is 5 feet by 5 feet, similar in character to the cabinetry. Anodized aluminum windows required no interior or exterior painting. The exterior is low-maintenance vertical cedar siding.

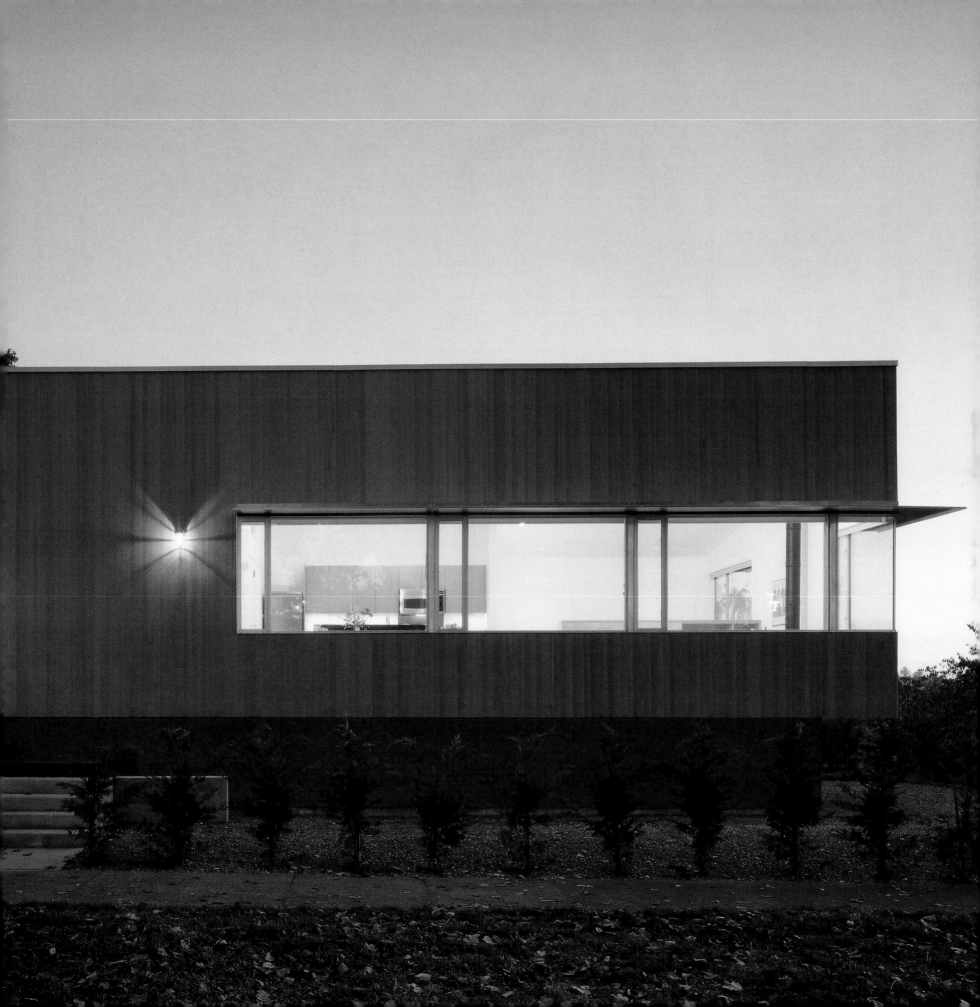

Floor Plan

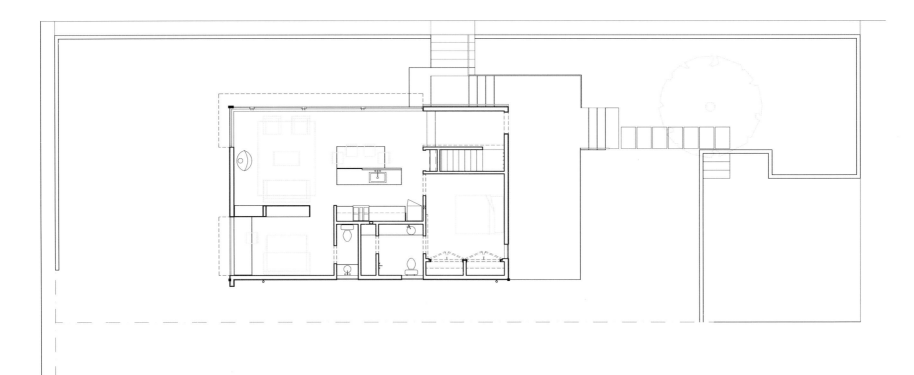

Section

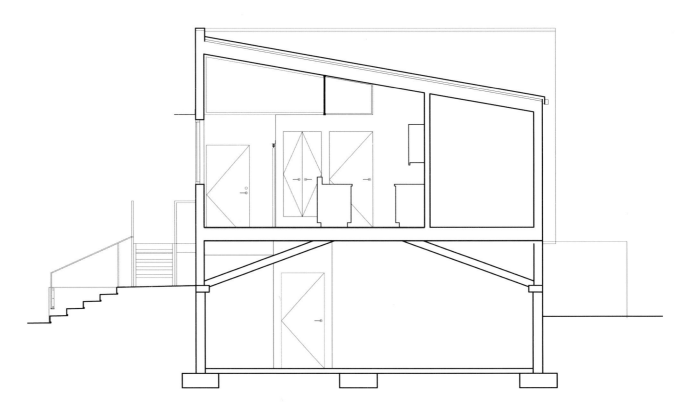

North Elevation

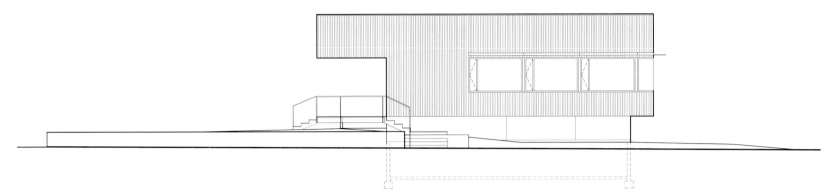

North-South Section

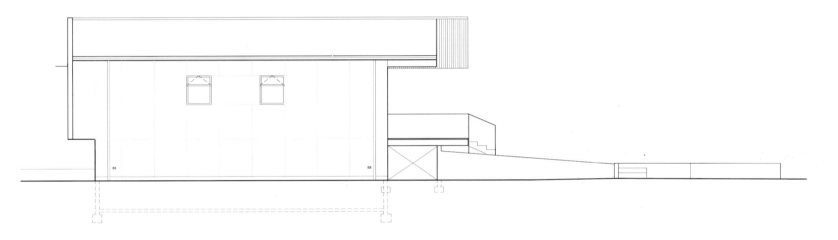

East Elevation

West Elevation

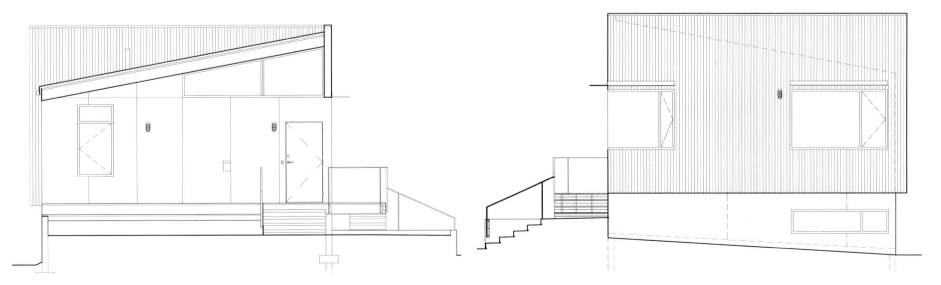

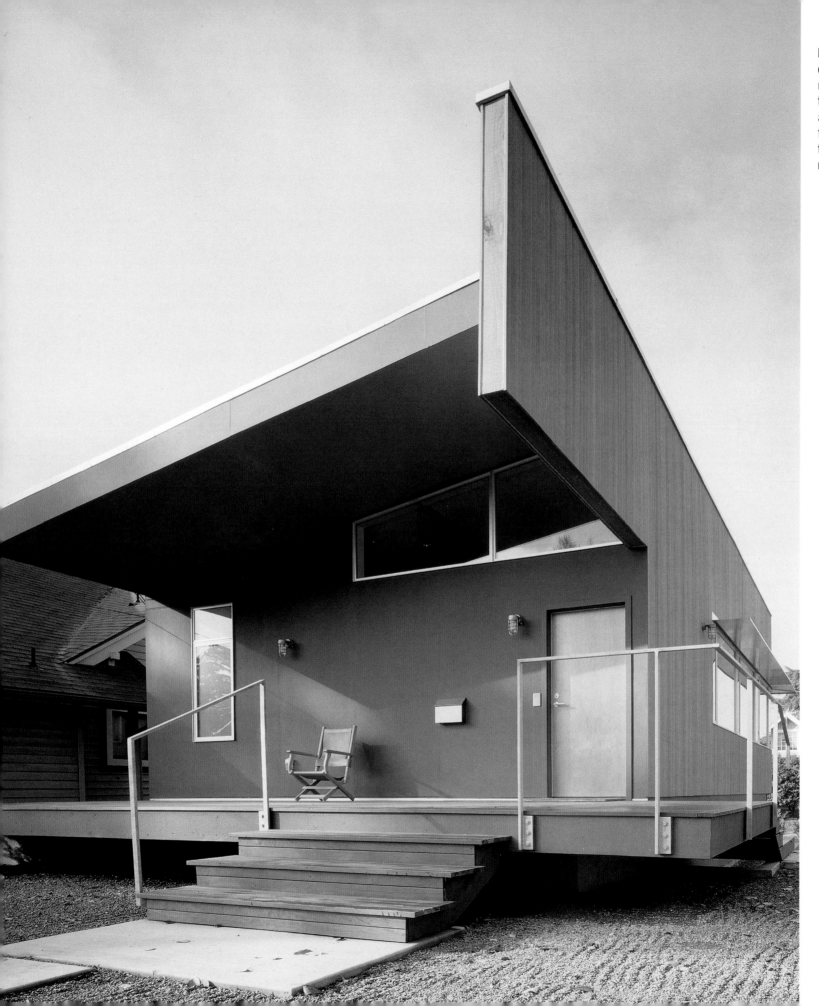

Left and Right: Using an existing foundation, the new house was cantilevered to give more floor area. The height of the foundation was increased to allow for more storage room in the basement.

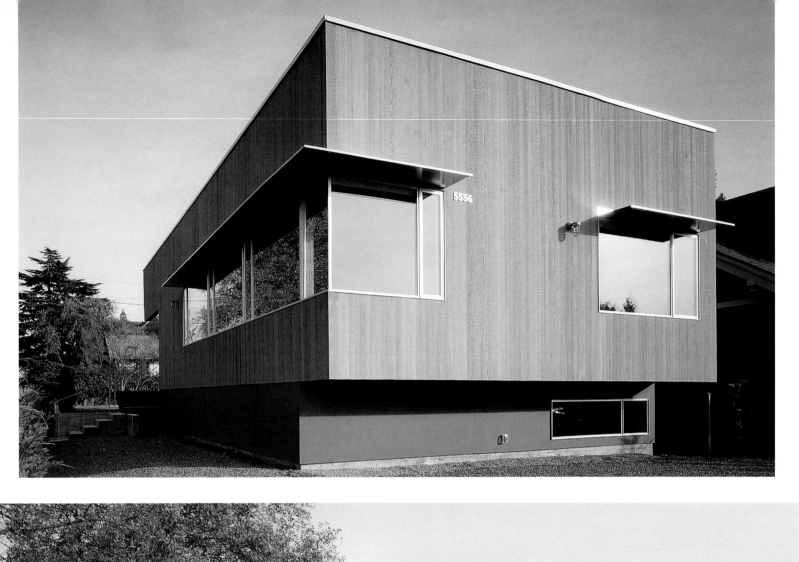

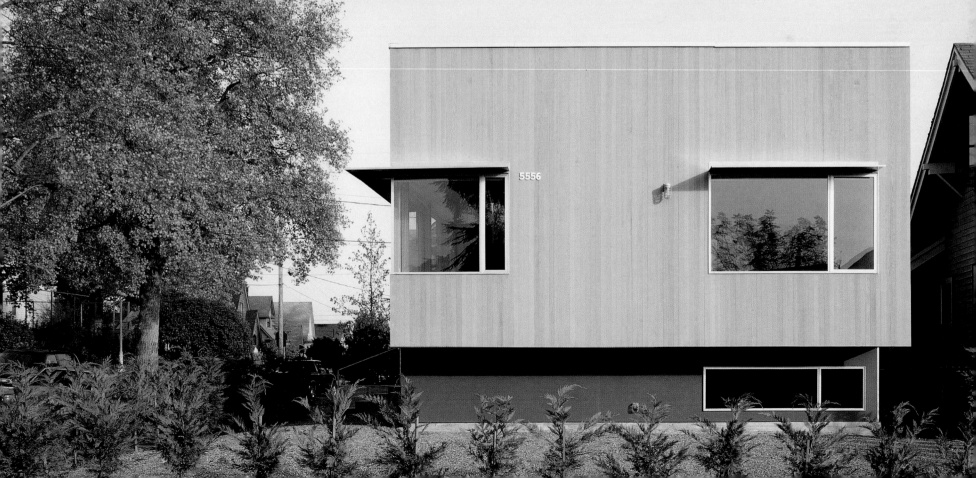

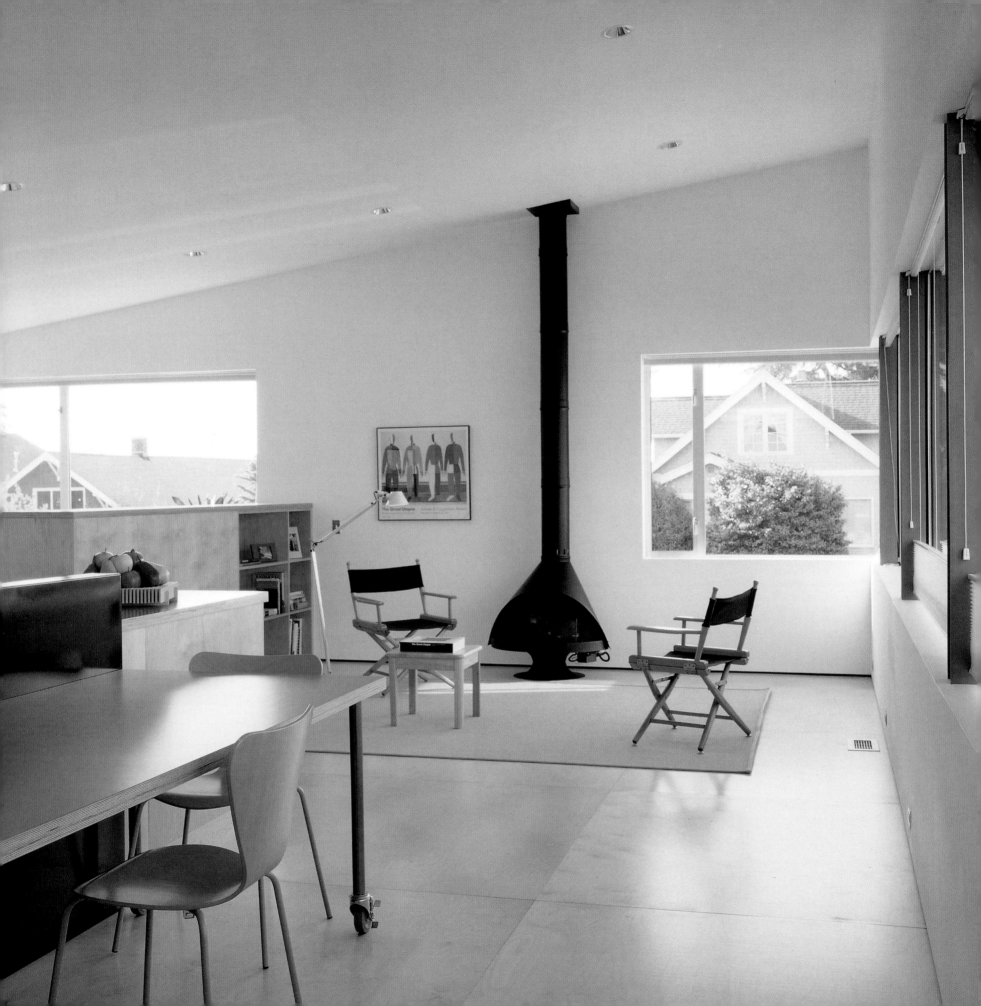

Left and Right: The open floor plan was kept simple and free of detail. A prefabricated gas fireplace provides necessary heat.

Below: Built-in birch plywood bookcases separate the study area from the living area.

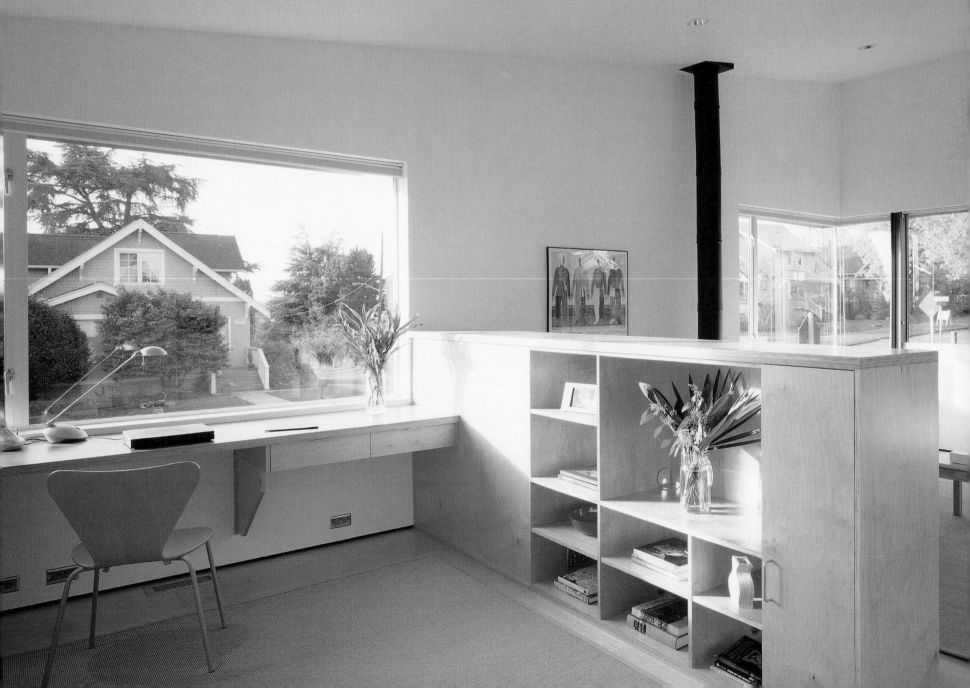

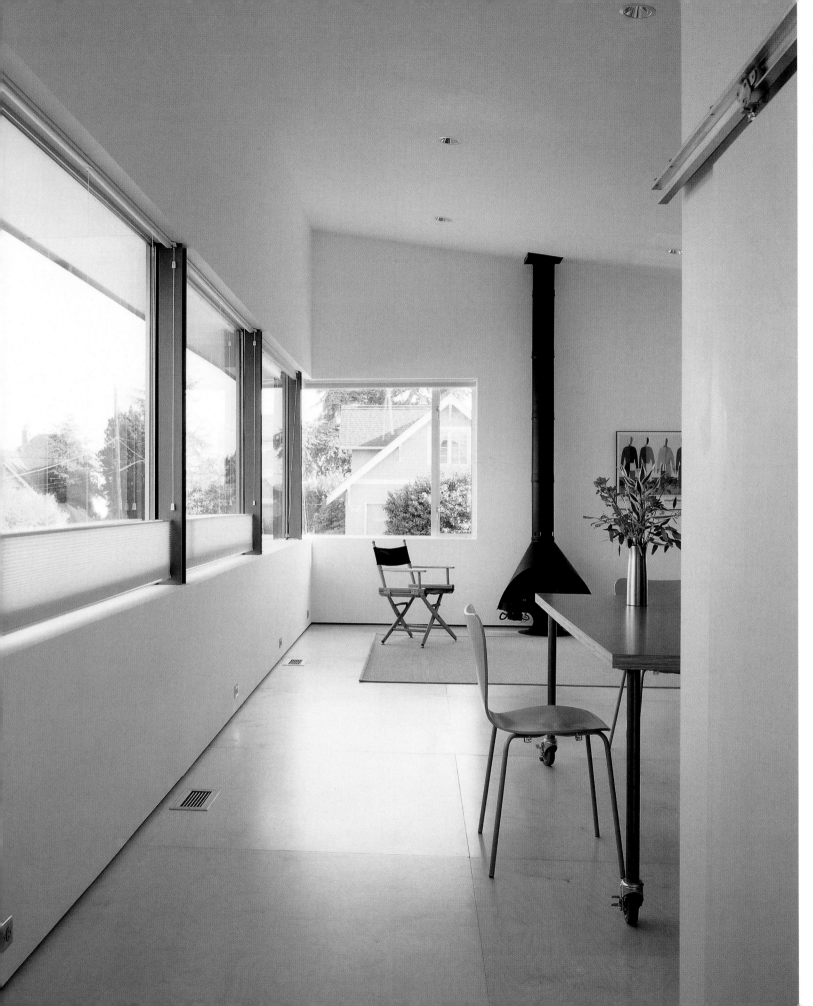

Left: Long aluminum ribbon windows give a decidedly modern touch to the design while providing ample light.

Right: The simplicity of the design carries over into the bathroom.

DOMESTIC MODERN
Returning to the City

place: **LOUISVILLE, KENTUCKY** | architects: **BUILDING STUDIO**

photography: **TIM HURSLEY**

PROJECT DESCRIPTION

The house, built on a "leftover," awkwardly shaped lot in an older inner-city neighborhood, was designed for a young couple with two children whom they wanted to raise in an urban rather than suburban environment. Their primary needs included a home that a young growing family could afford, and a simple design that, while new, would fit comfortably within the existing neighborhood. Because of the long, narrow lot, privacy from adjacent neighbors was a big issue, as was the need to have plenty of outdoor space in which to garden. With neighbors' homes close by, the north and south sidewalls have minimal openings and serve as privacy barriers. The carport on the street side insulates the living areas from the street while providing a protected courtyard for children's outdoor play. A rear, screened porch and outdoor sitting area opens onto the deep rear yard and is shielded on the south and protected overhead by a wood trellis and covered roof.

KEEPING COSTS DOWN

The house consist of two simple rectangles that intersect where the lot angle changes, allowing conventional framing. The open floor plan minimizes interior partitioning. The ground floor is essentially one room, opening onto front, side, and rear gardens. The exterior utilizes materials that are of common size and that are durable and inexpensive. Standard insulated glass was used in an economical aluminum-framed curtain wall system. The foundation is slab on grade, and the floors are sealed concrete.

PRIMARY BUILDING MATERIALS

Wood framing was used throughout, and all interior walls are painted gypsum wallboard. The exterior consists of pre-painted industrial siding with 1 ½-inch-deep ribs, standard polycarbonate and Fiberglas panels, and Fiberglas composition shingles as exterior wall sheathing.

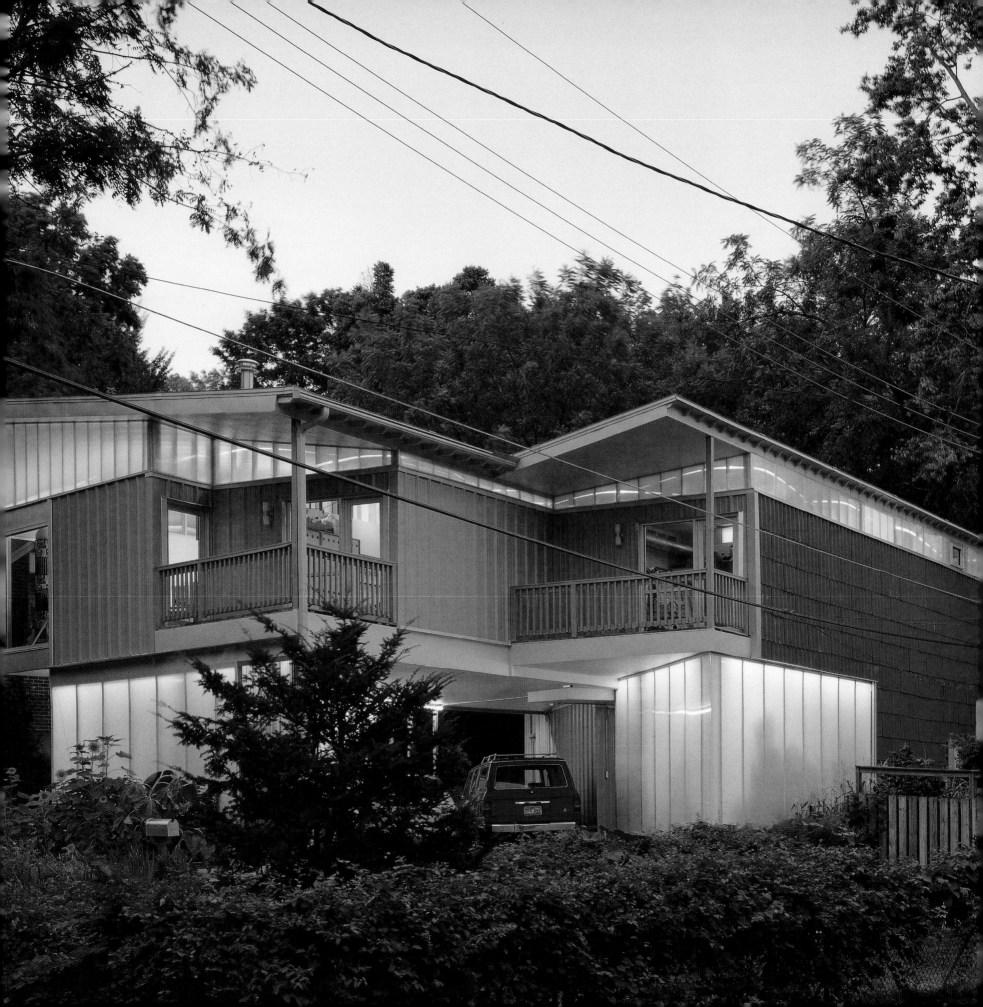

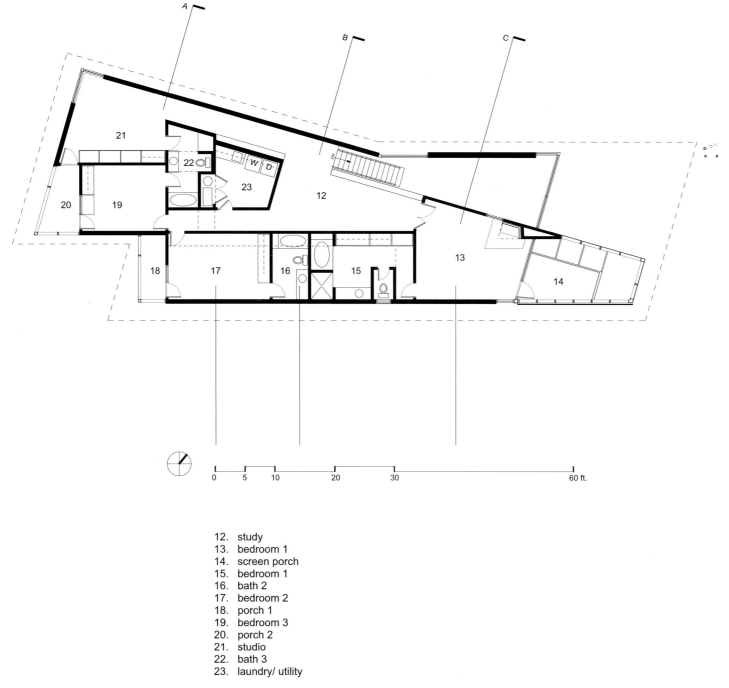

12. study
13. bedroom 1
14. screen porch
15. bedroom 1
16. bath 2
17. bedroom 2
18. porch 1
19. bedroom 3
20. porch 2
21. studio
22. bath 3
23. laundry/ utility

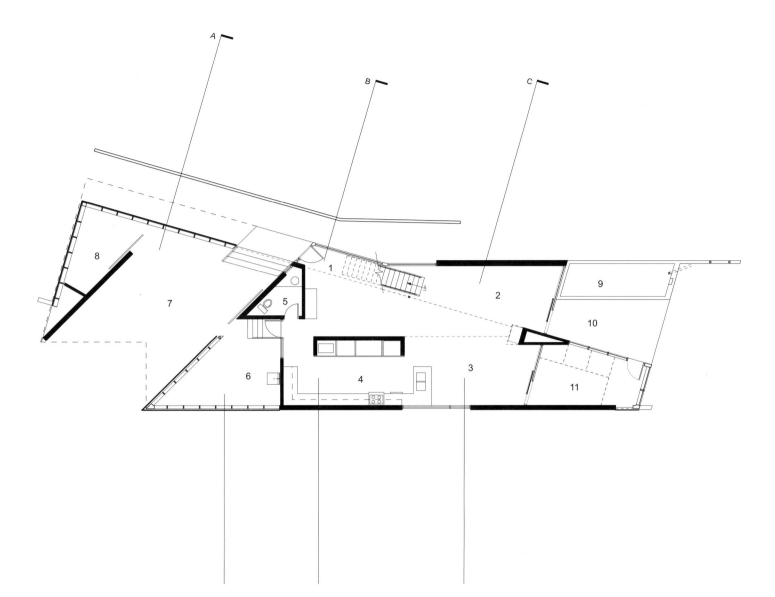

1. entry
2. living
3. dining
4. kitchen
5. guest bath
6. work area
7. garage
8. storage
9. water garden/ cistern
10. patio
11. screen porch

North Elevation

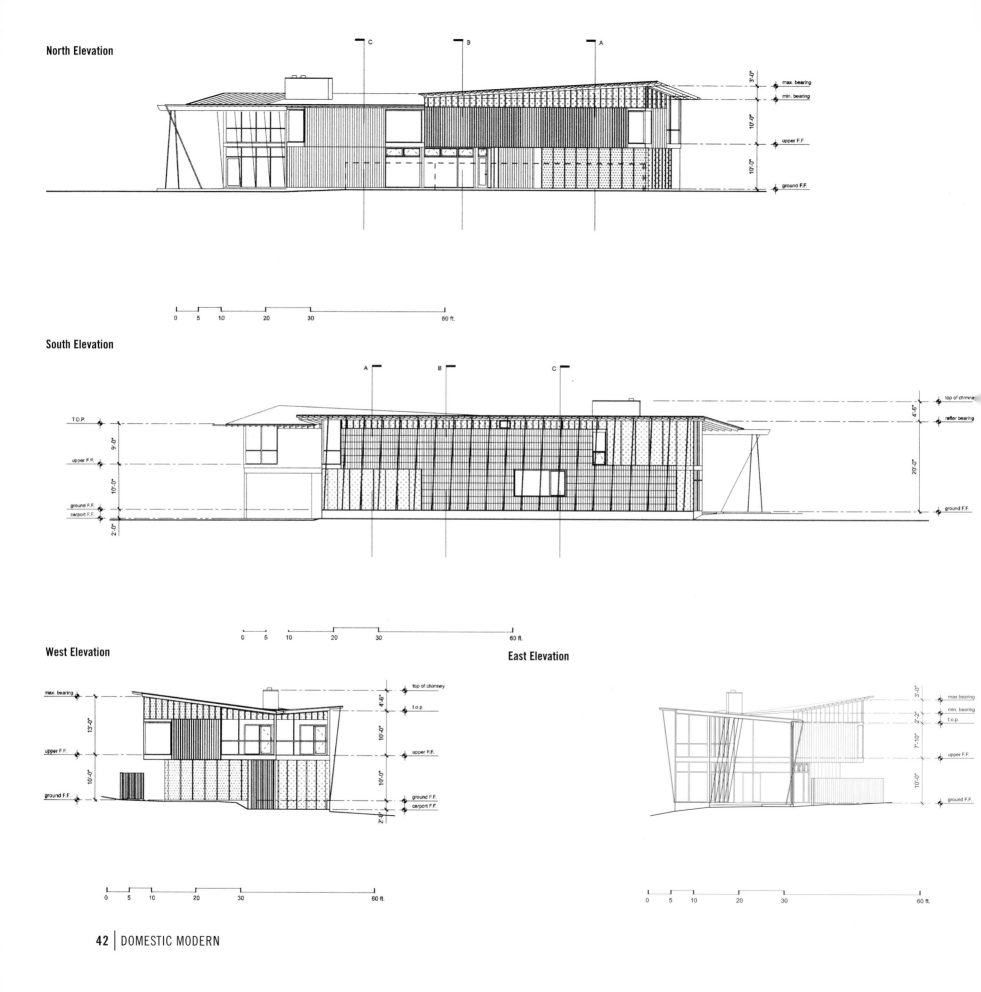

3'-0" max. bearing
min. bearing
10'-0" upper F.F.
10'-0" ground F.F.

0 5 10 20 30 60 ft.

South Elevation

4'-6" top of chimney
rafter bearing

T.O.P.
9'-0" upper F.F.
10'-0" ground F.F.
carport F.F.
2'-0"

20'-0" ground F.F.

0 5 10 20 30 60 ft.

West Elevation **East Elevation**

max. bearing top of chimney
4'-6" t.o.p.
13'-0" 10'-0"
upper F.F. upper F.F.
10'-0"
ground F.F.
carport F.F.
2'-0"

0 5 10 20 30 60 ft.

3'-0" max bearing
2'-2" min. bearing
t.o.p.
7'-10" upper F.F.
10'-0" ground F.F.

0 5 10 20 30 60 ft.

Section A

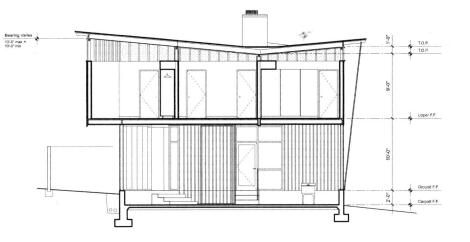

Bearing Varies
13'-0" max *
10'-0" min

1'-0"
T.O.P.
T.O.P.

9'-0"

Upper F.F.

10'-0"

Ground F.F.

2'-0"

Carport F.F.

0 5 10 20 30 ft.

Section B

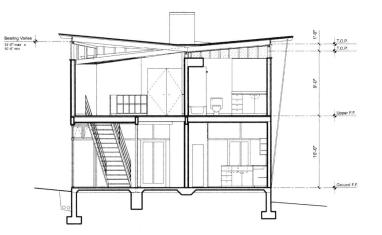

Bearing Varies
13'-0" max *
10'-0" min

1'-0"
T.O.P.
T.O.P.

9'-0"

Upper F.F.

10'-0"

Ground F.F.

0 5 10 20 30 ft.

Section C

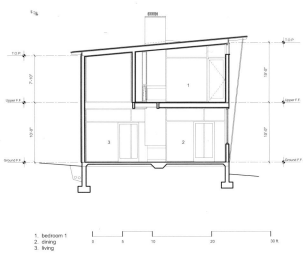

T.O.P.

T.O.P.

7'-10"

10'-0"

Upper F.F.

Upper F.F.

10'-0"

10'-0"

Ground F.F.

Ground F.F.

1. bedroom 1
2. dining
3. living

0 5 10 20 30 ft.

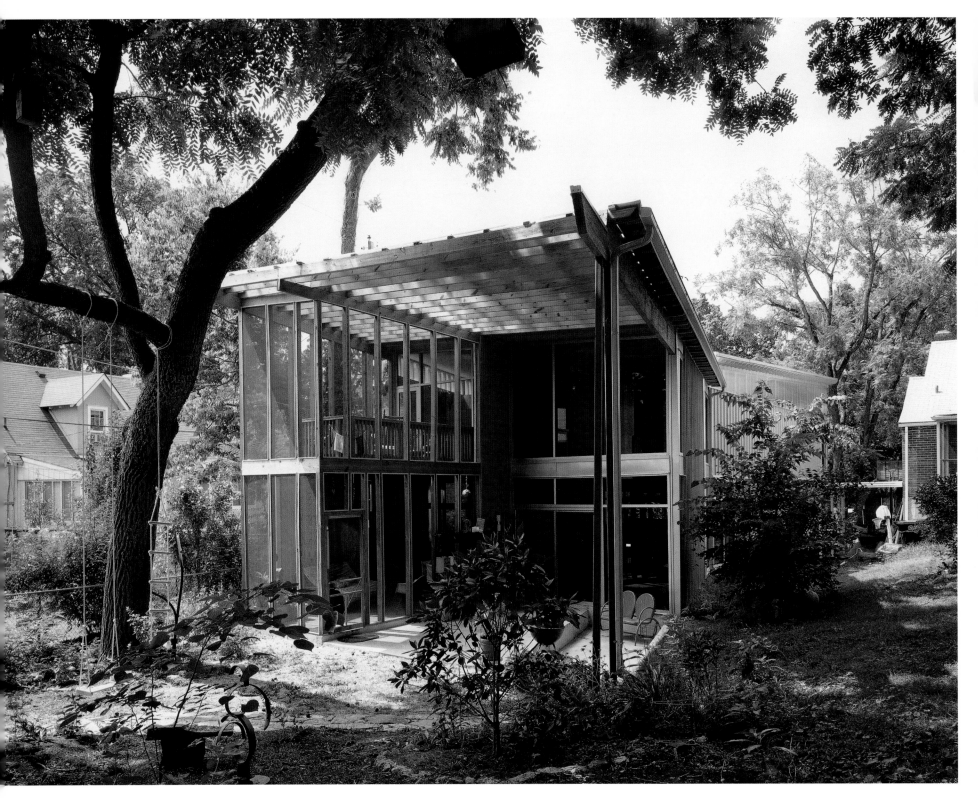

Above and Right: Positioned at the rear of the house, the porch enjoys a view into the deep garden.

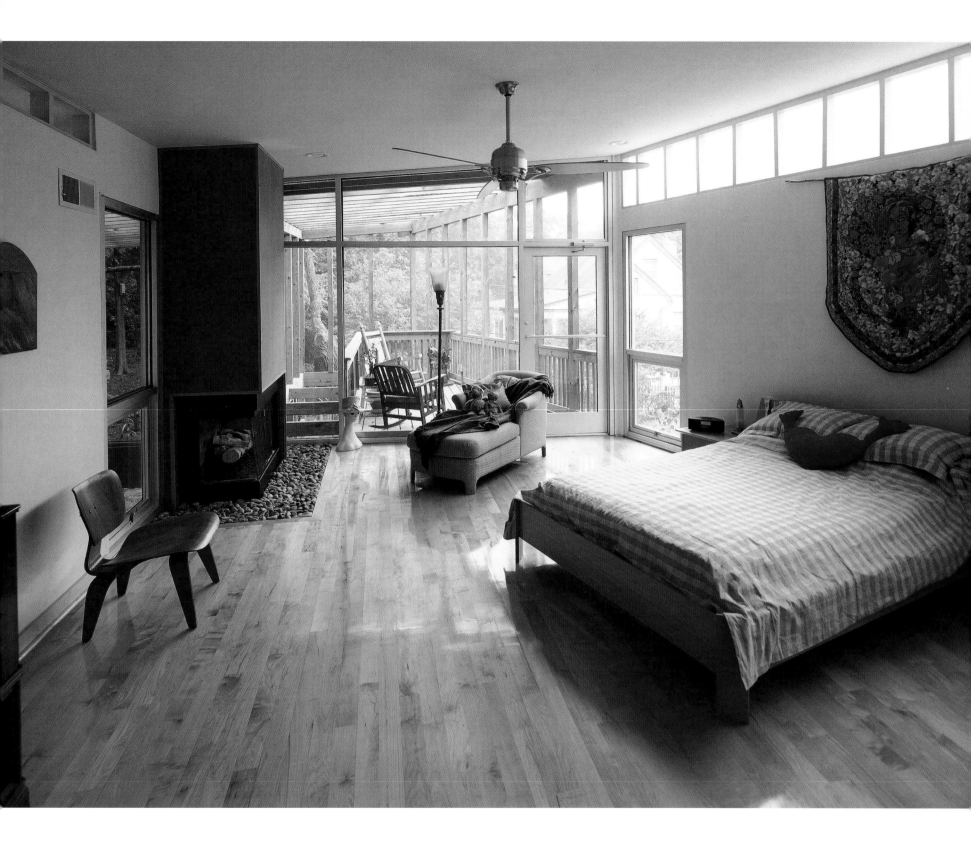

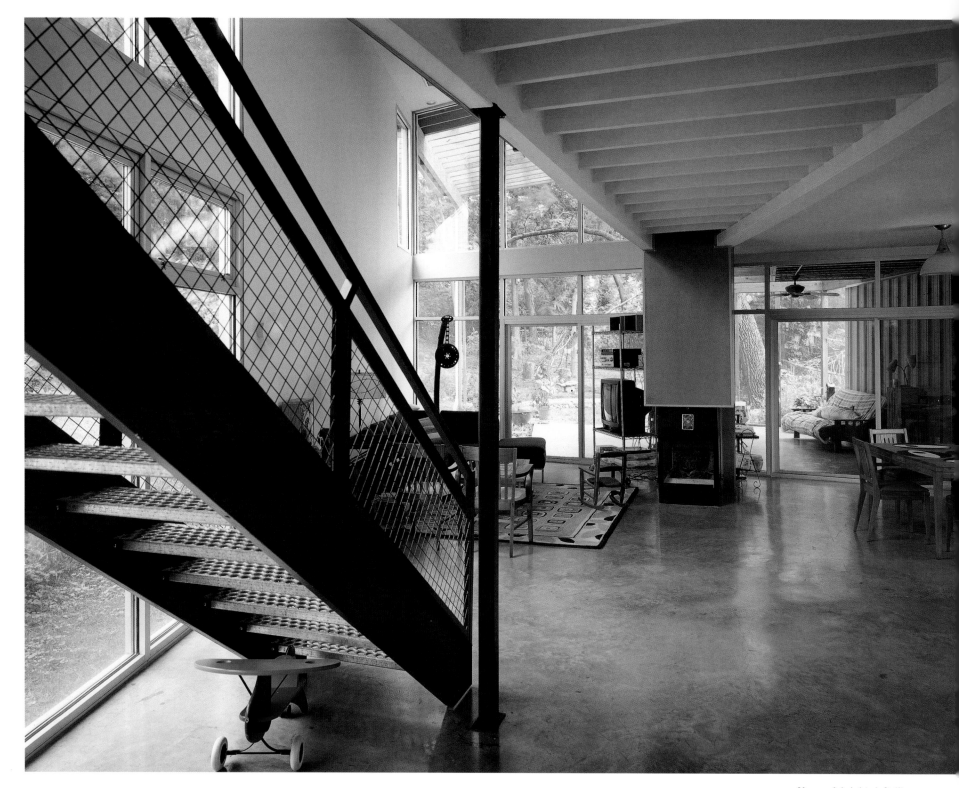

Above: A bright, loft-like space on the first floor keeps construction costs down by eliminating unnecessary framing and drywall for partitions and doors.

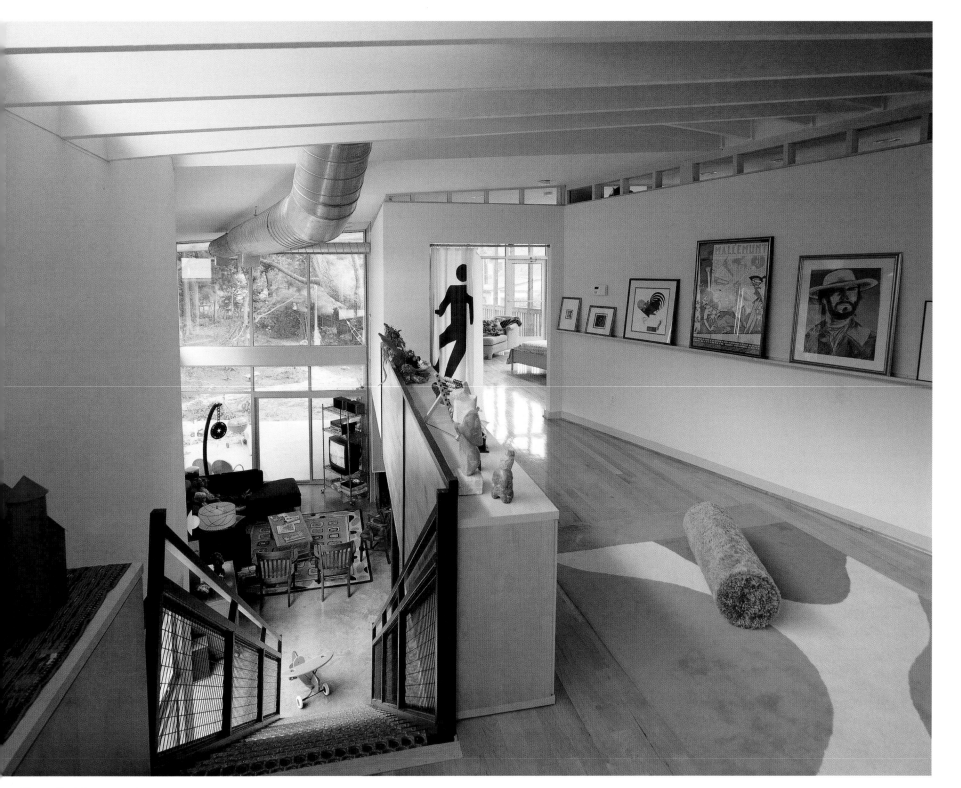

Above: Upstairs, exposed ductwork for heating and air conditioning also requires no framing or drywall and continues the loft motif.

LILLIAN WAY

From Bungalow to Loft

place: **LOS ANGELES, CALIFORNIA** | architects: **ALEKS ISTANBULLU ARCHITECTS**

photography: **ART GRAY**

PROJECT DESCRIPTION

Lurking behind the walls of this modest 1,200-square-foot two-bedroom house was a dramatic loft space waiting to be realized. With all of the dividing walls and the ceiling removed and a large skylight placed squarely in the center, a once dark and conventional space has been transformed into a minimalist urban retreat. A large storage wall divides the public and private spaces. The living area extends across the full length of the house, incorporating an open space that is reserved for the client's everyday practice of yoga.

KEEPING COSTS DOWN

Several small steps were taken that resulted in big savings. Originally, the client wanted to add an additional 400-square-foot bedroom to the house. However, the architect was able to accommodate her programmatic requirement within the existing space, saving thousands of dollars on new construction. Because of the totally open plan where one living space flows into the other, no doors were used except for the bathroom. During demolition, so many walls were removed that there was insufficient support for the dropped ceiling. With the attic exposed, the architect decided to use the pitched roof as the ceiling. Insulation was added and the drywall was applied directly to the rafters. The original house was quite dark. Rather than add windows, which would drive up costs, a single skylight in the middle of the house was added. Since the space is completely open, light now floods throughout. The kitchen was left untouched except for the addition of new cabinet doors. The only custom feature was the fabrication of the dividing wall between the bedroom and the living room, which sports 20 linear feet of closet space on the bedroom side and storage for the client's CD music collection on the public side.

PRIMARY BUILDING MATERIALS

Standard wood framing was used in the renovation. The storage wall is constructed of maple plywood, as are the new kitchen cabinet doors. The floors are also maple.

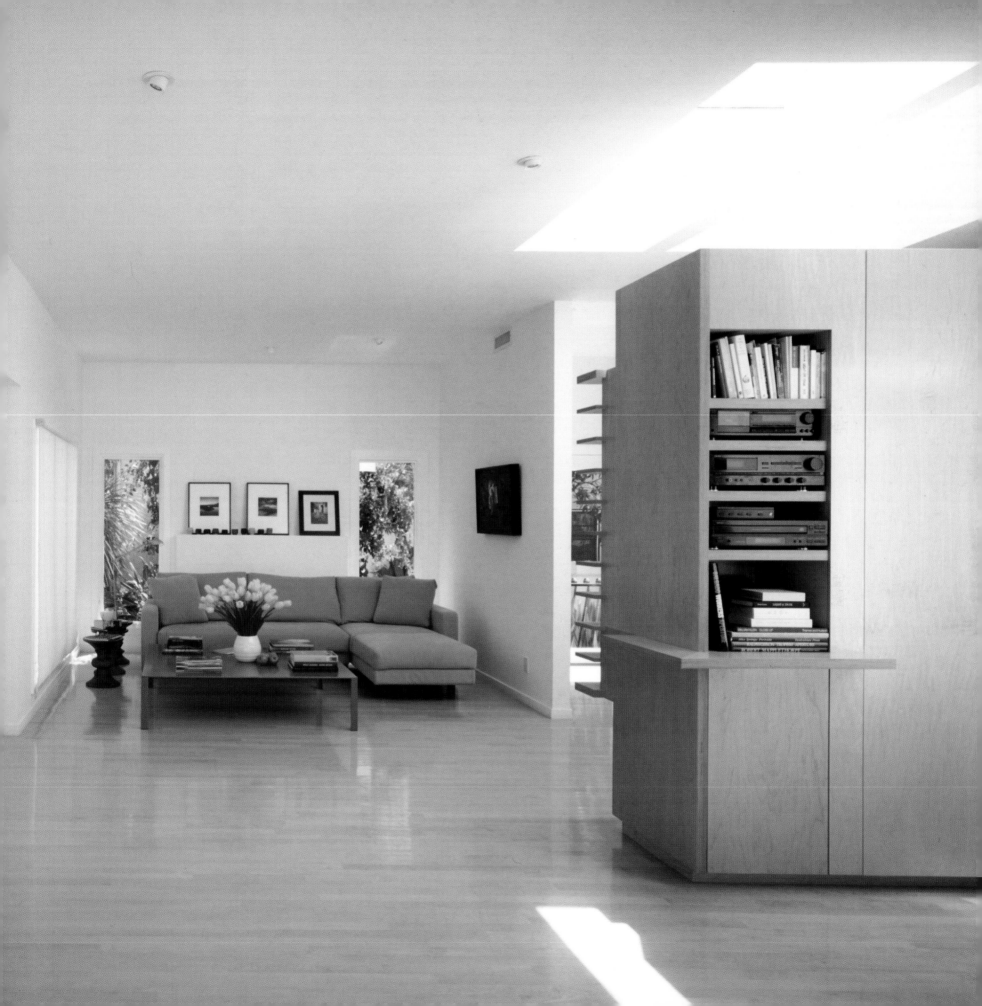

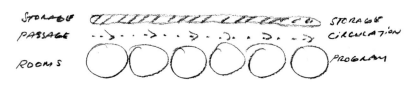

STORAGE ──────────── STORAGE
PASSAGE ─ ∙ → ∙ → ∙ → ∙ → ∙ → CIRCULATION
ROOMS ○ ○ ○ ○ ○ ○ PROGRAM

tree

closets

Kitchen

bedroom

dining

bath

sitting

Topo

music

½" AIRSPACE

CD STACKING AREA

CD shelf

CD STACKING AREA

CD shelf

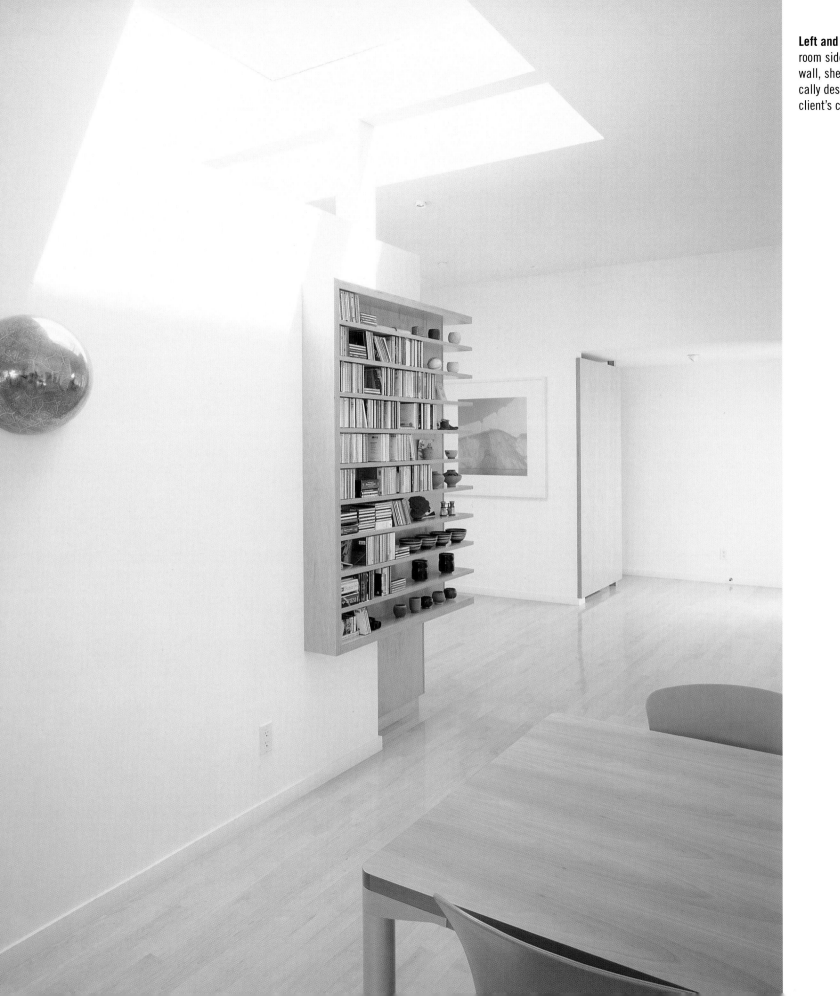

Left and Right: On the living room side of the storage wall, shelving was specifically designed to hold the client's collection of CDs.

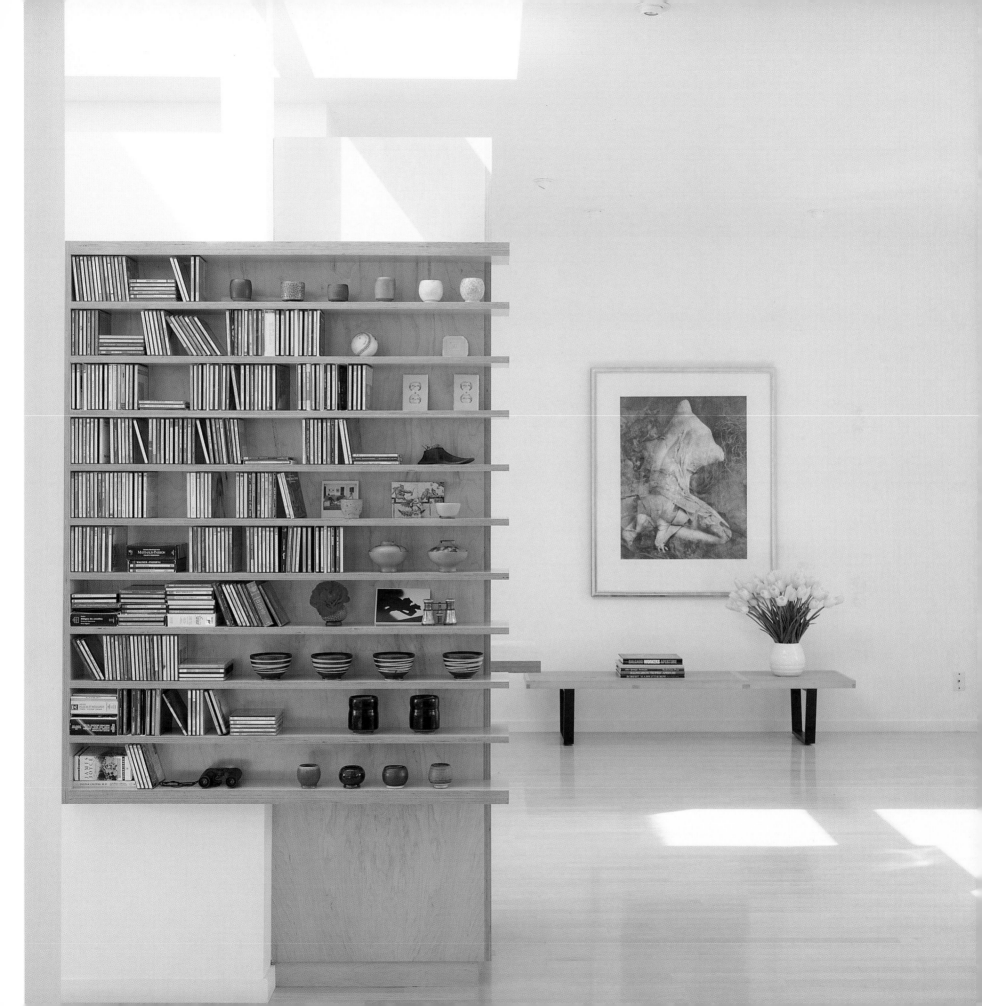

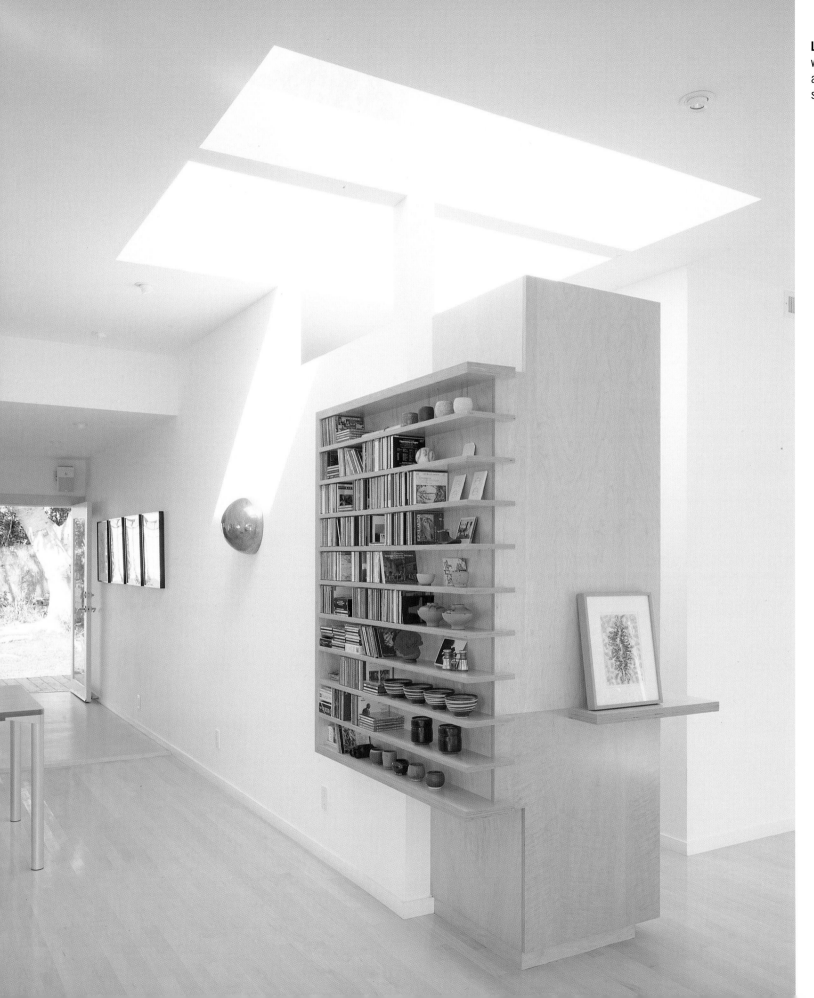

Left and Right: Moving the wall to the bedroom side, there are now 20 linear feet of closet space.

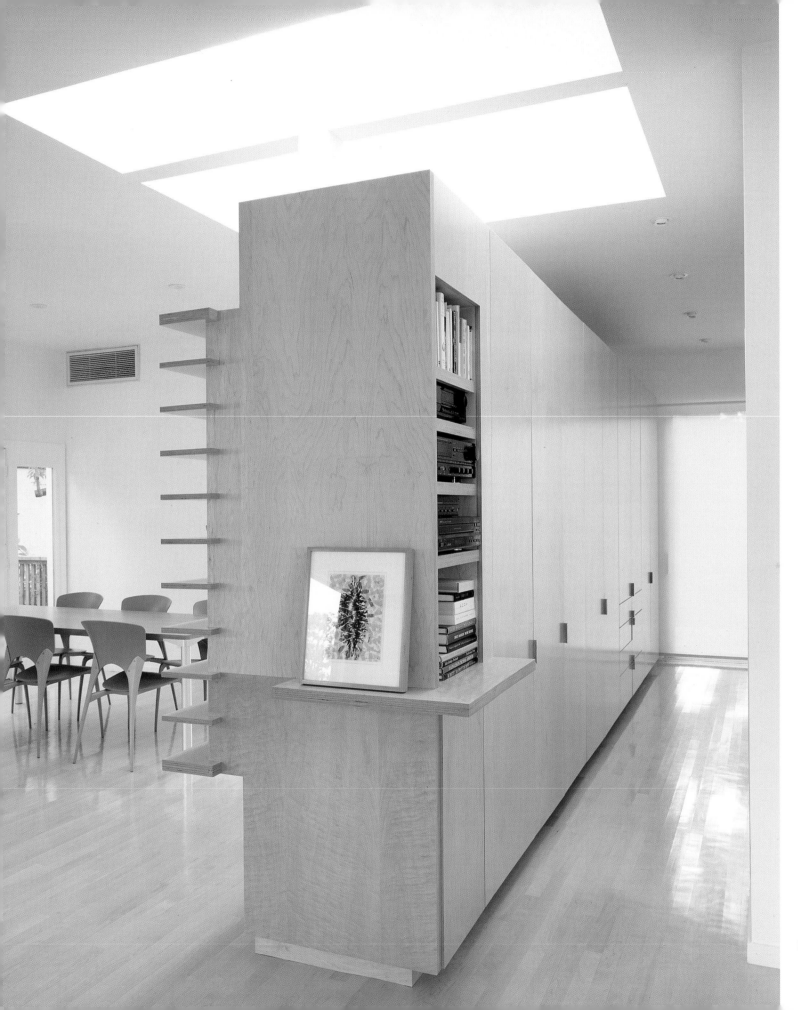

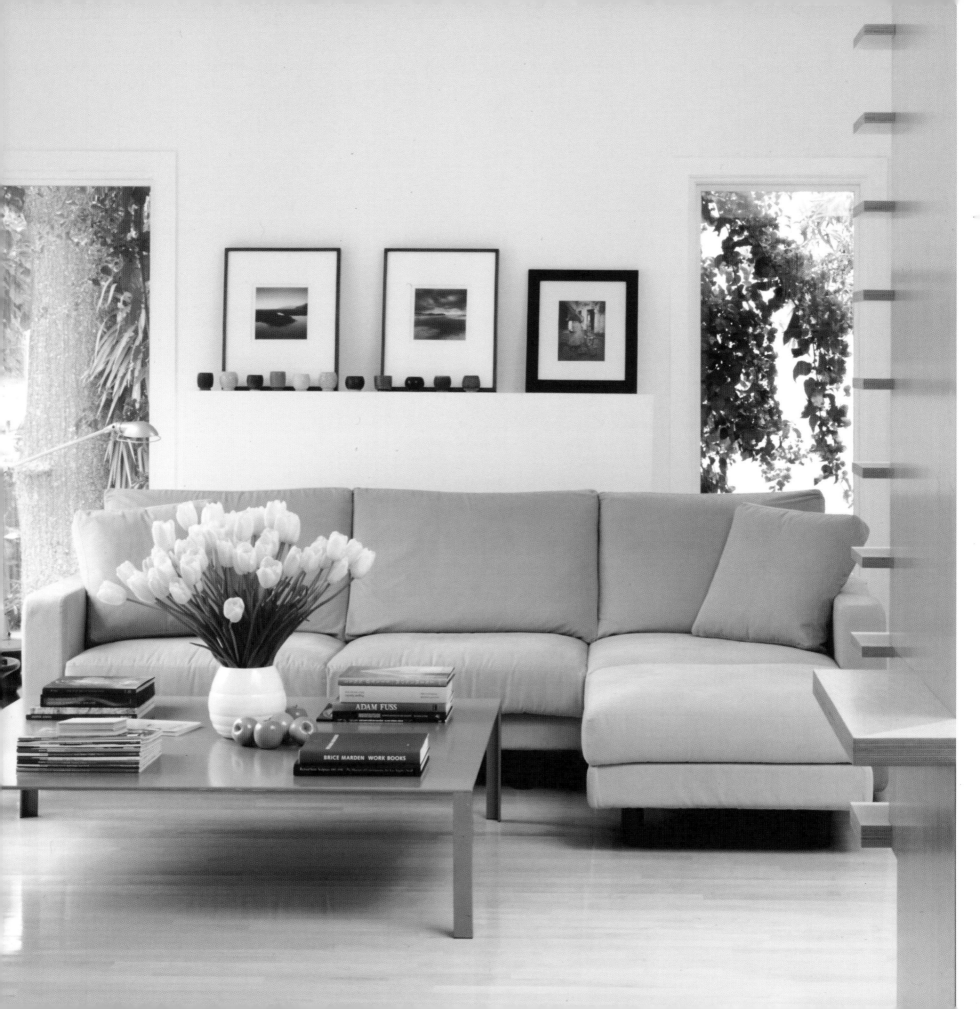

Left: A view of the living area from the storage wall

Above: The storage wall divides the public and private spaces in the house.

Above Right: Storage space was also a major factor in the design of the master bath.

PATEL/CAPOOR

The New Native House

place: **MADISON COUNTY, KENTUCKY** | architects: **GUYON ARCHITECTS**

photography: **SCOTT GUYON**

PROJECT DESCRIPTION

This 3,800-square-foot residence is located in horse country along a tall ridge that runs next to the Kentucky River. Its design, while modern, is influenced by "work buildings" of the rural South, including barns, sheds, silos, and smokehouses, as well as the rock fences of this region and the common tractor sheds that dot the hillsides of local farms. The interior structure of the building is arranged around two crossing stone walls. The dry-laid limestone masonry runs longitudinally down the main hallway, with a second wall crossing at the entry axis and along the fireplace in the main living space. The public spaces are arranged to the east of the fireplace, while the bedrooms, study, and baths are to the west.

KEEPING COSTS DOWN

A standard wood-frame construction with dimensional lumber for the floor and roof systems was employed, along with steel columns for additional structural support. Energy efficiency was achieved with geothermal central heating and cooling. All exterior finishes, including the aluminum-clad windows and cedar siding, are low maintenance.

PRIMARY BUILDING MATERIALS

The exterior utilizes bleached cedar v-joint siding with metal barn roofing, dry stone masonry walls, and steel columns. The dry stone masonry walls continue inside, where the floors are white oak and the cabinetry is maple. The windows are clad in black anodized aluminum.

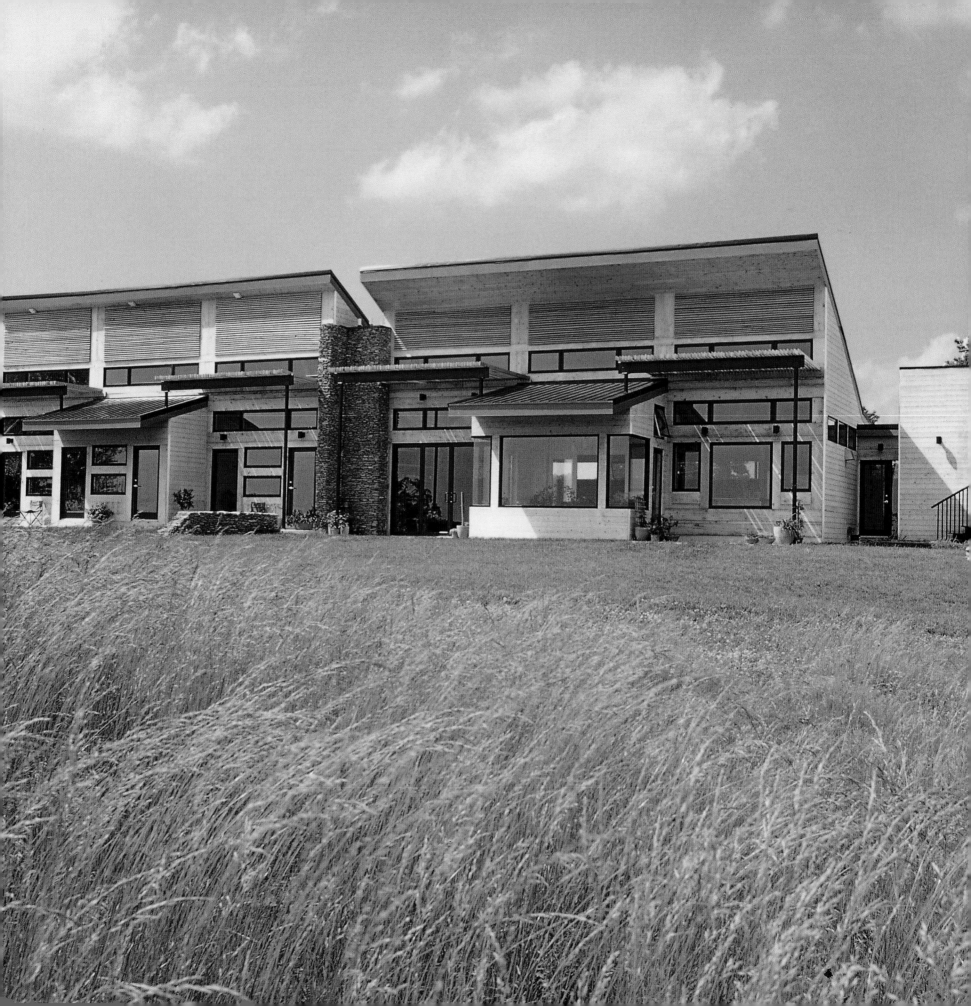

Site Plan

Axonometric

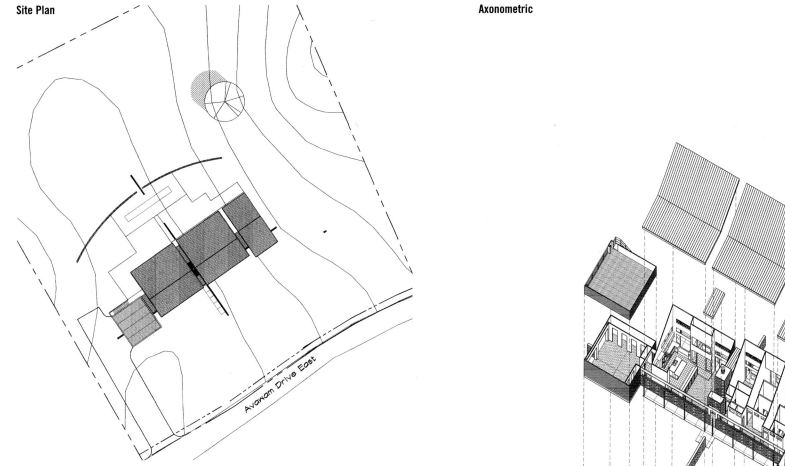

Avawam Drive East

Floor Plan

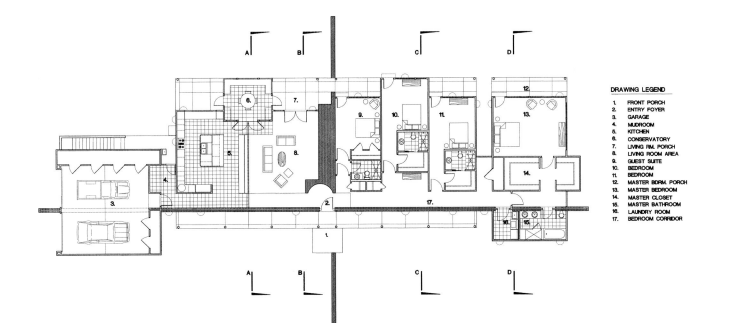

DRAWING LEGEND

1. FRONT PORCH
2. ENTRY FOYER
3. GARAGE
4. MUDROOM
5. KITCHEN
6. CONSERVATORY
7. LIVING RM. PORCH
8. LIVING ROOM AREA
9. GUEST SUITE
10. BEDROOM
11. BEDROOM
12. MASTER BDRM. PORCH
13. MASTER BEDROOM
14. MASTER CLOSET
15. MASTER BATHROOM
16. LAUNDRY ROOM
17. BEDROOM CORRIDOR

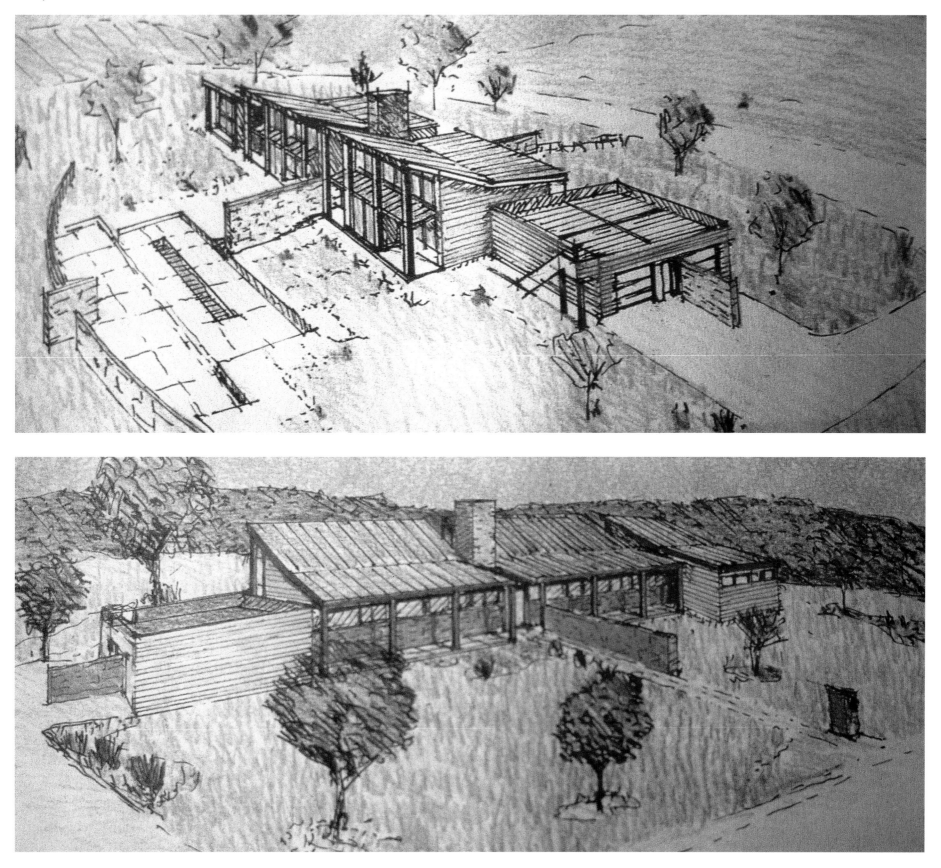

East Elevation

West Elevation

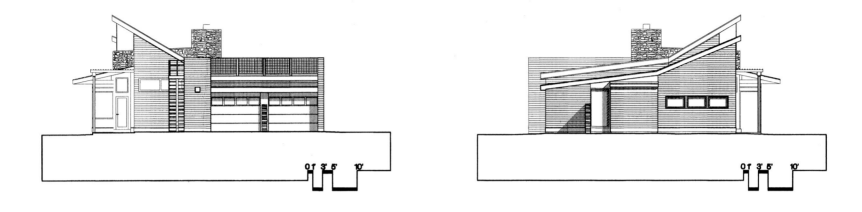

South Elevation

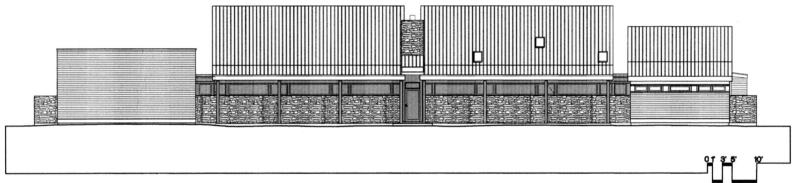

North Elevation

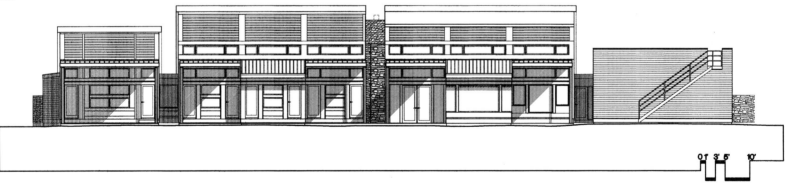

Section A

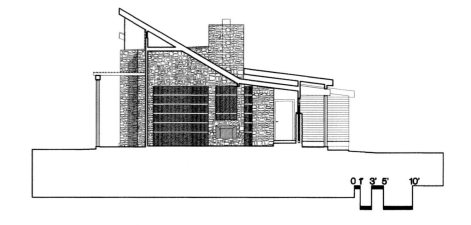

Section B

0 1' 3' 5' 10'

Section C

0 1' 3' 5' 10'

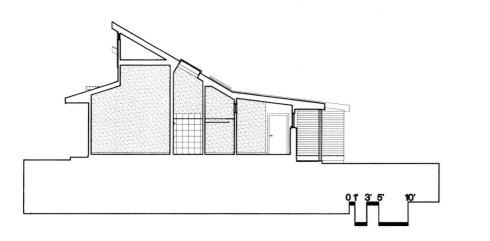

Section D

0 1' 3' 5' 10'

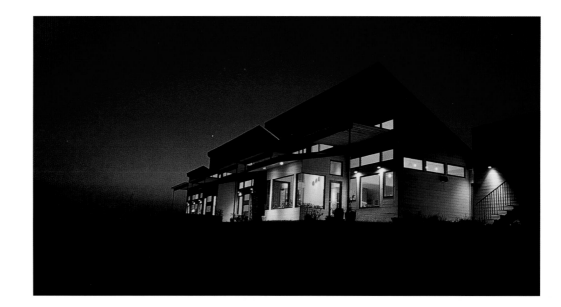

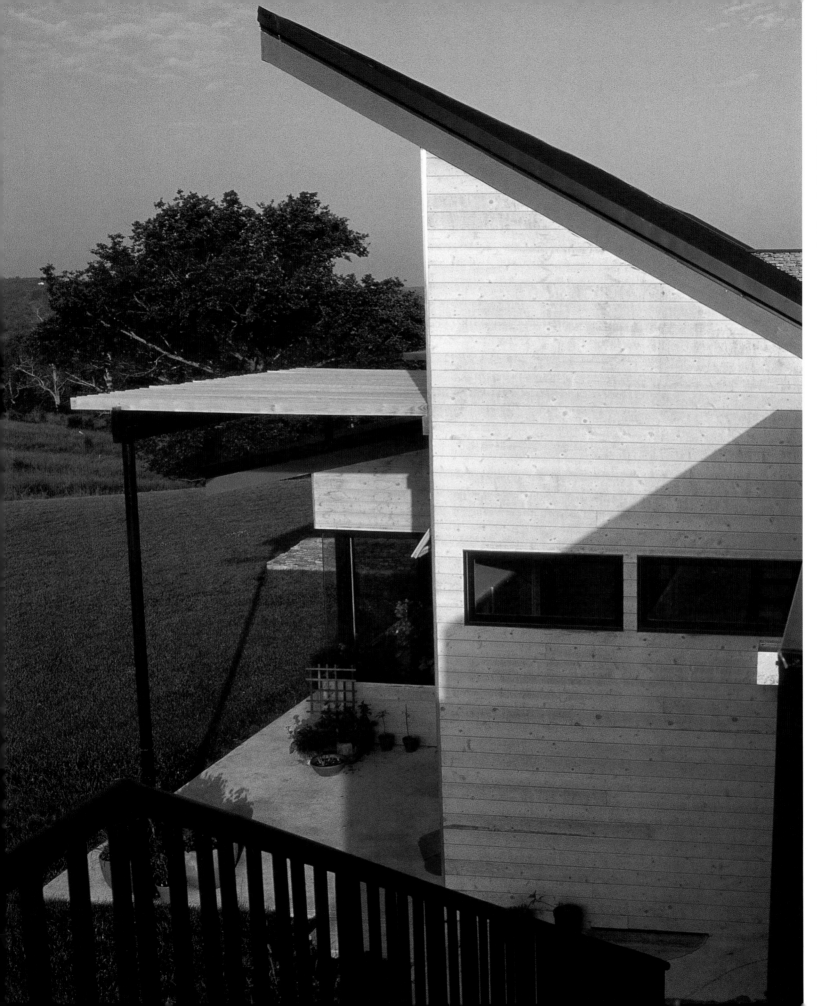

Left and Right: The house runs along a ridge with sweeping views of the the Kentucky River. It has been placed along a South facing ridge with the intention of greeting the visitor from the road to the north and opening to the sky toward the south.

Below Right: A lone elm tree dominates the site.

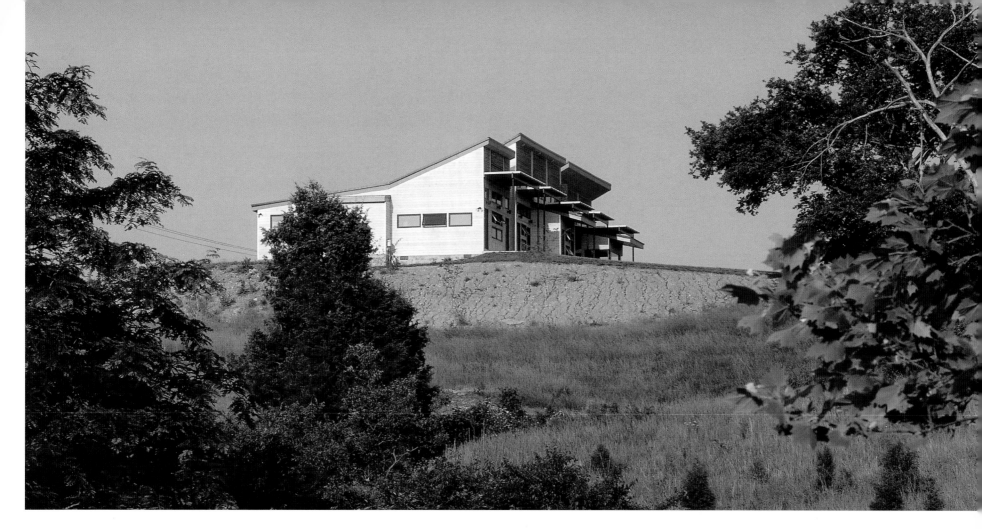
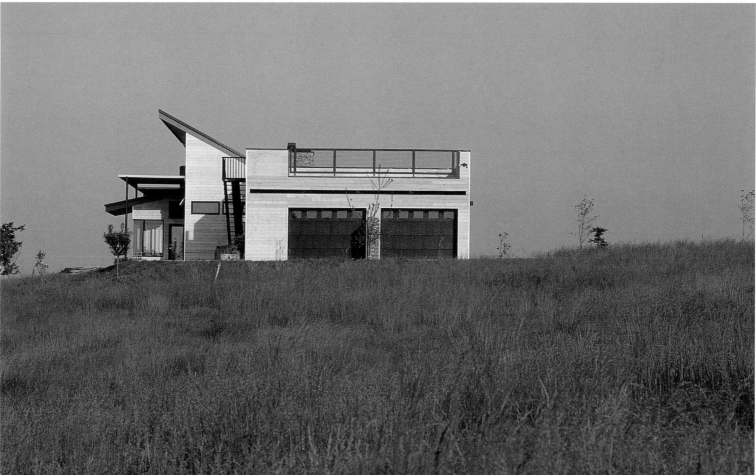

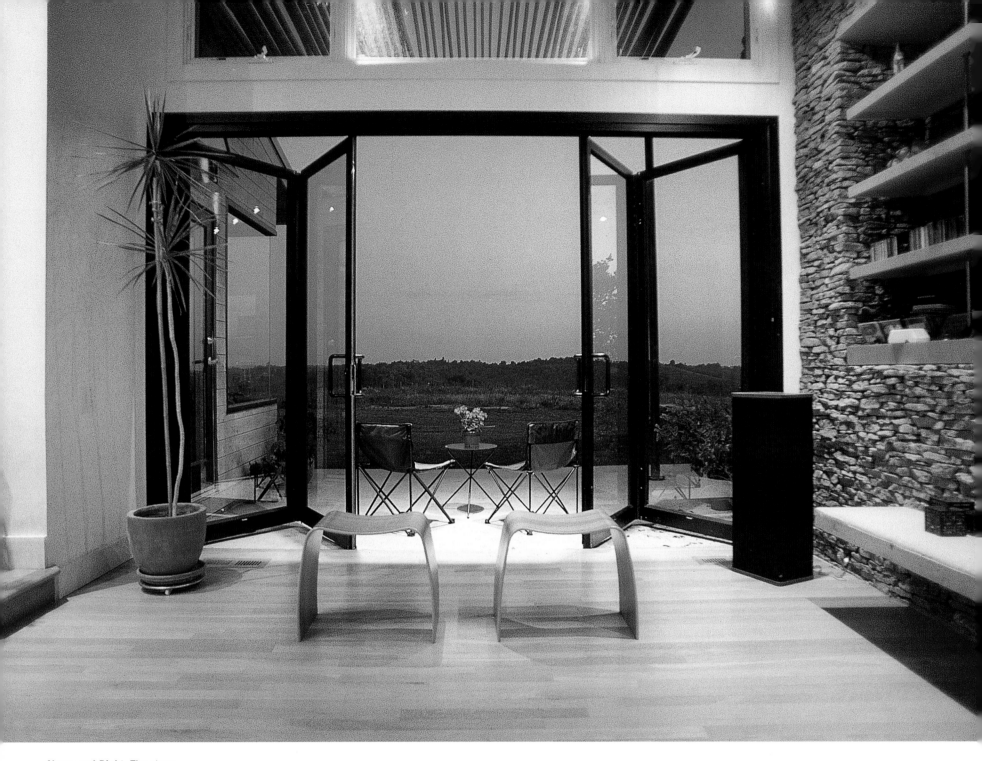

Above and Right: The stone walls were laid from small pieces of stone, creating a fabriclike surface. The fireplace wall divides the public and private spaces of the house. While stone masonry can be expensive, it is a common building technique in the region of the country.

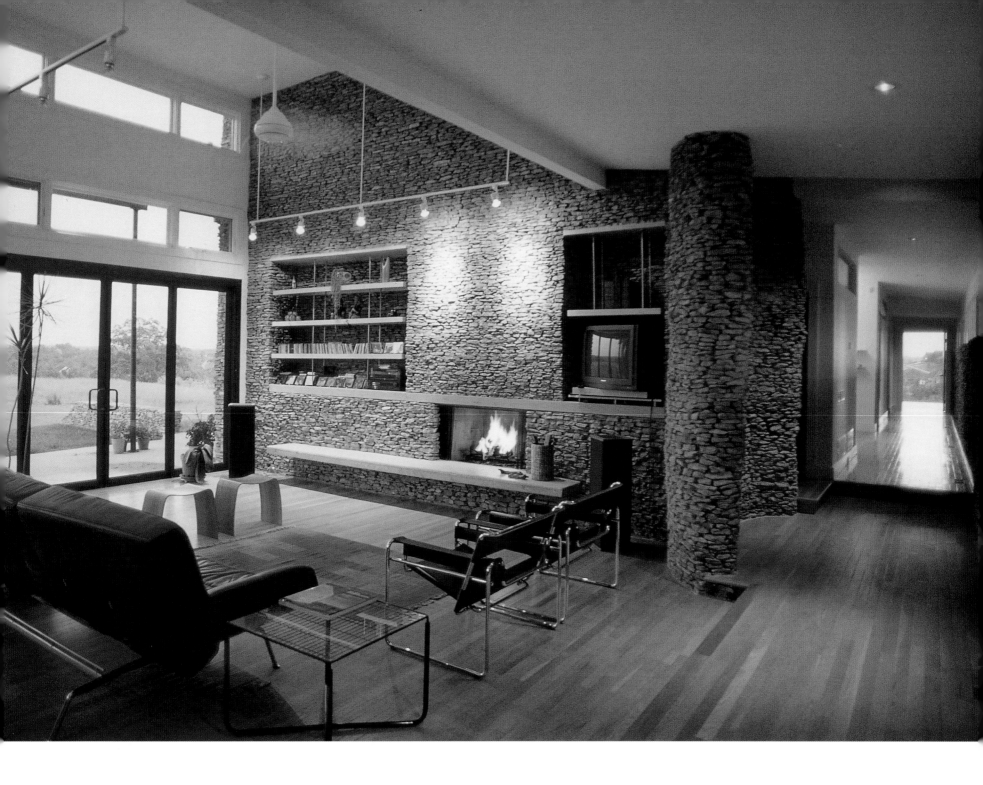

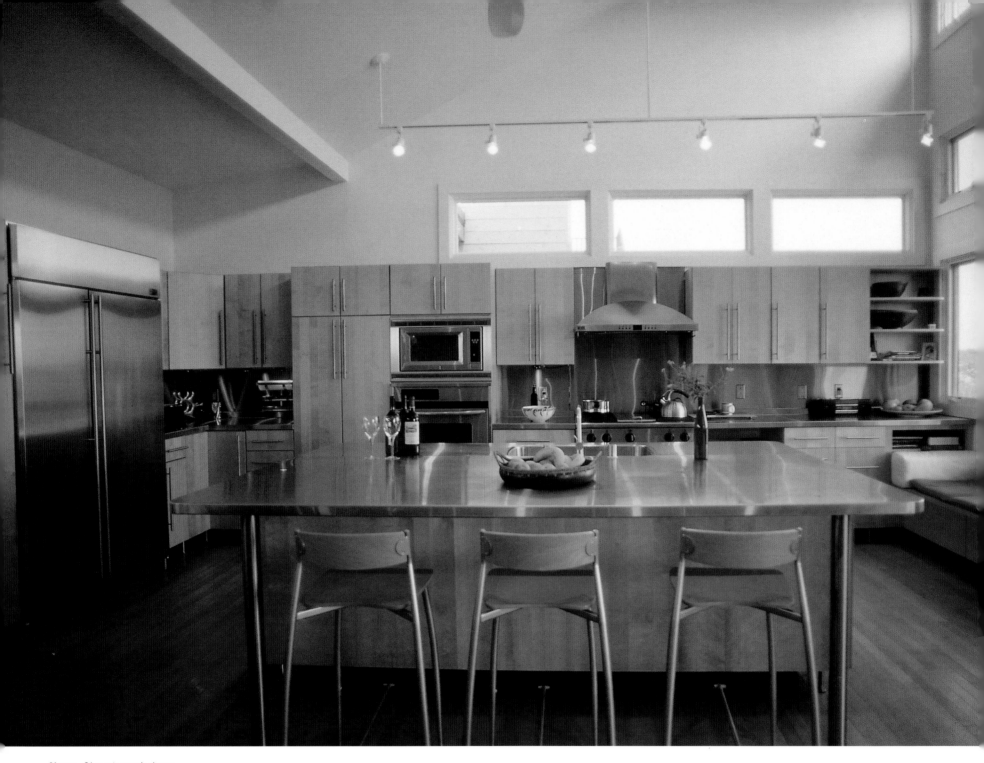

Above: Clerestory windows above the kitchen cabinets brings in additional light. The kitchen is seen here from the living area.

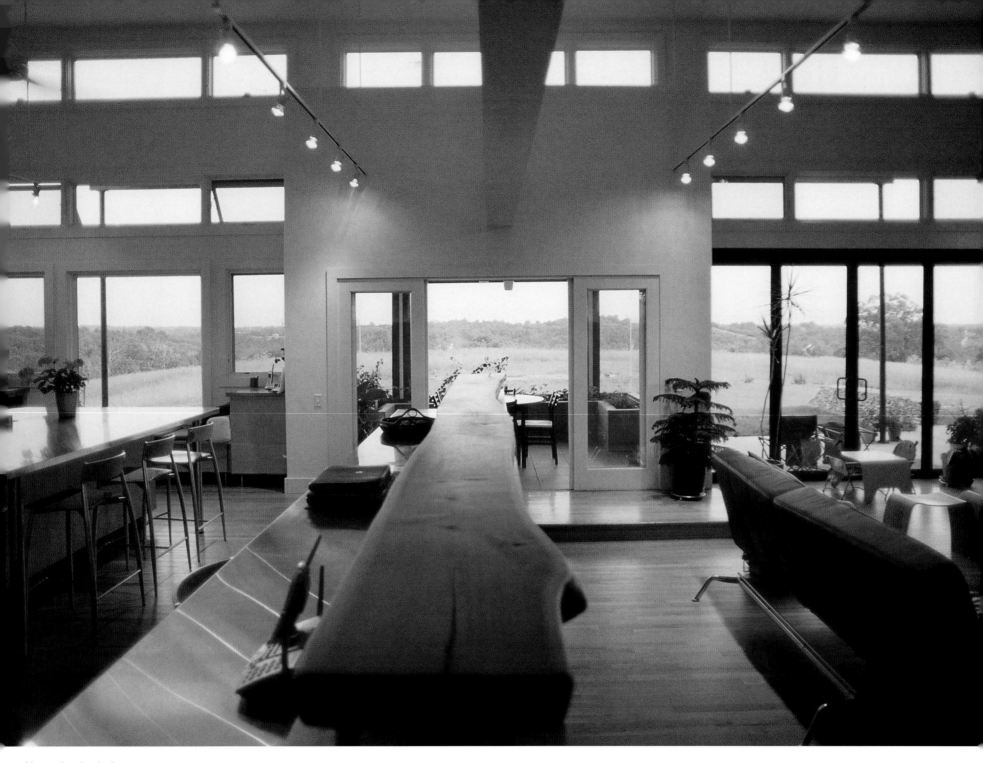

Above: Ample glazing provides the living and dining areas with exceptional light and views.

700 PALMS

Raw, Honest Materials on a Tight Urban Site

place: **VENICE, CALIFORNIA** | architects: **STEVEN EHRLICH ARCHITECTS**

photography: **EHRHARD PFEIFFER**

PROJECT DESCRIPTION

This house was designed for a couple who wanted a large open space that would accommodate overnight guests and large family gatherings. Set in the free-spirited oceanside community of Venice, California, the house is clad inside and out in rusted steel, maintaining privacy yet fully embracing the outdoors from within. Through pivoting metals doors, the 15-foot-high living room opens up on three sides—to the lap pool on the west, to a north courtyard and guest house, and to the south garden. Stairs lead up to a pair of mezzanine-level sleeping/lounging lofts, with decks and a glass bridge that spans the living room and leads to another flight of stairs to the master bedroom and study. The top floor is flooded with light from a shed roof, which opens onto a long west-facing clerestory.

KEEPING COSTS DOWN

When opened entirely to the elements, the house is an airy pavilion, with temperate ocean breezes making air-conditioning unnecessary. The concrete absorbs the sun's warmth in the winter and acts as a radiant heat source for cold nights. Photovoltaic sunshades at the roof line store and augment energy consumption.

PRIMARY BUILDING MATERIALS

The wood-and-steel-framed structure is outlined by a steel exoskeleton. The interior back wall is shot-blasted structural concrete masonry, and the ground floor is concrete slab.

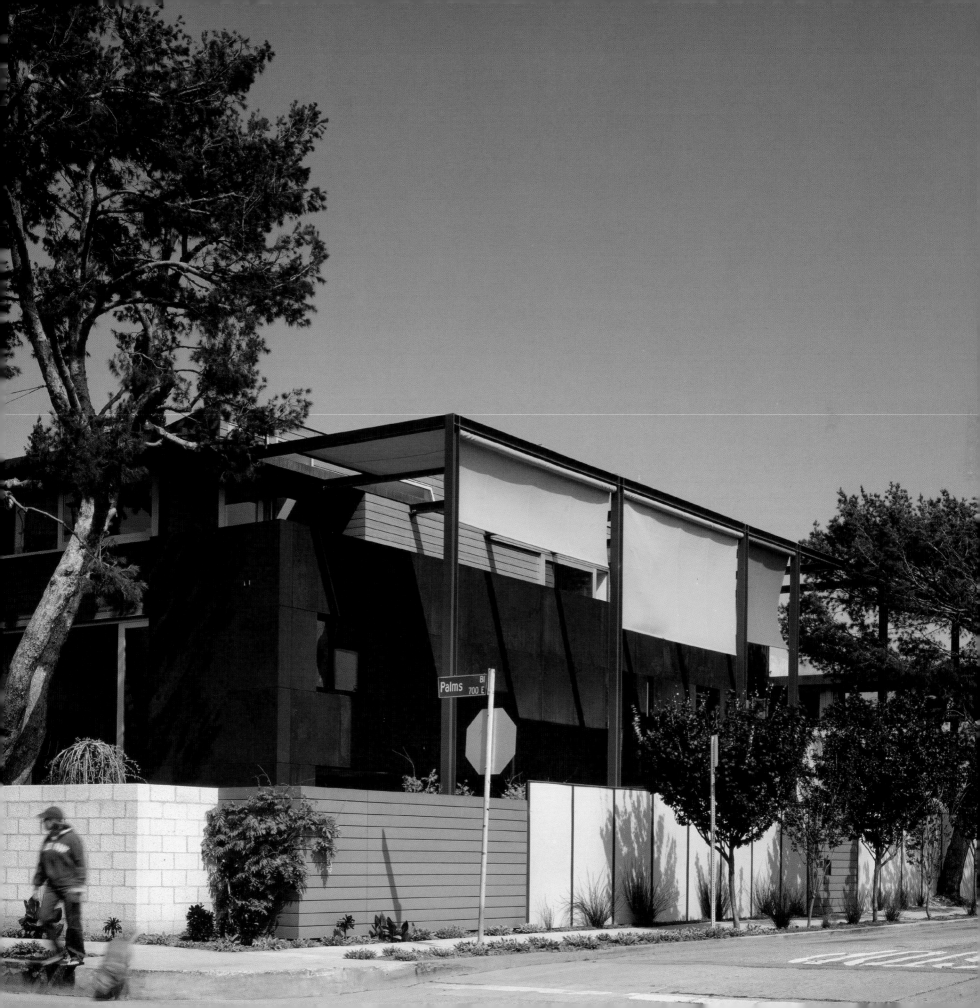

Second-floor Plan

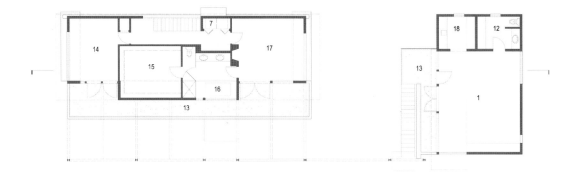

Mezzanine Plan

1. LIVING SPACE
2. POOL
3. ENTRY
4. POWDER ROOM
5. DINING ROOM
6. KITCHEN
7. LAUNDRY
8. STORAGE
9. GARAGE
10. BRIDGE
11. BEDROOM
12. BATHROOM
13. DECK
14. LIBRARY
15. CLOSET
16. MASTER BATHROOM
17. MASTER BEDROOM
18. KITCHENETTE
19. OPEN TO BELOW

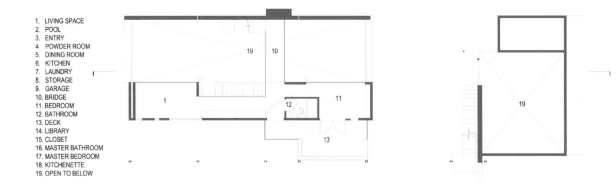

First-floor Plan

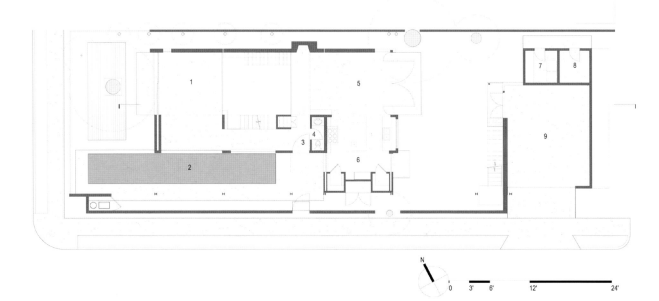

N

0 3' 6' 12' 24'

West Elevation

East Elevation

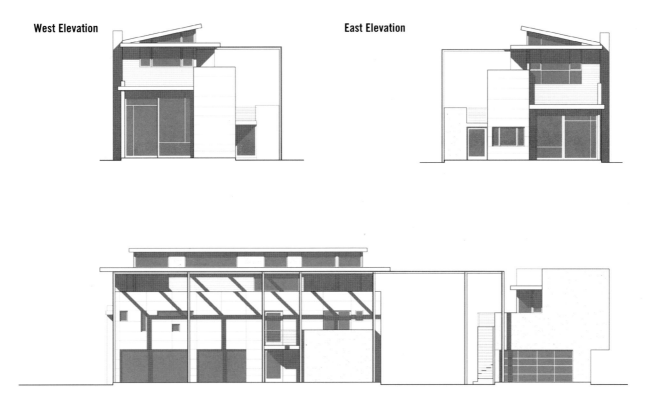

South Elevation

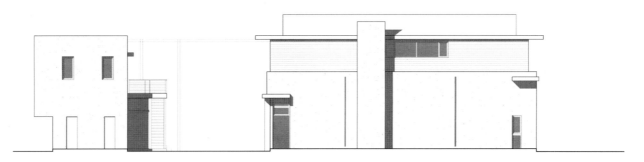

North Elevation

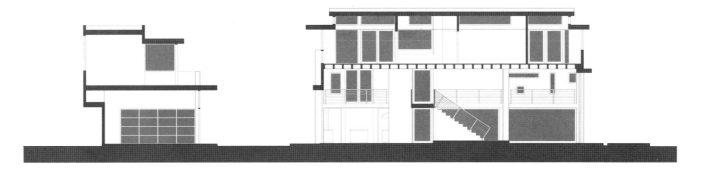

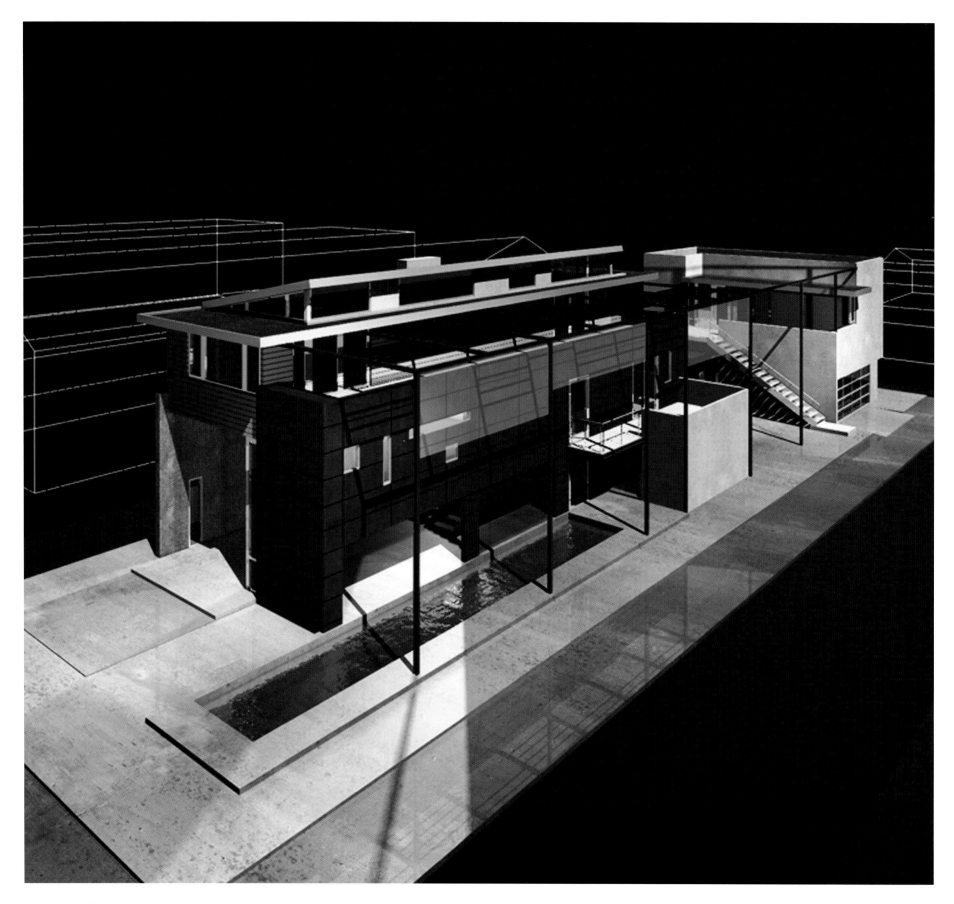

Left: Computer-generated model showing the west elevation, with the lap pool and guest house to the north

Right: Computer-generated axonometric

Below: Computer-generated model

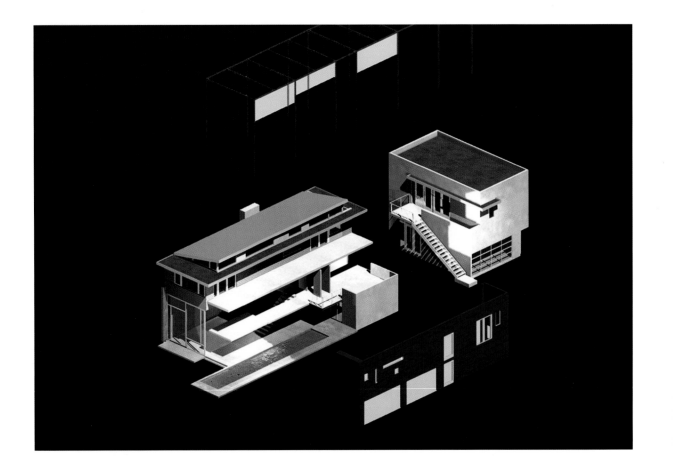

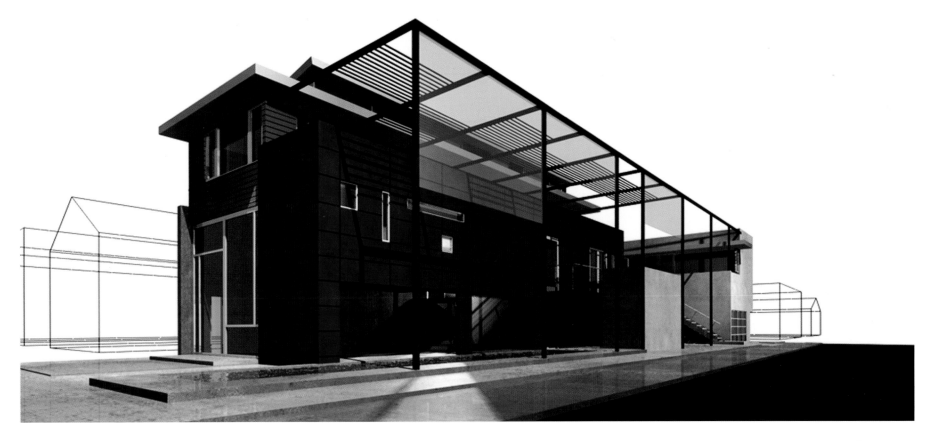

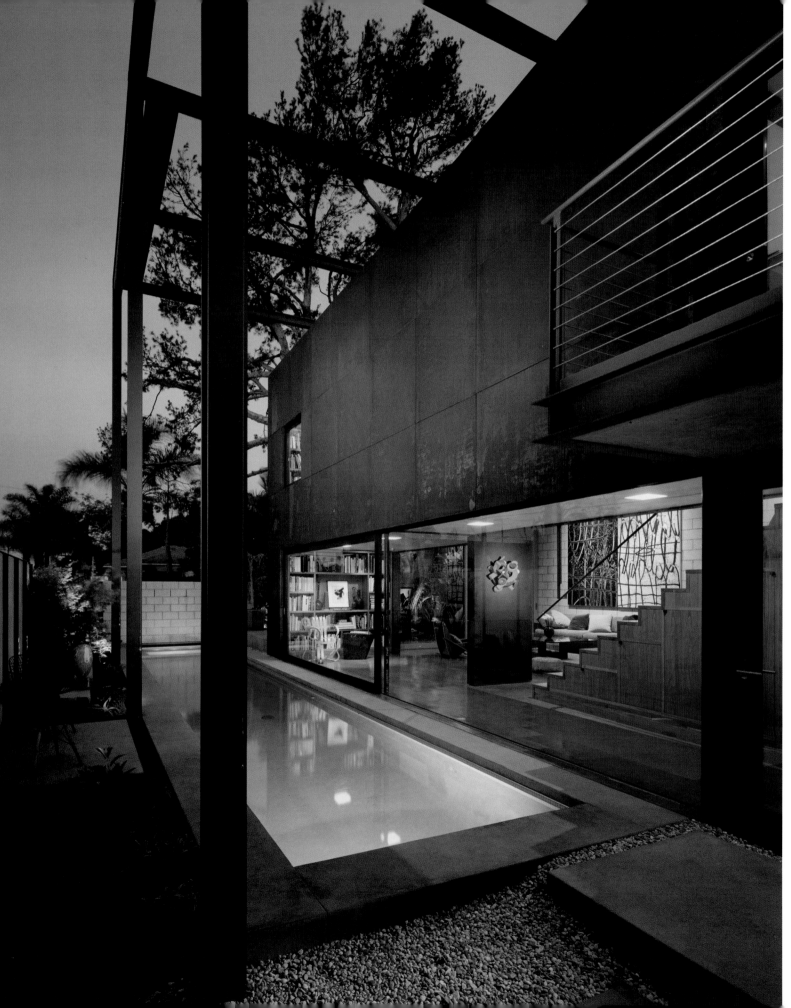

Left: A view of the lap pool at dusk looking north

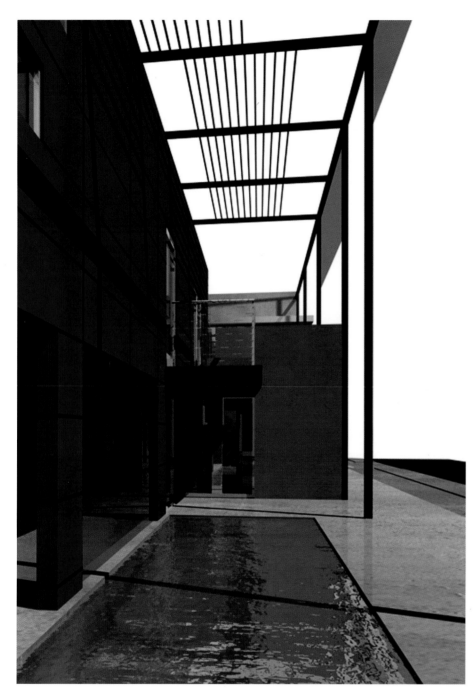

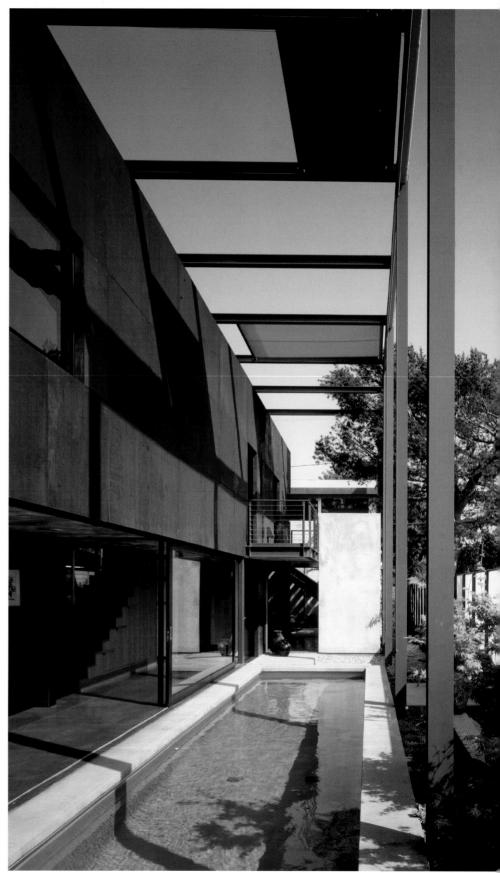

Above: Computer-generated model showing the west elevation with the lap pool

Right: View of the lap pool with the guest house beyond

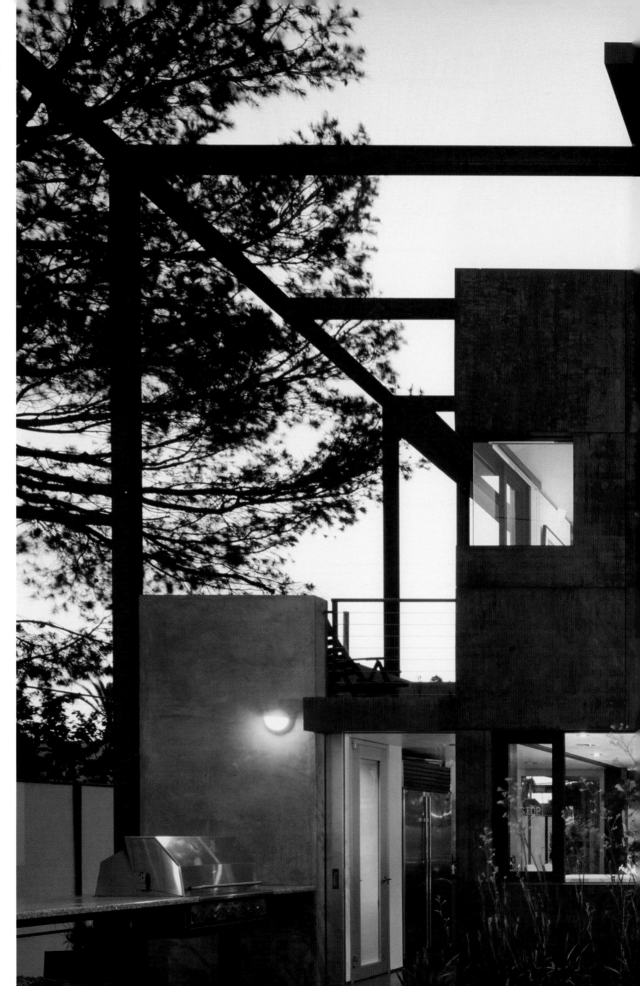

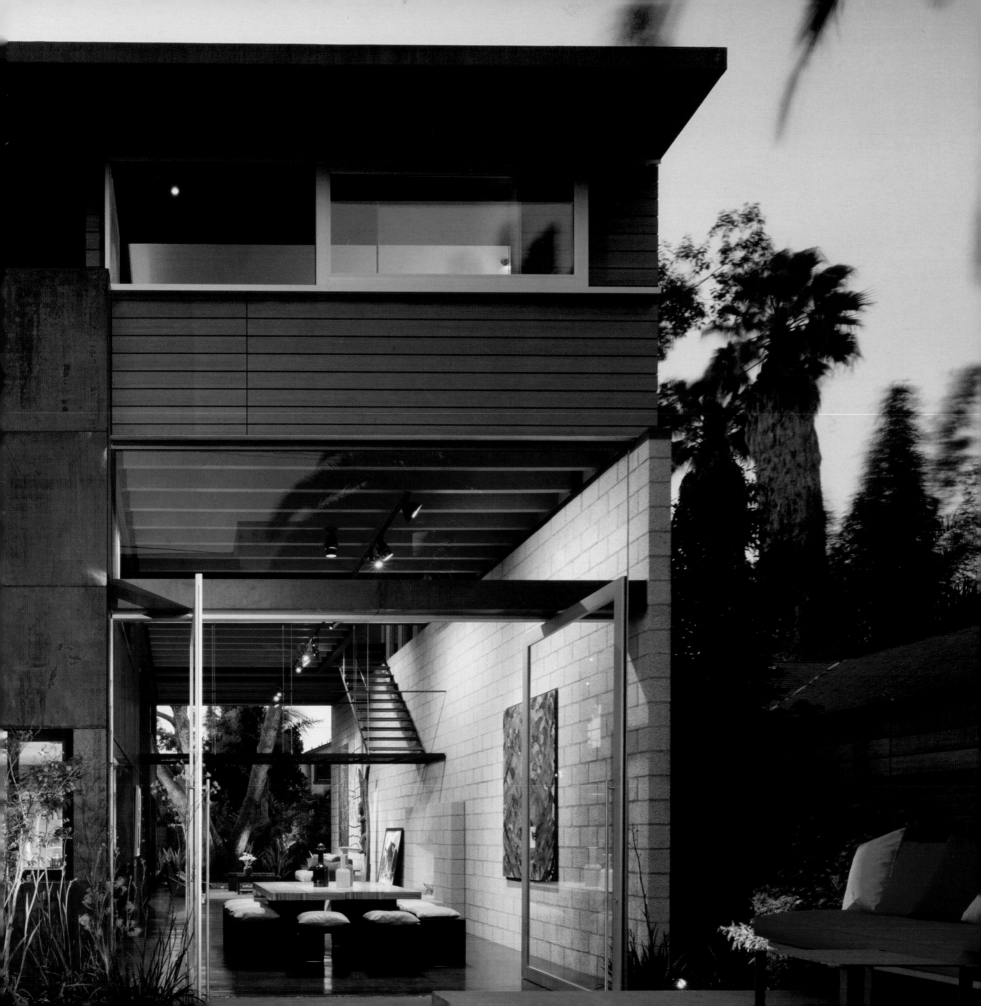

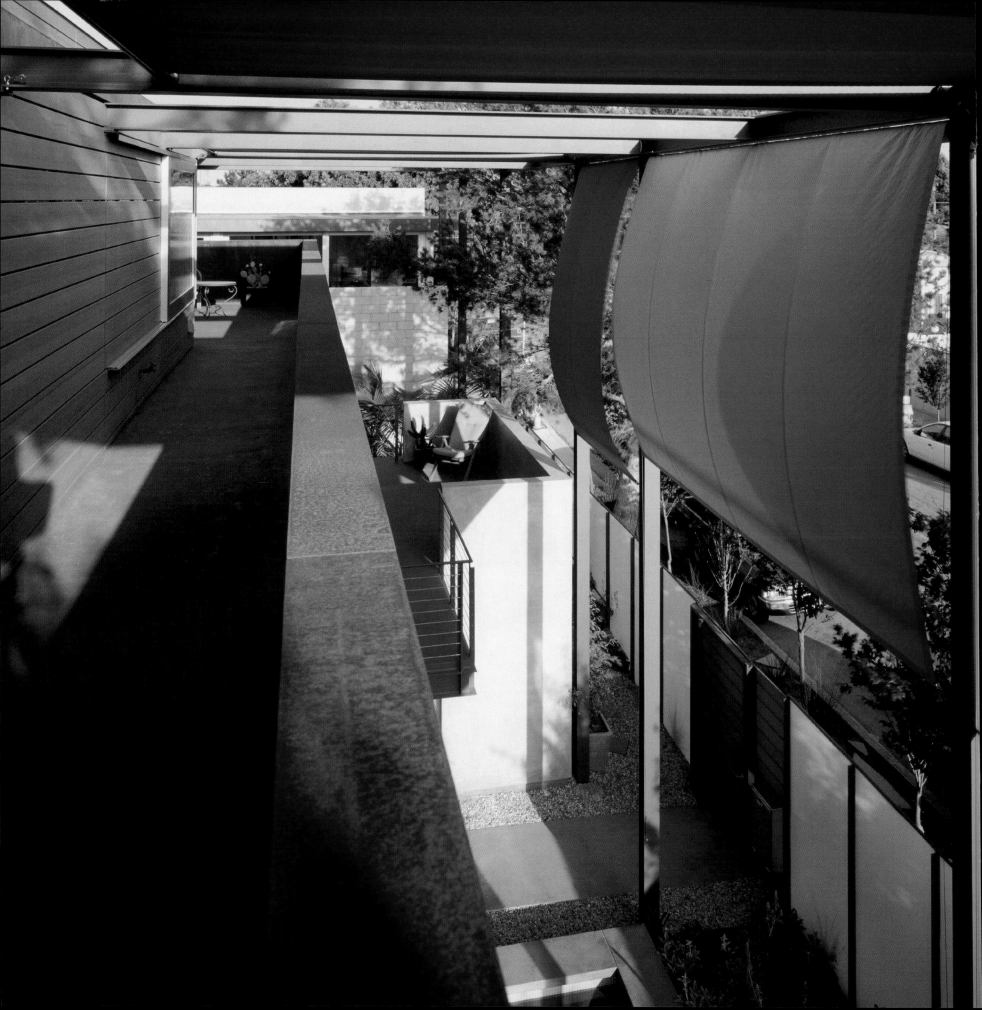

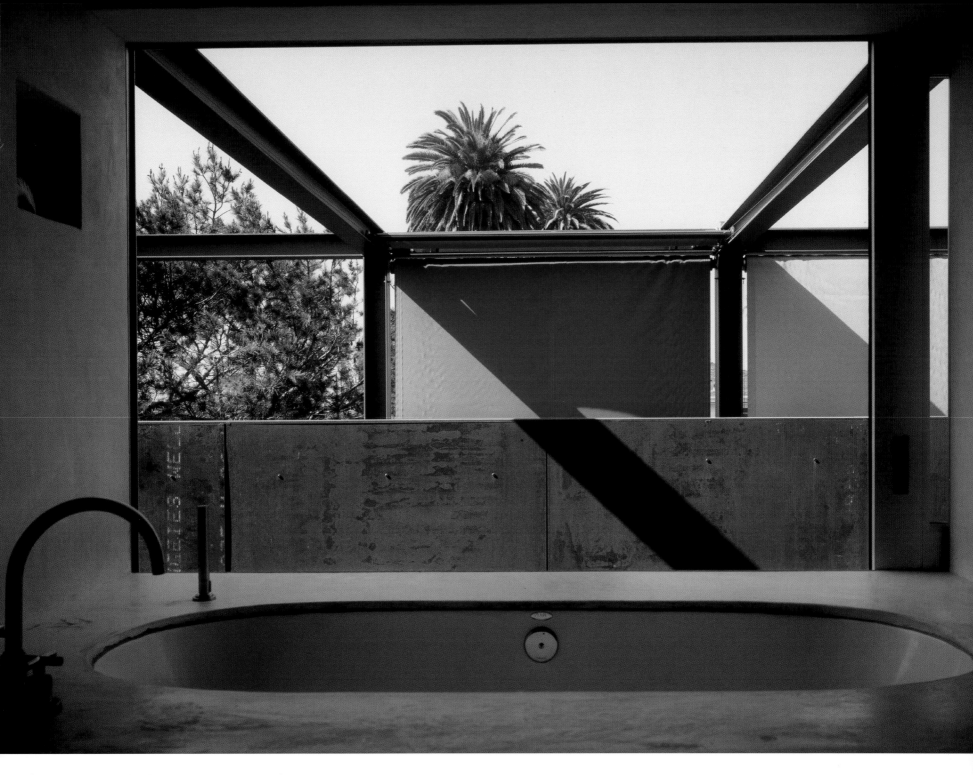

Left: The house is clad inside and out with rusted steel, durable and maintenance-free. The canvas shades provide privacy and shade and add dramatic color to the composition.

Above: The master bathroom is open yet private

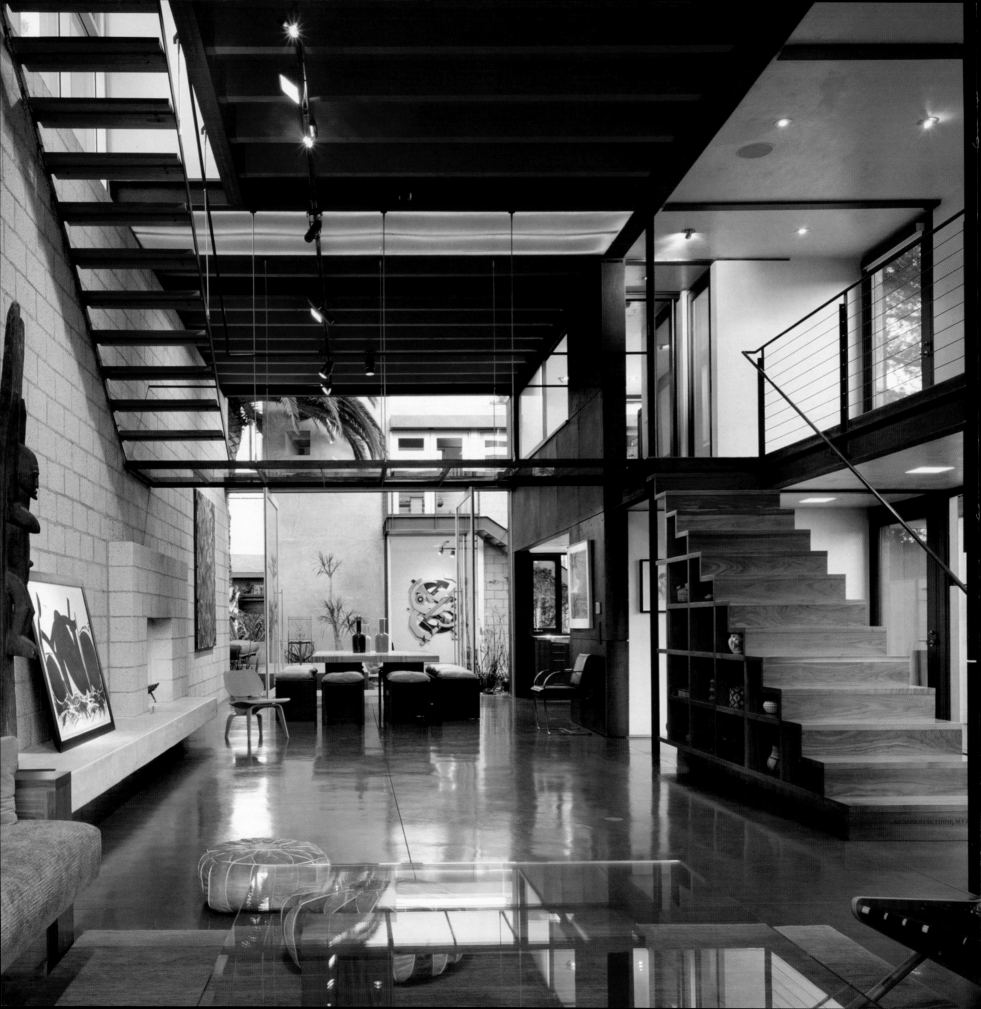

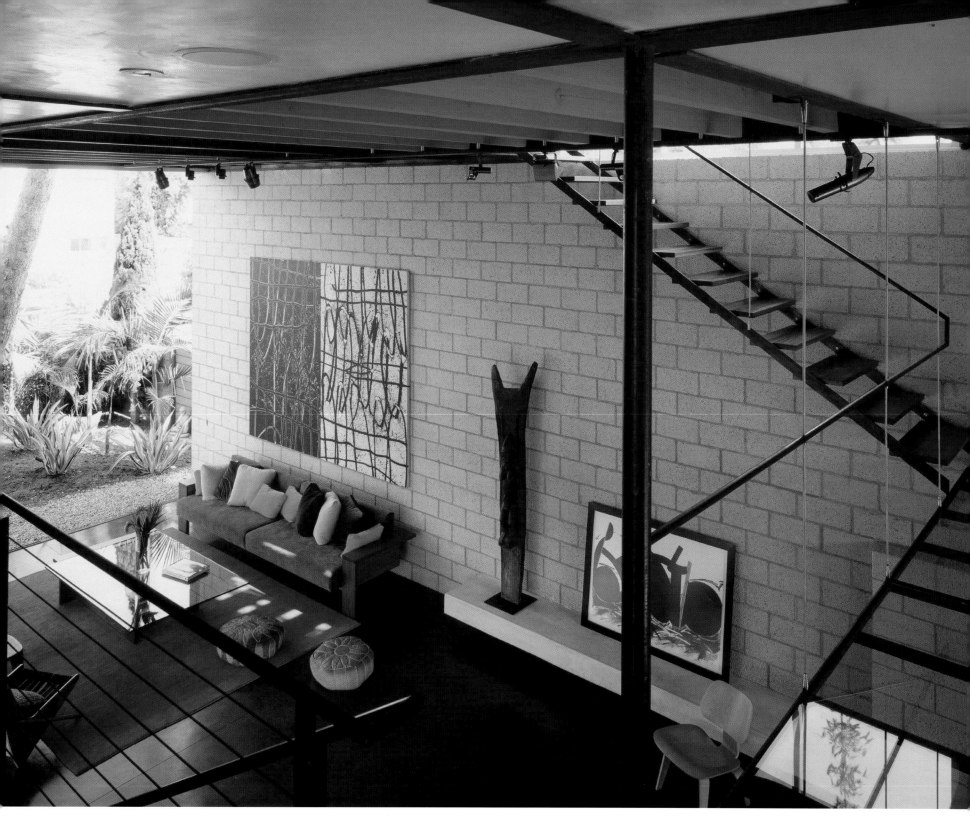

Left: The living room with the glass bridge to the master suite

Above: A view from the second floor to the living room

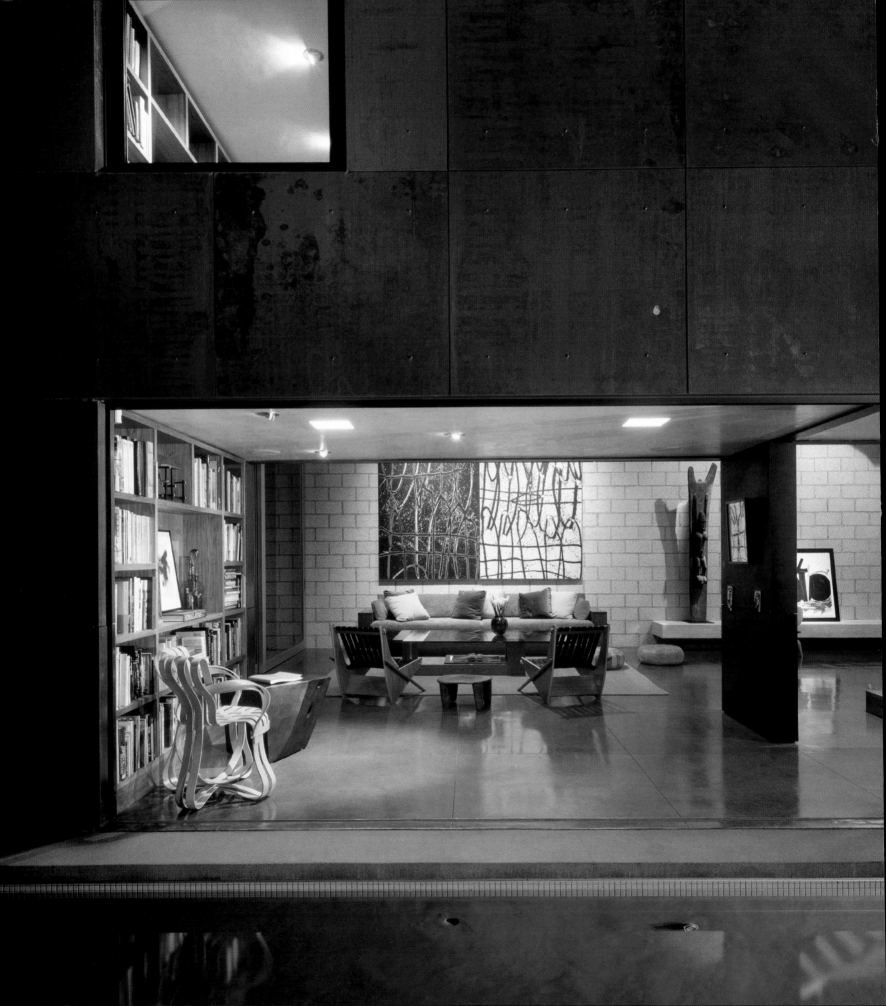

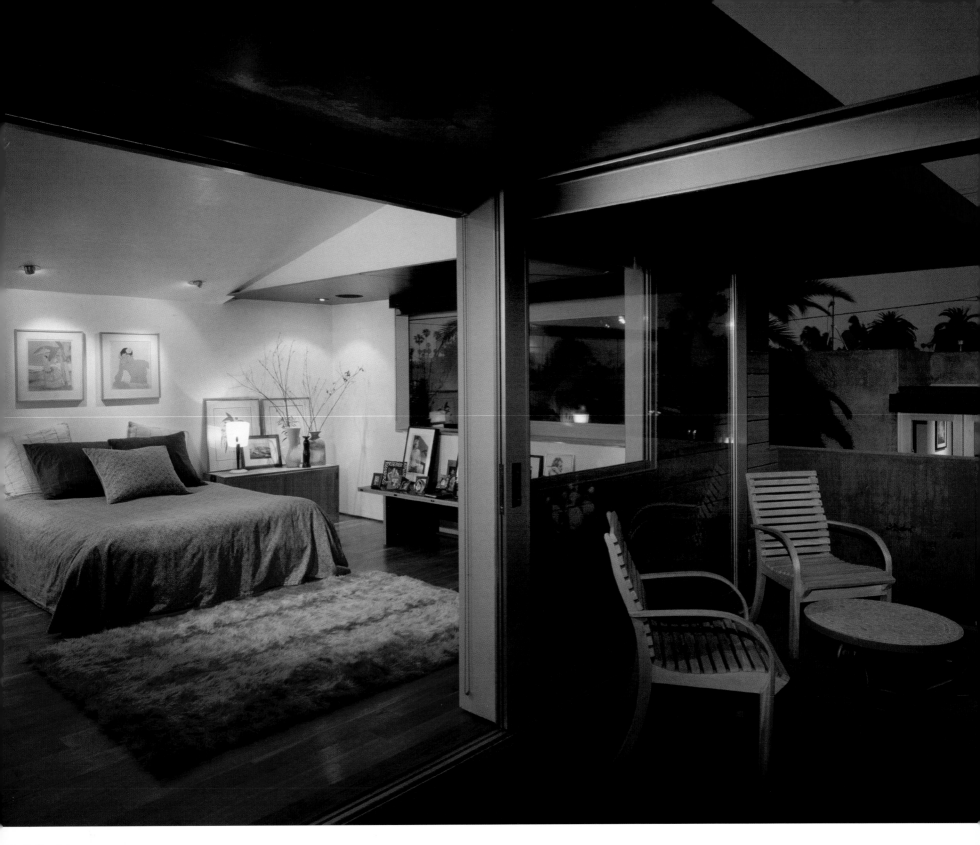

Left: The living room as seen from the lap pool

Above: The master bedroom suite

EAGLE ROCK HOUSE
First a Vacation, then a Retirement House

place: **SCHUYLKILL COUNTY, PENNSYLVANIA** | architects: **DACRUZ DESIGN**

photography: **EDUARD HUEBER/ARCHPHOTO**

PROJECT DESCRIPTION

This house was essentially designed to be two houses in one: a small retirement dwelling for two people while at the same time large enough to accommodate an extended family during weekend visits. The entry-level floor is a self-sufficient space with a master bedroom, kitchen, and living area. Clerestory windows along the south wall of the open living space provide privacy from the entry court, while extensive glass on the north wall opens to the adjacent deck and woodlands. Carved into the hillside below are guest bedrooms and baths.

KEEPING COSTS DOWN

The house consists of two simple volumes with two load-bearing walls. The sloping site allows the basement level to function as a full, usable floor, opening out onto a screened porch, thus eliminating more above-ground second-floor framing. All heating and air conditioning ductwork is positioned in the downstairs corridor in the ceiling joists, eliminating the need for soffits upstairs or down.

PRIMARY BUILDING MATERIALS

Standard building materials were used throughout, with no custom finishes. The exterior cladding is horizontal tongue-and-grove western red cedar and Carolina ledge stone, and the roof is standing seam-painted metal.

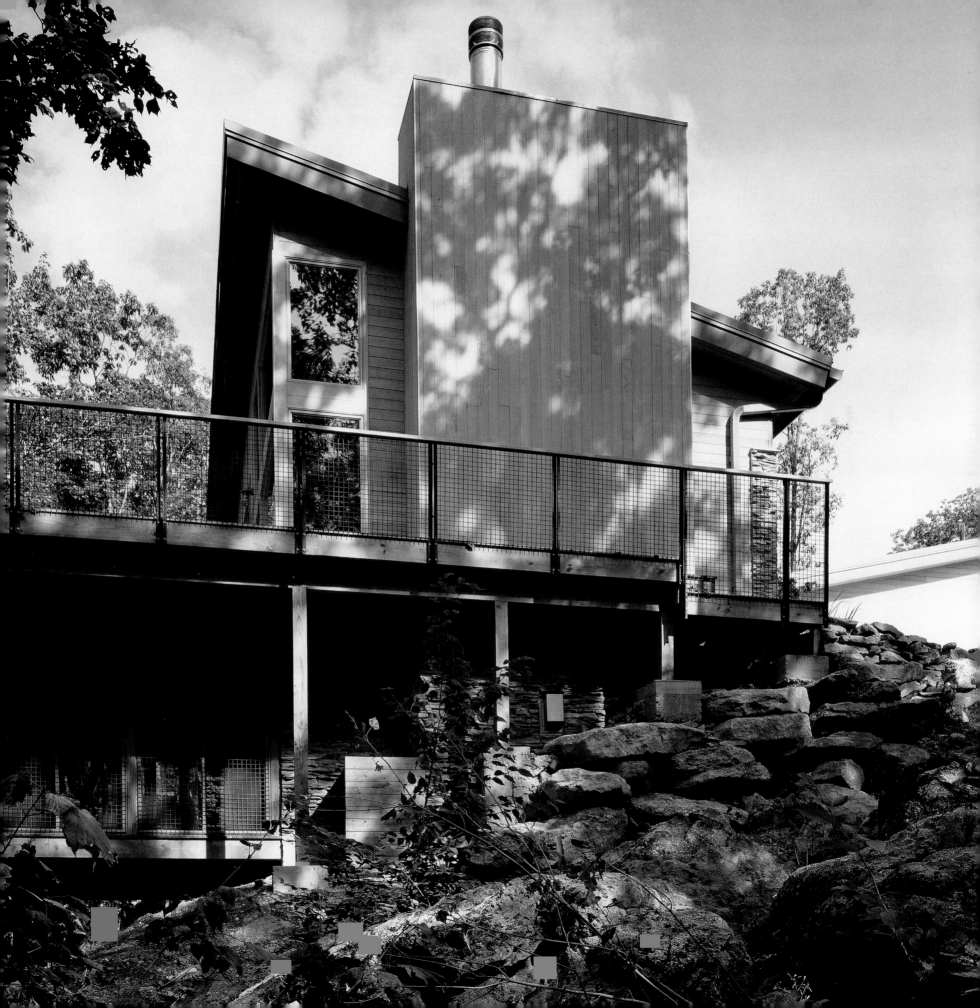

Site Plan

Second-level Plan

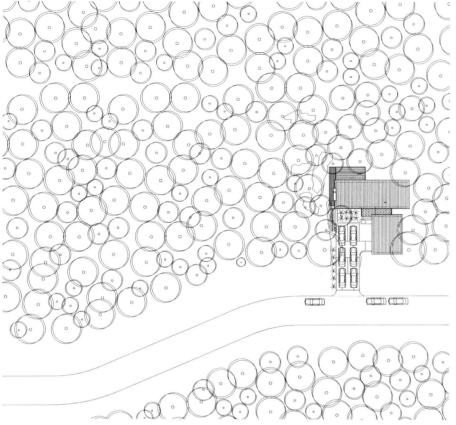

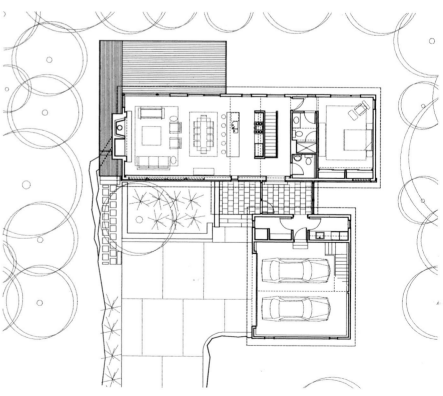

Concept Sketch

Ground-level Plan

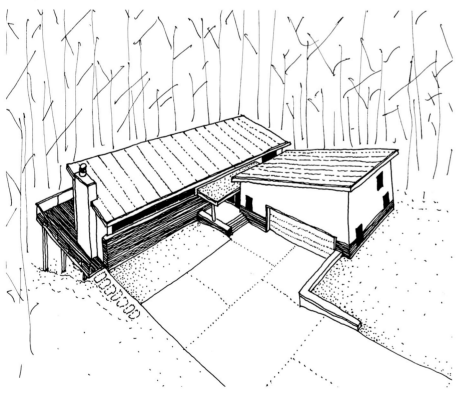

South Elevation

East Elevation

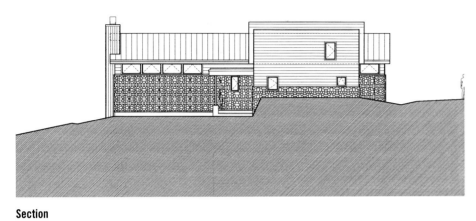

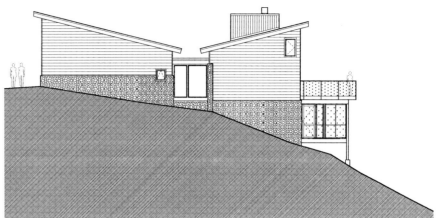

Section

West Elevation

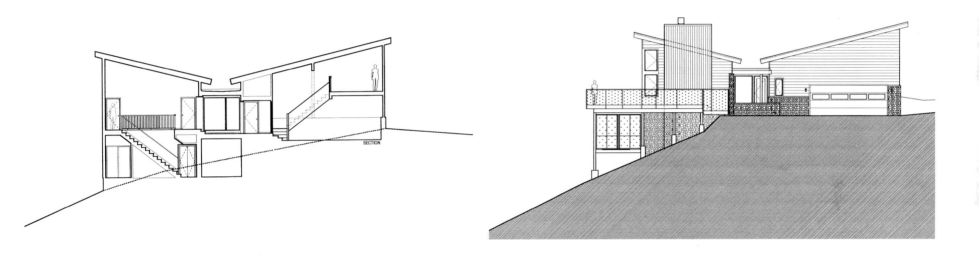

SECTION

Left: View of the entry porch, where the exterior Carolina stone, western red cedar, and slate floor of the porch extend into and through the entry foyer

Below Left: View from the entry foyer to the entry porch

Right: View from the entry foyer to the staircase to the downstairs bedrooms

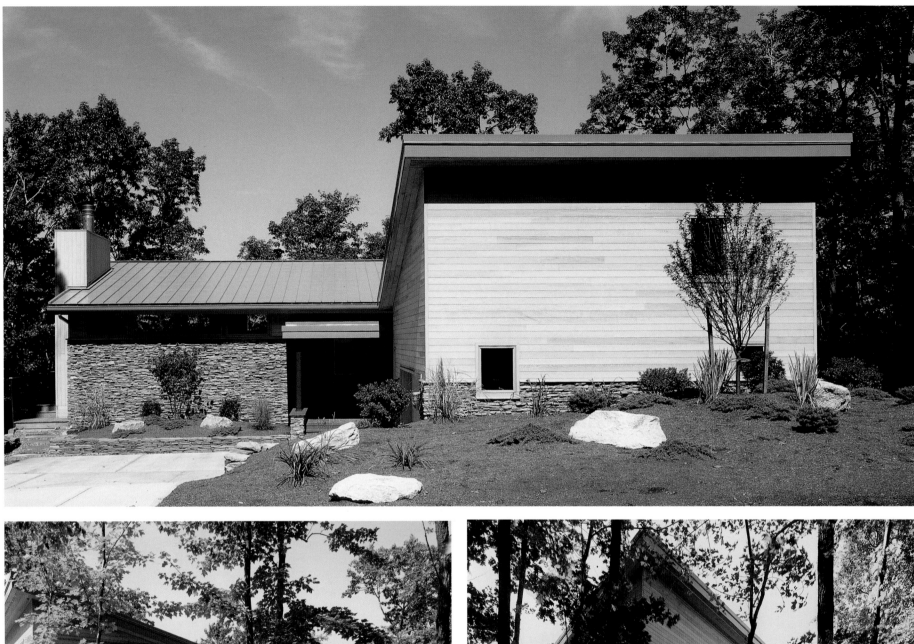

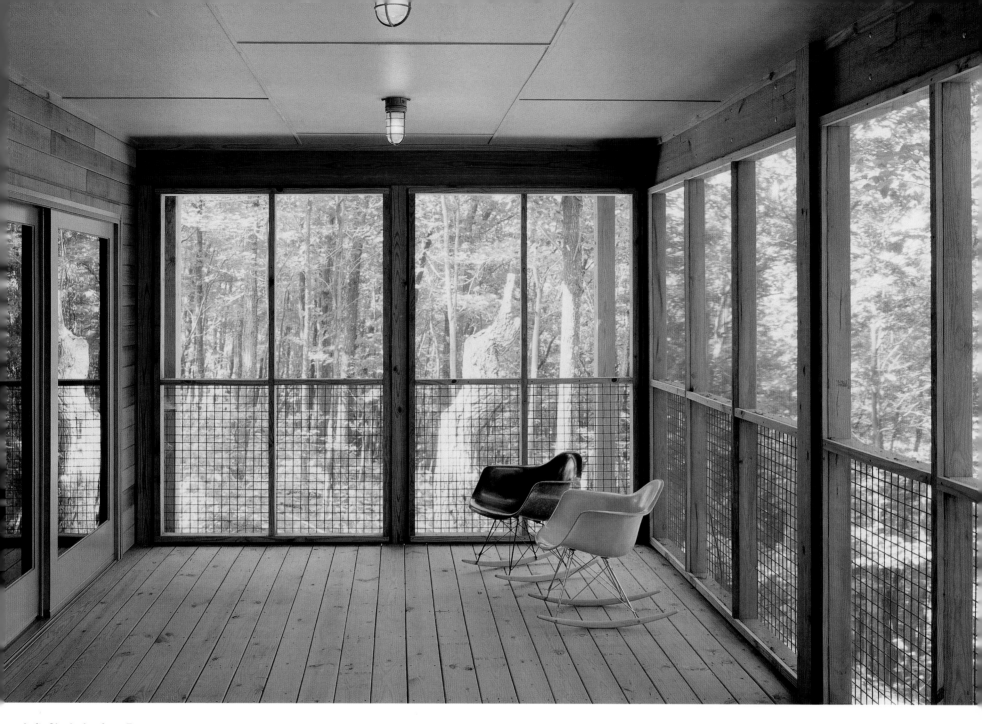

Left, Clockwise from Top:
Entry; view of the northwest corner from below; and view of the west facade showing the relationship between the two garages and the house

Above: The lower-level screened porch opens off the downstairs family room. Also located on this level are guest rooms.

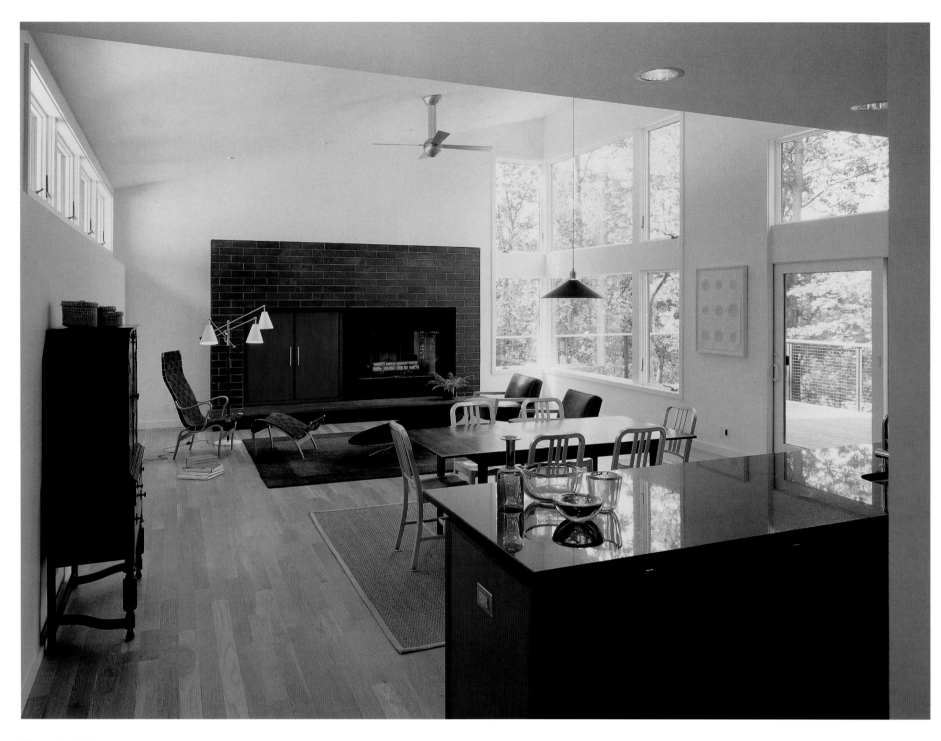

Above: The living room interior was designed as a backdrop for the client's collection of vintage modern furniture.

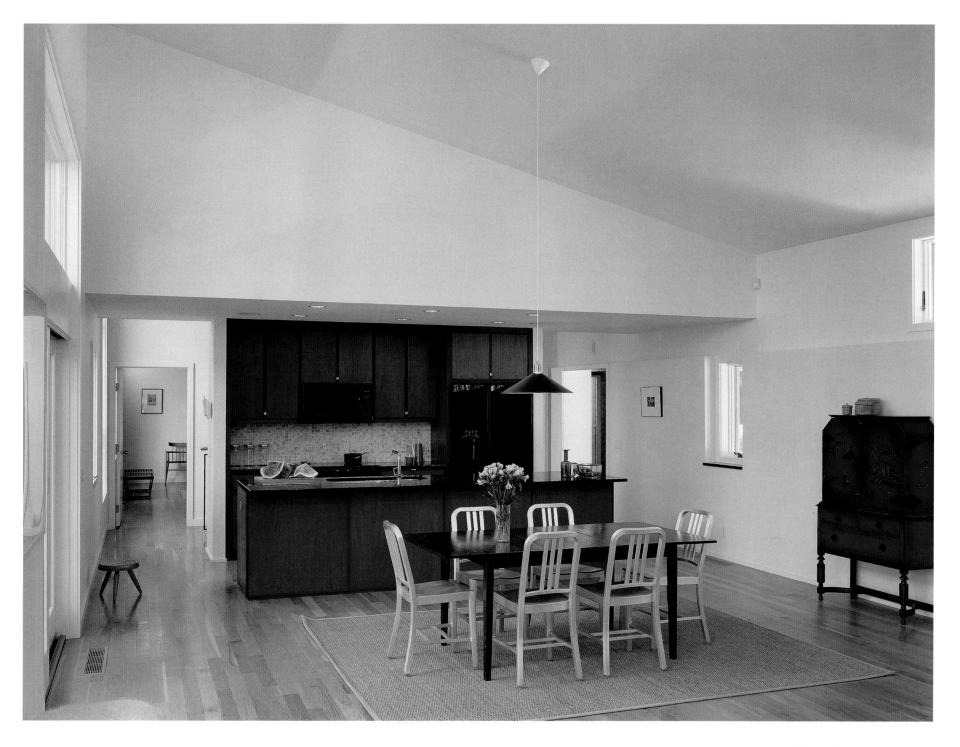

Above: The kitchen as seen from the living room, with the master bedroom at the end of the hall

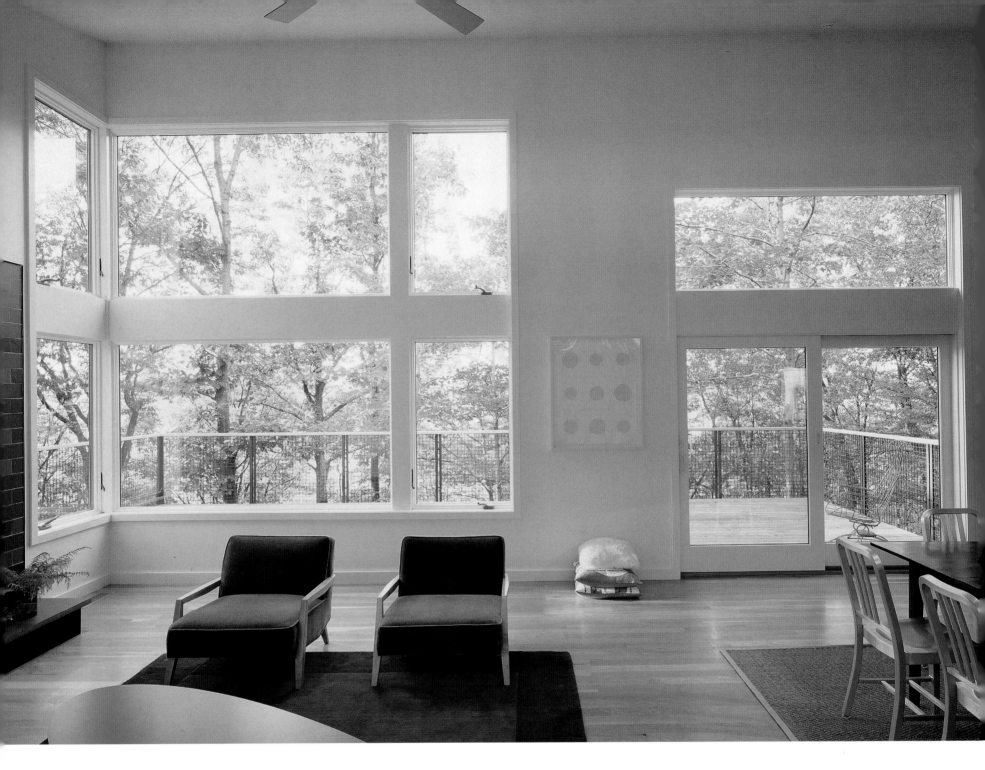

Above: View from the living/dining
areas to the deck

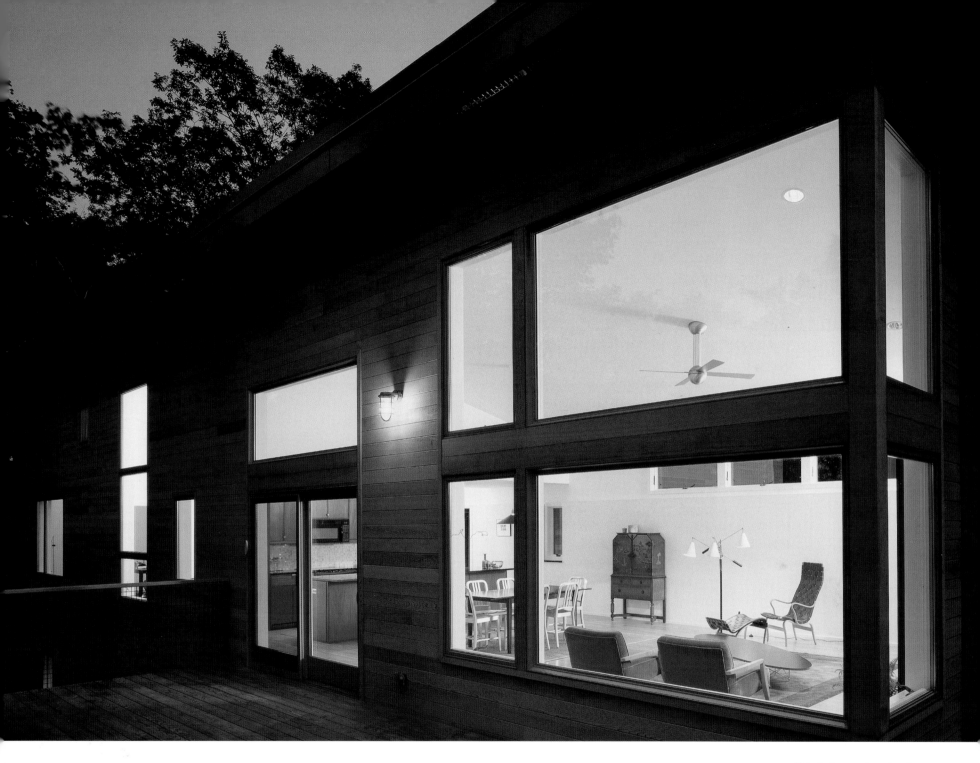

Above: An evening view from the deck into the living, dining, and kitchen areas

LAGERBERG

Making Every Inch Count

place: **SEATTLE, WASHINGTON** | architects: **E. COBB ARCHITECTS**

photography: **STEVE KEATING**

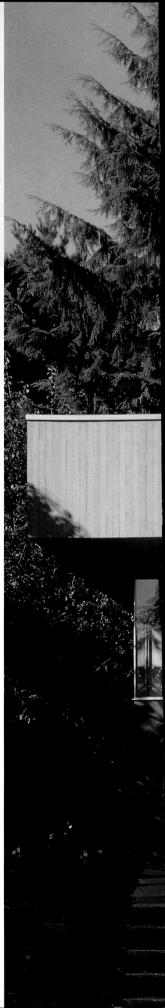

PROJECT DESCRIPTION

For this residence for a young family, an existing one-story house was selectively demolished, and the existing foundation and basement served as the starting point for the new house. As a design priority, every inch of space within the house was to be essential to its specific use. The result is a strikingly modernist two-story structure with a second-floor master suite and two bedrooms with one bath on the first floor. A third bathroom is located in the basement. Large strip windows that wrap around the corners of the house bring light deep into the interior of the house.

KEEPING COSTS DOWN

Generally, framing labor represents less than 10 percent of a typical residential construction budget; the real cost is incurred when a design scheme prohibits the use of standard materials and assembly techniques. The interior of this house is complex in order to accommodate the tight programmatic requirement for the limited space available. However, careful attention was paid to creating a design that accommodated standard building material sizes in order to meet the limited budget. By utilizing the existing basement, excavation and foundation costs were minimized.

PRIMARY BUILDING MATERIALS

The interior wood flooring consists of baltic birch plywood, 5 feet by 5 feet, similar in character to the cabinetry. Anodized aluminum windows required no interior or exterior painting. The exterior is low-maintenance vertical cedar siding.

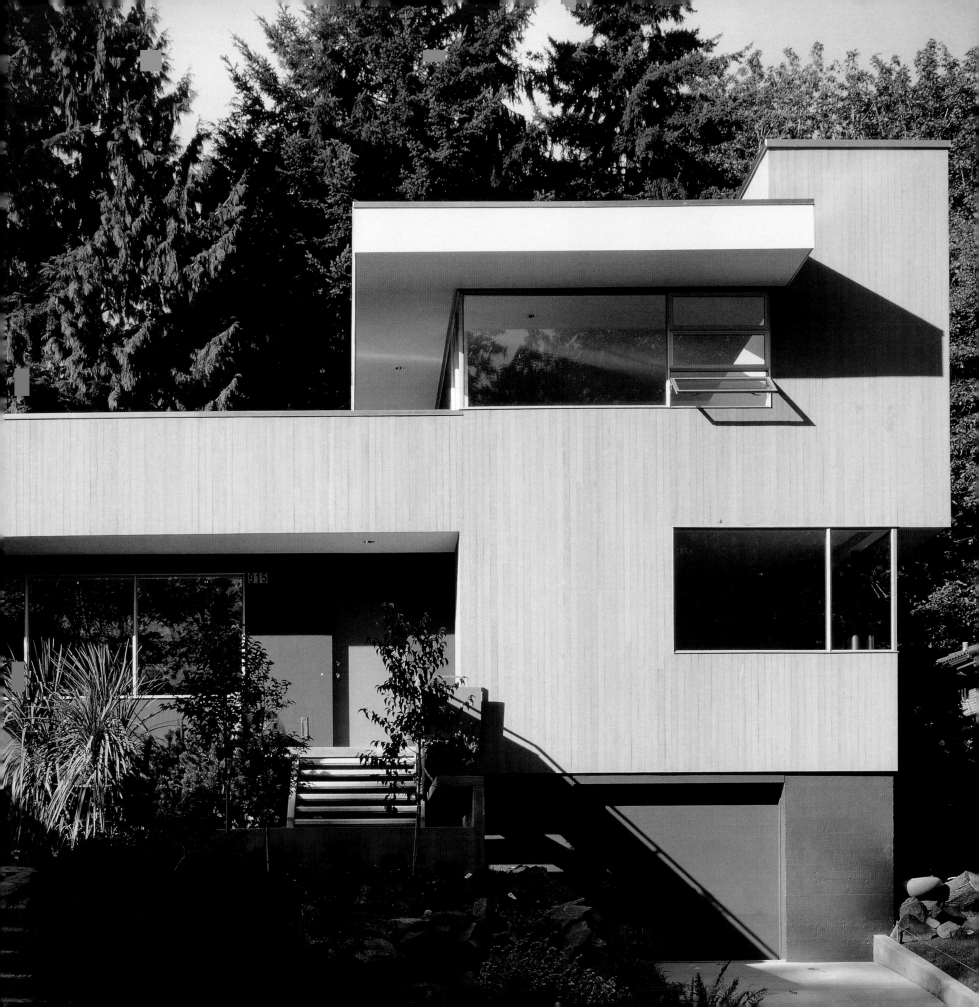

Second-floor Plan

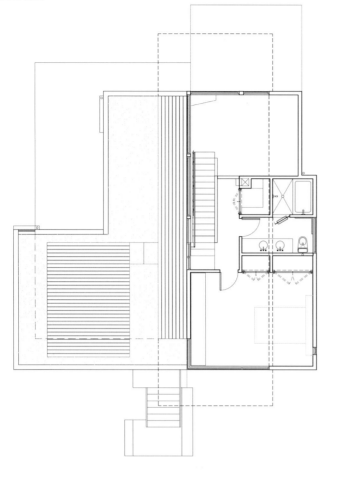

First-floor Plan

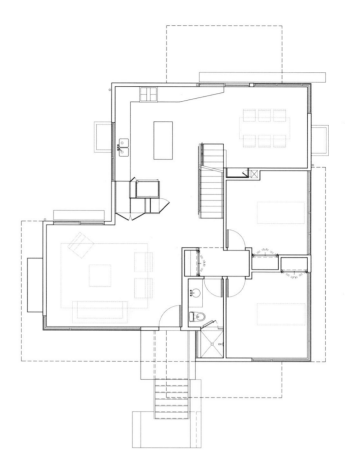

Basement

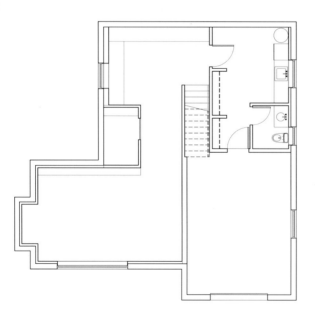

North-South Section

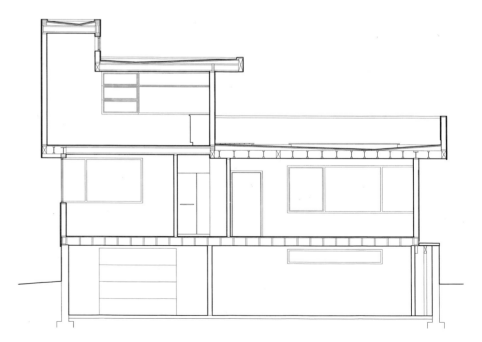

North Elevation

East Elevation

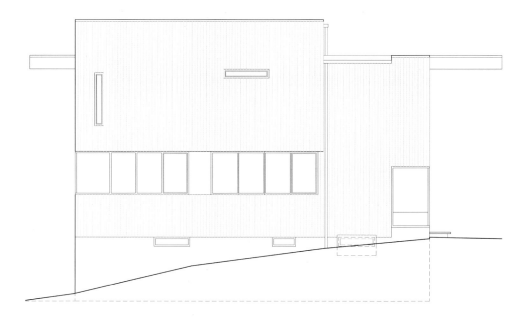

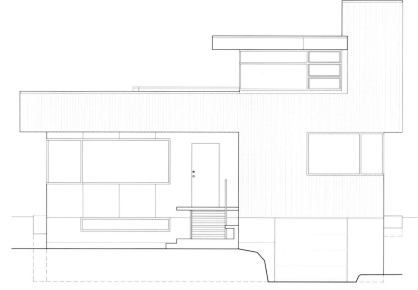

South Elevation

West Elevation

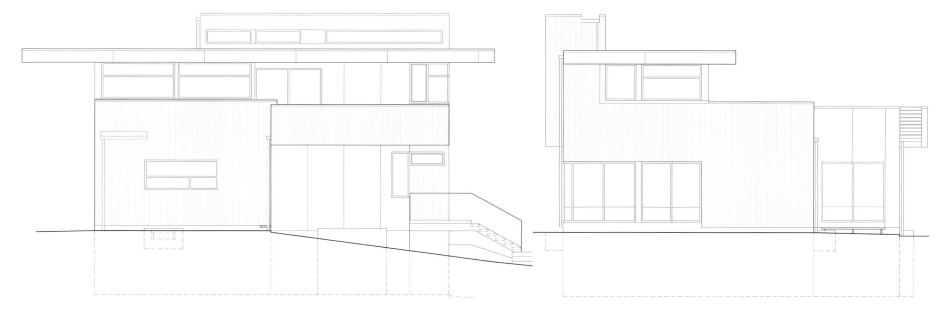

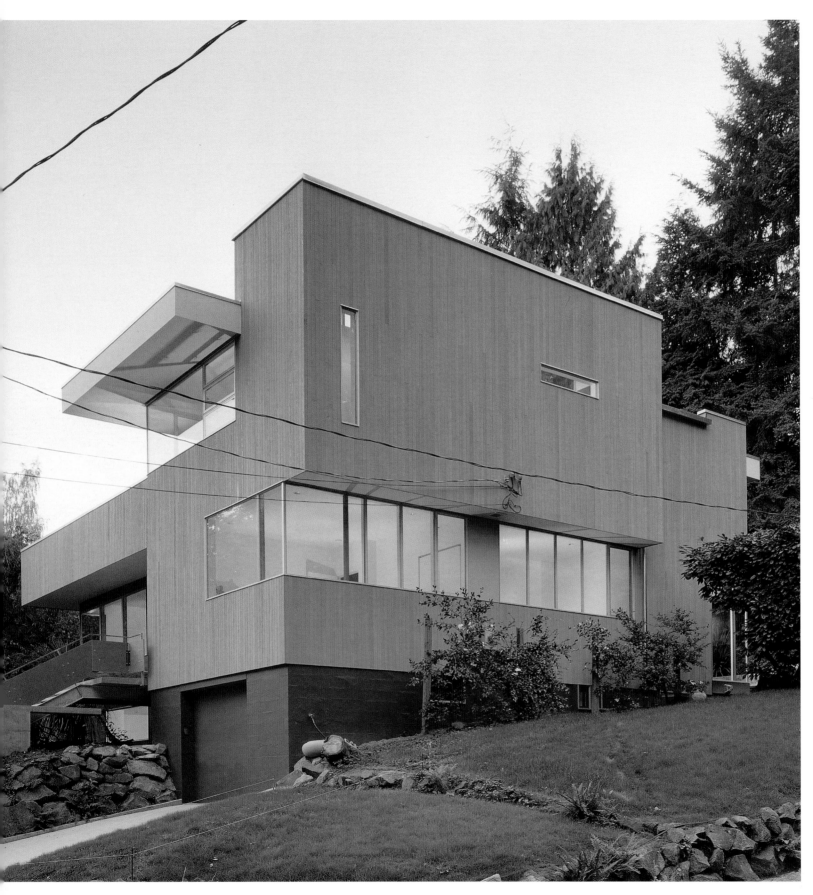

Left: View of entry with master bedroom suite above

Right: At the rear of the house, the dining room is level with the ground.

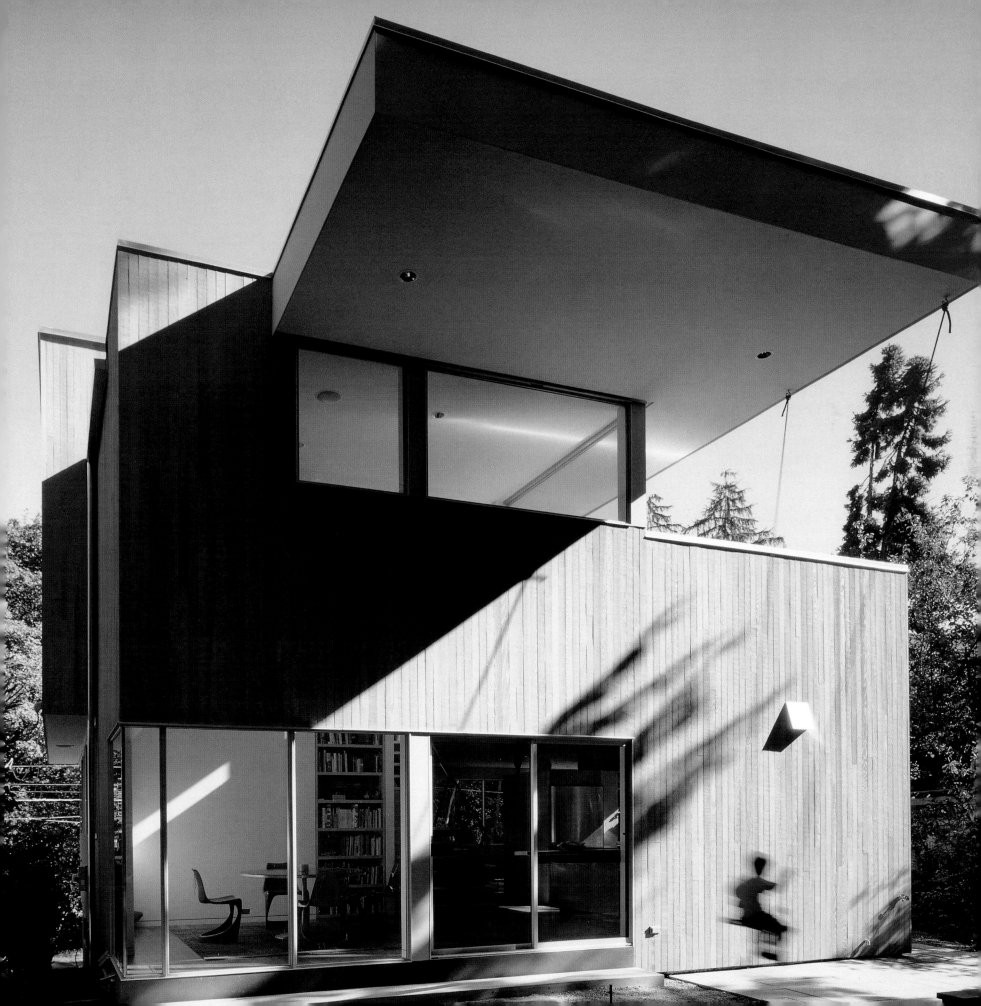

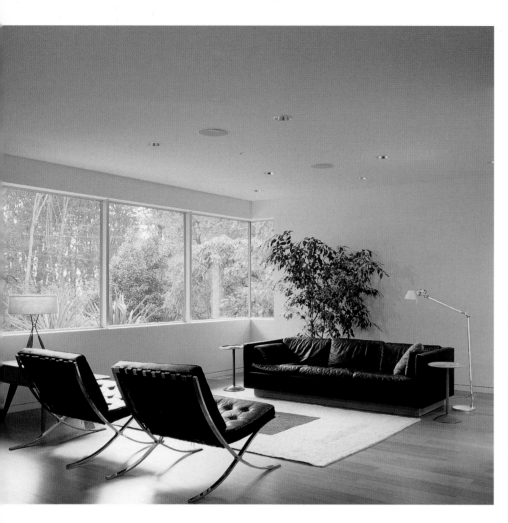

Above and Right: The first floor is programatically tightly packed with two bedrooms and a bath as well as the public spaces. And yet it feels open and spacious because the public spaces flow one into the other and large ribbon windows extend the view. The double-height dining room ceiling with its clerestory windows pull the eye upward creating additional visual interest.

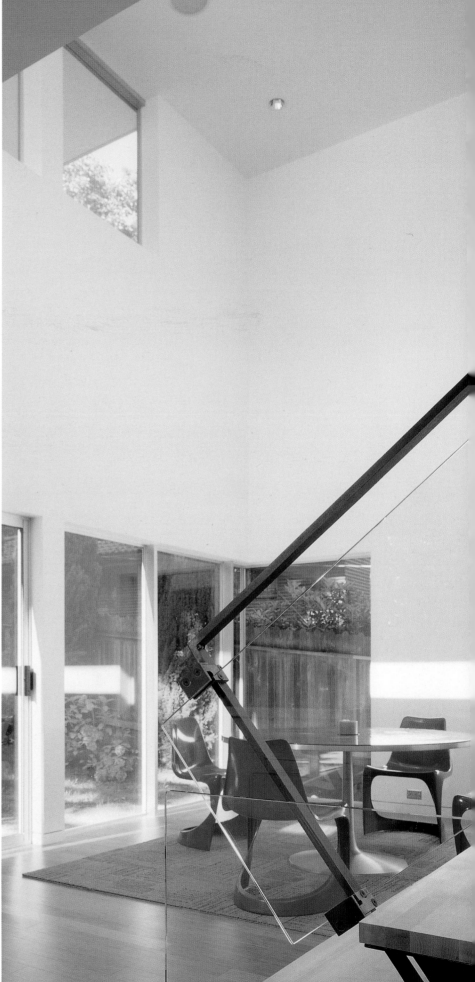

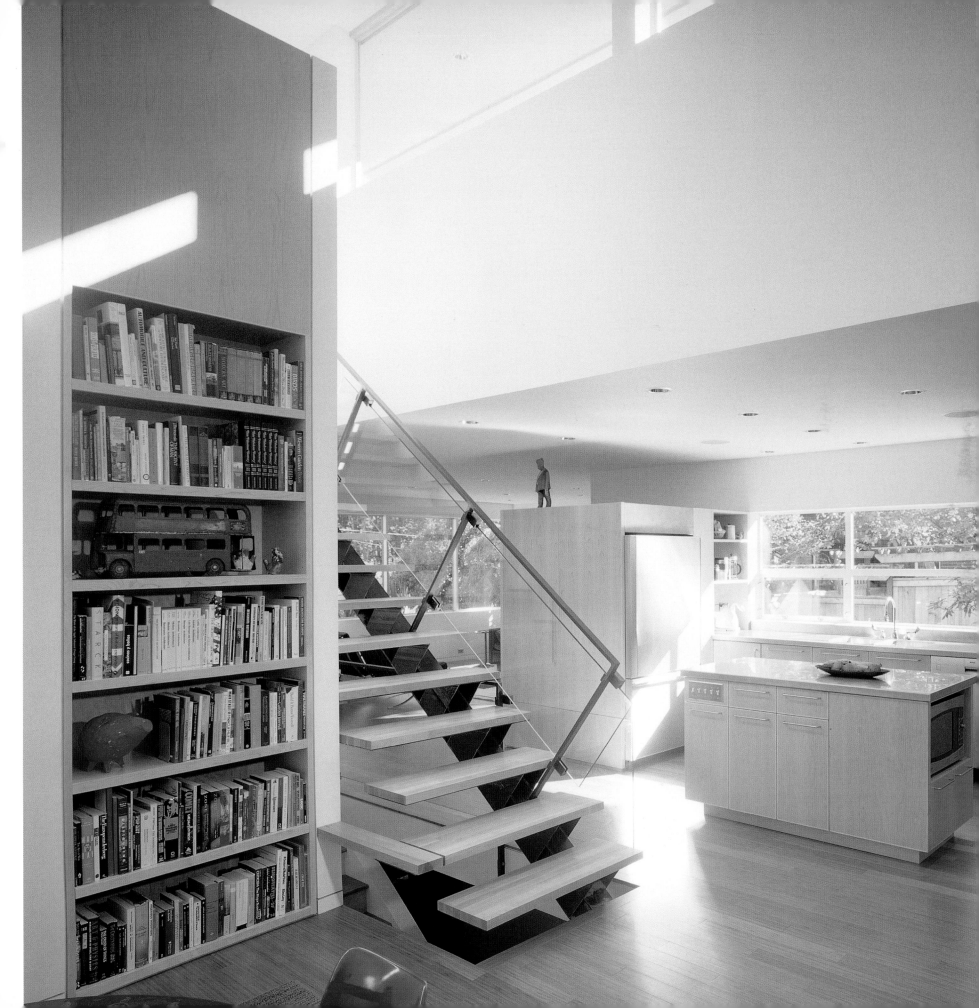

Left and Right: Window openings were carefully positioned to admit maximum light while providing privacy in the second-floor master bedroom suite.

DAVELIN

Designer and Builder

place: **WAYLAND, MASSACHUSETTS** | architect: **STEPHEN CHUNG**

photography: **BOB O'CONNOR**

PROJECT DESCRIPTION

This 1,300-square-foot house was designed and built by the architect for his young family. Located in a sub-urban Boston neighborhood, an existing house was demolished except for the foundation and basement, which was incorporated into the design of the new house. From the street, the house, with its gleaming mahogany finish, resembles a finely crafted cabinet. In designing the house, the architect was interested in investigating the interplay and expressive potential of common building materials, in this case, stained mahogany wood and white painted plaster and wood. The conventional arrangement of a stained wood exterior and a white interior is employed, but also reversed in certain instances. The white walls of the interior are extended into the front part of the house, forming an entry court. The exterior siding extends into the interior of the house and is articulated as wainscoting, flooring, cabinetry, and shelving.

KEEPING COSTS DOWN

In order to save costs for the project, the architect acted as general contractor (and occasionally as builder) for the project. Because of this arrangement, the architect took full advantage of the opportunity to make numerous changes in the field as new ideas arose. The end result is a house that could not have been built from the plans alone. Instead, this house was built like a full-scale model.

PRIMARY BUILDING MATERIALS

Using standard wood framing, the house is sheathed in vertical stained mahogany boards and painted wood. White plaster walls and mahogany flooring, trim, and cabinets complete the interior pallet.

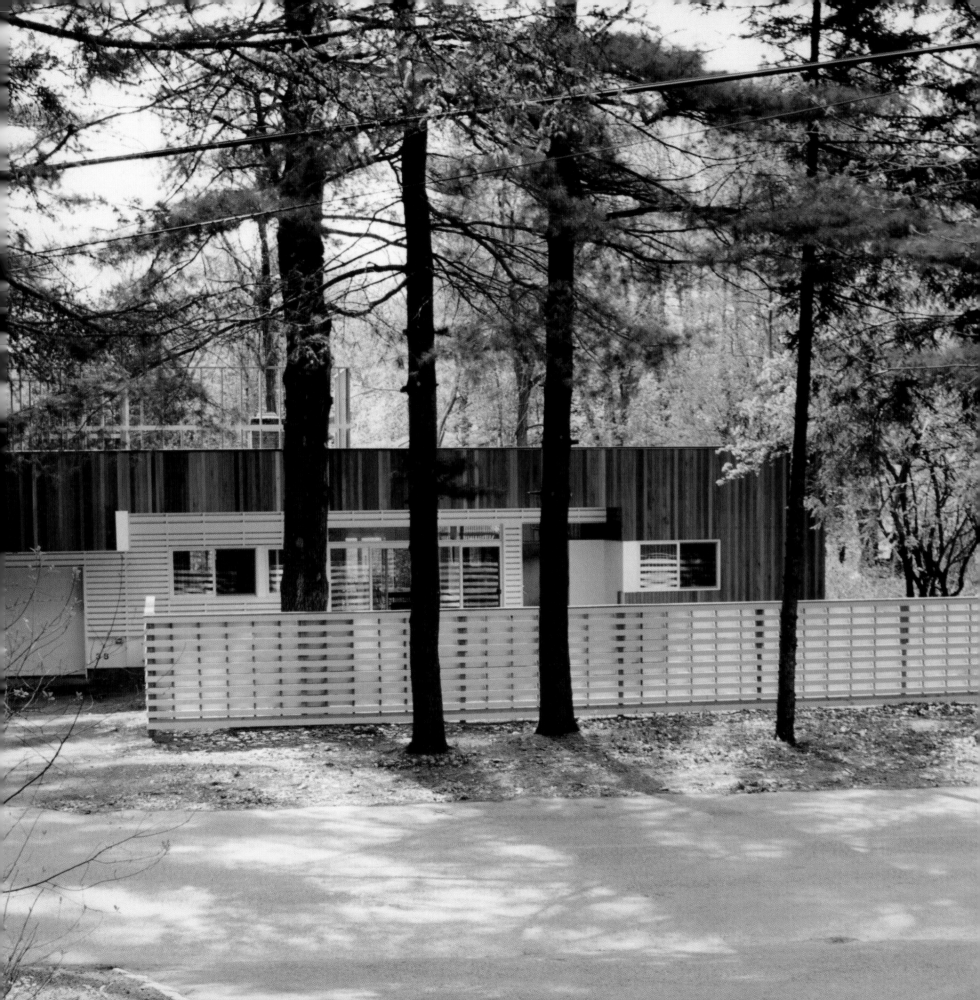

Floor Plan

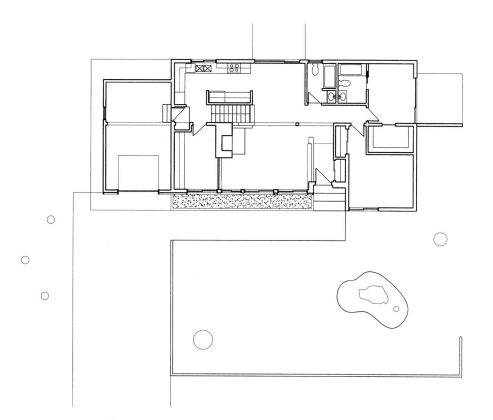

Elevation

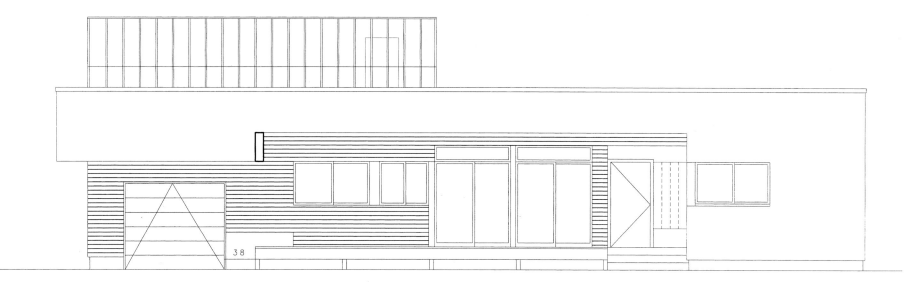

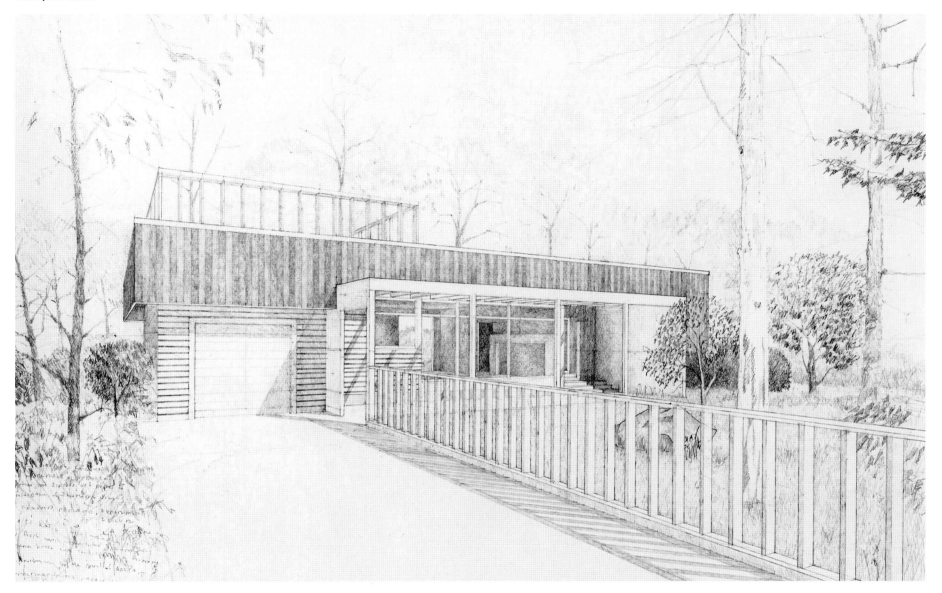

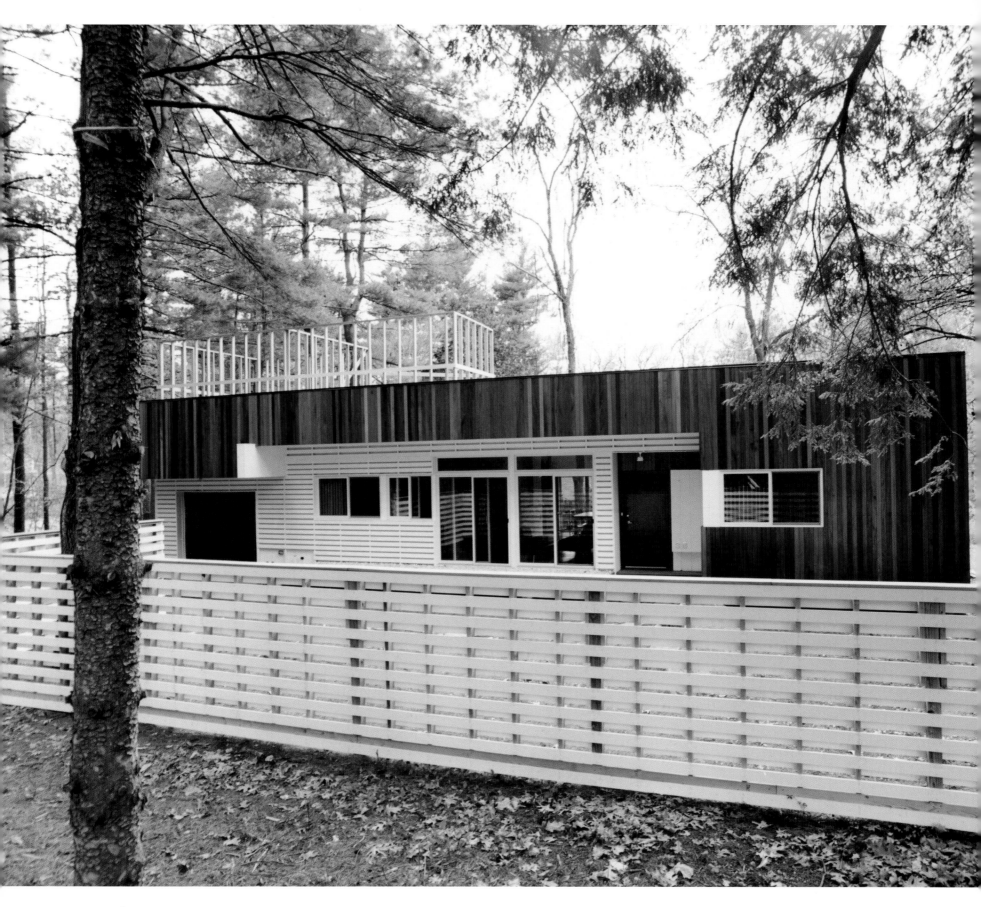

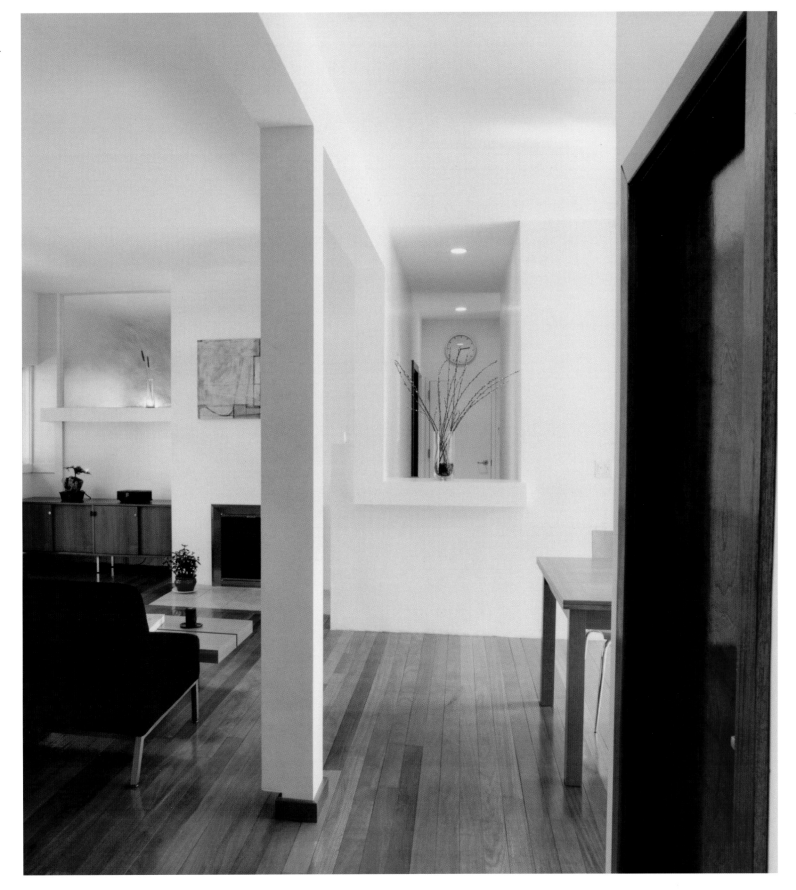

Left and Right: The exterior and interior are an interplay between painted wood, plaster, and stained mahogany.

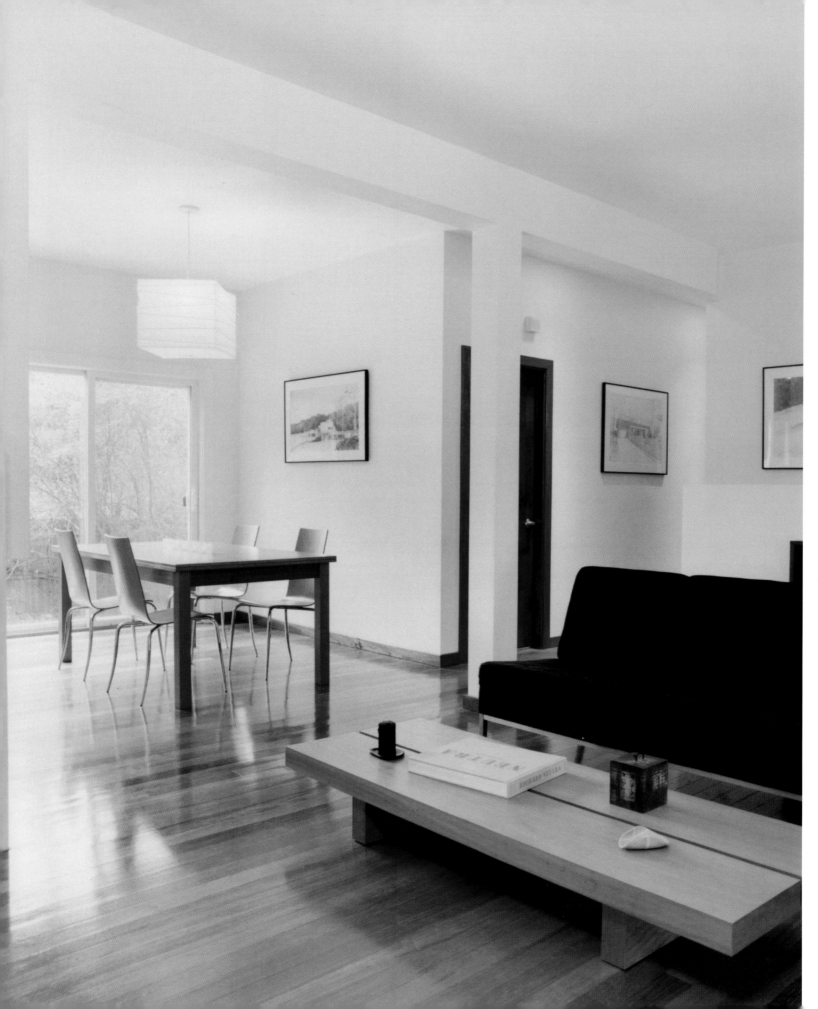

Left: The dining area as seen from the living room; the rich pallet of mahogany and plaster in a small house gives it an air of quiet luxury

Right: The living room as viewed from the dining room; the spare modern furnishings harmonize with the home's equally spare finishes.

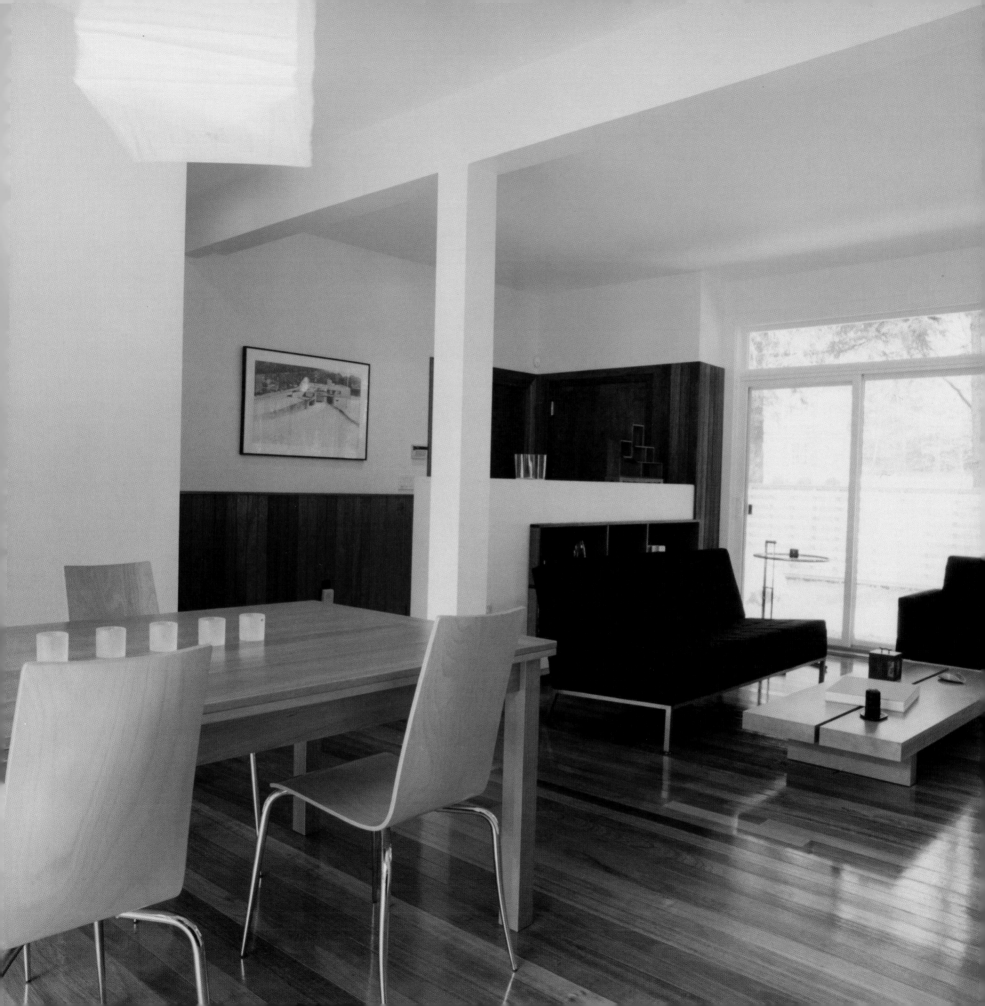

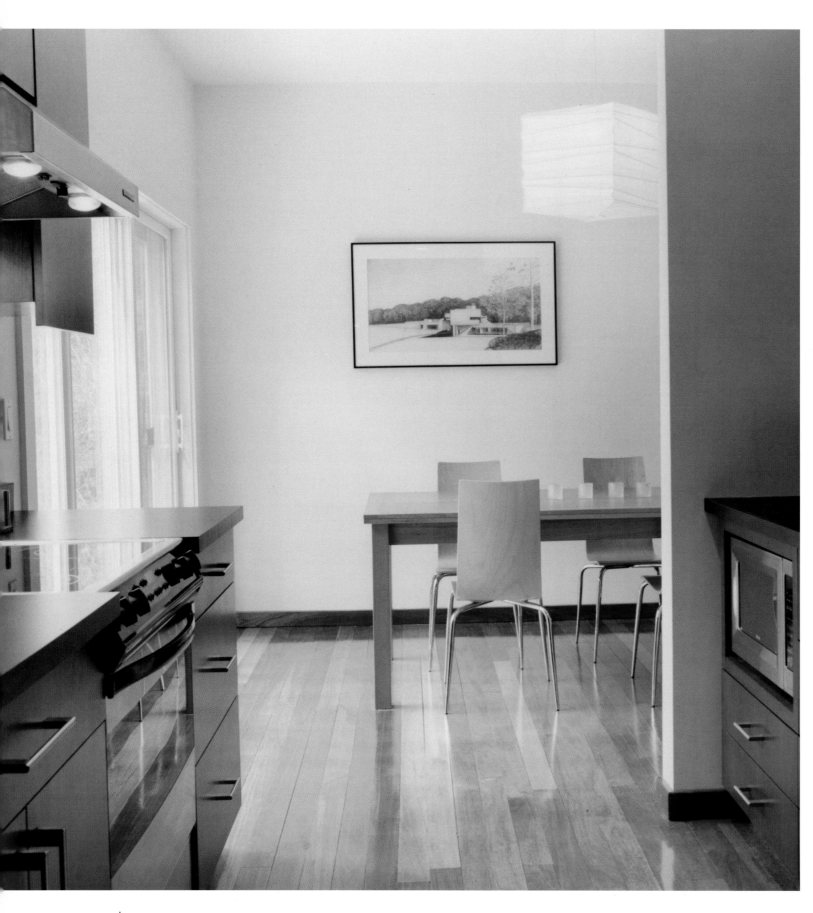

Left and Right: The cabinet-like finish of the exterior mahogany siding is reflected in the kitchen cabinets, also of mahogany. Continuing the wooden flooring into the kitchen visually unifies it with the dining and living areas.

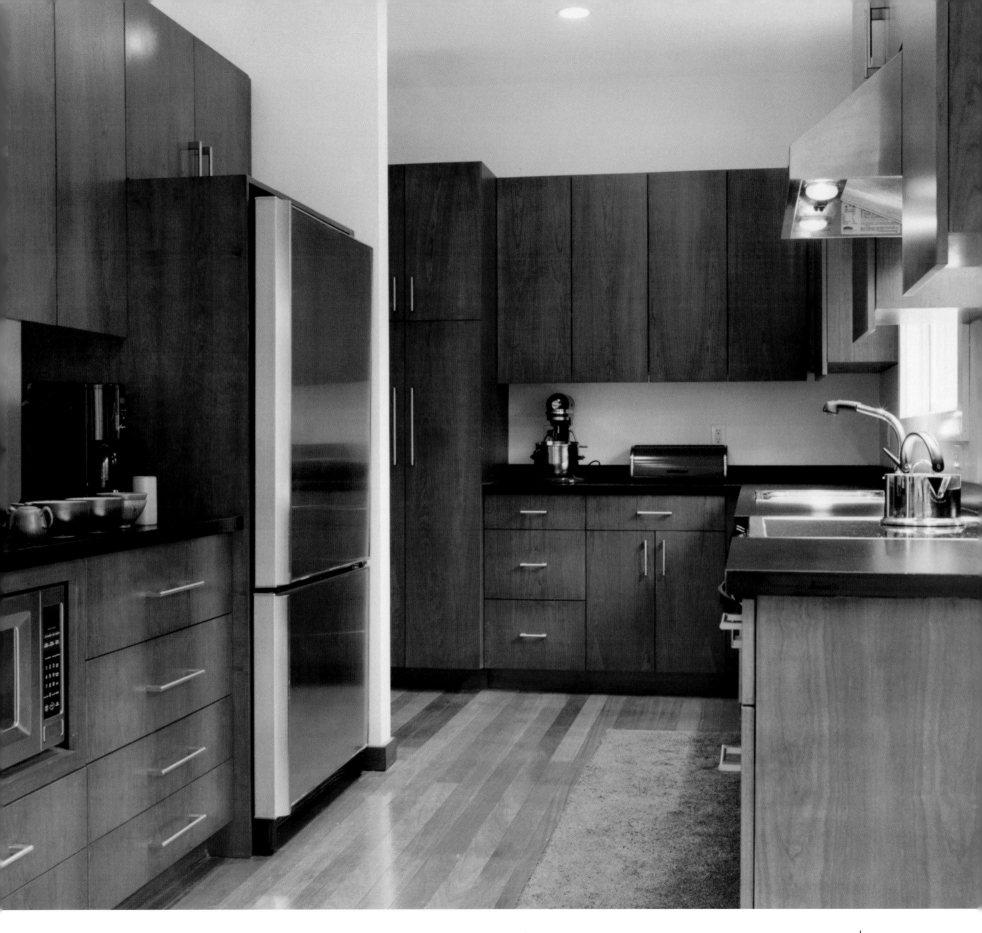

AMHERST
A Small Budget and an Open Mind

place: **AMHERST, MASSACHUSETTS** | architects: **ANMAHIAN WINTON ARCHITECTS**

photography: **PETER VANDERWARKER**

PROJECT DESCRIPTION

This 2,700-square-foot residence was designed for a young family. The limited budget presented an opportunity to create spatial richness through clear and simple means. The form and character of the house is intended to amplify its relationship with the site, a forest of slender white pine trees. The internal logic of the house is defined by two primary design elements. One is a continuous wood wall of solid white pine boards that differentiates utilitarian space from living space. In some places, the wall accommodates books, and in others, it opens up as a portal to the kitchen, the study, and the foyer. The other element is a semi-transparent box of white pine lattice that separates the living room from the family room and encloses the staircase. It also provides a luminous, spatial connection between the first and second floors. The staircase consists of an open steel frame, allowing light from the window and skylight within the lattice enclosure to find its way to surrounding spaces.

KEEPING COSTS DOWN

The simplicity of the design of this house, along with the utilization of inexpensive, off-the-shelf building materials, kept the project within budget. The dimensions of the house adhere specifically to framing lengths that can be achieved with stock lumber and a small labor force. The house does not feature any custom materials or design features.

PRIMARY BUILDING MATERIALS

Exterior siding consists of vertical and horizontal cedar boards and cedar slats. White pine was used to construct the interior dividing wall as well as the slats for the staircase enclosure.

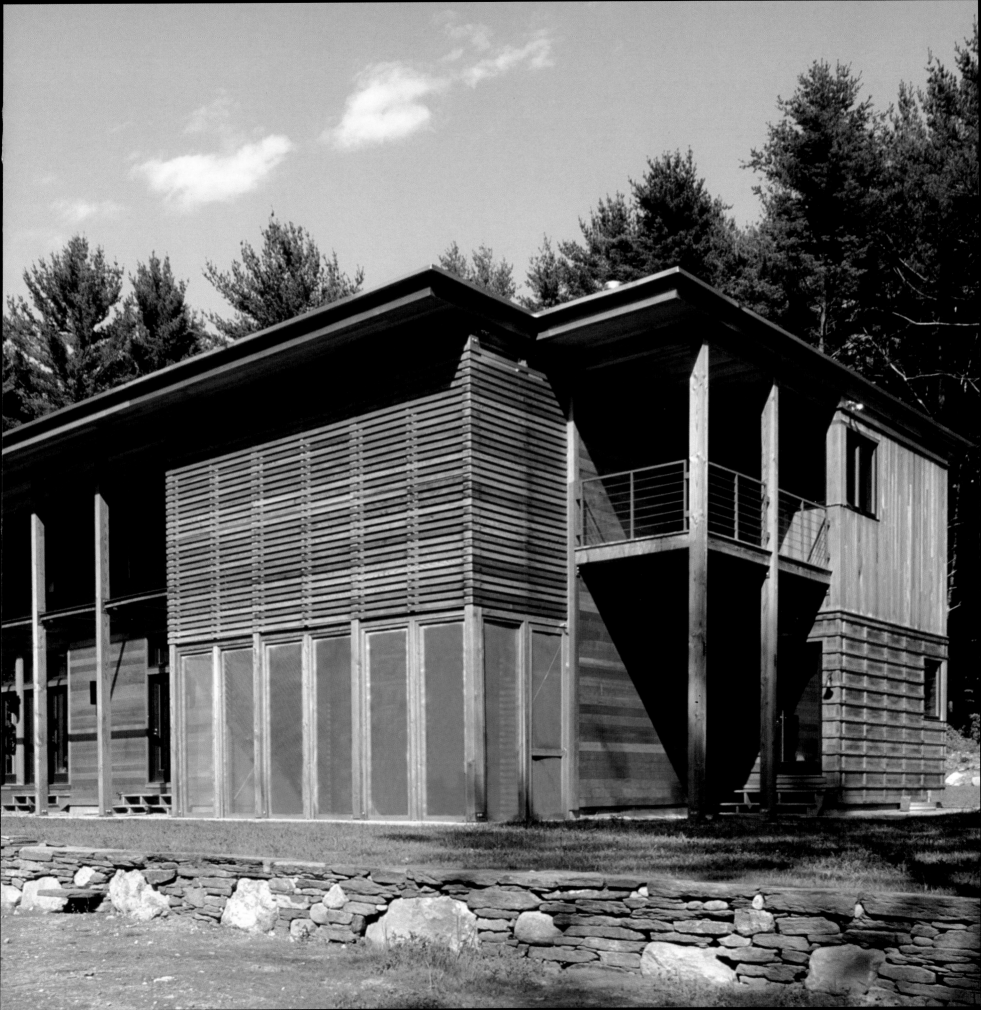

Site Plan

0' 10' 20' 40' 80'

Site plan

Second-floor Plan

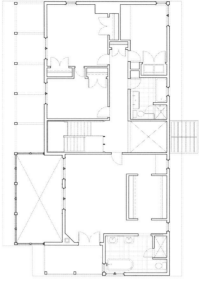

First-floor Plan

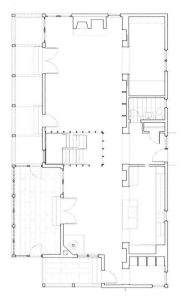

South Elevation

North Elevation

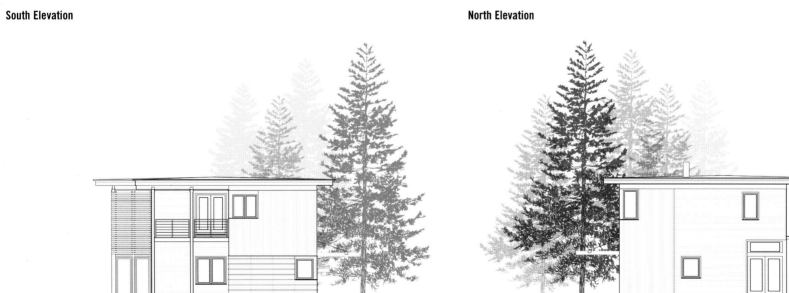

Section Model

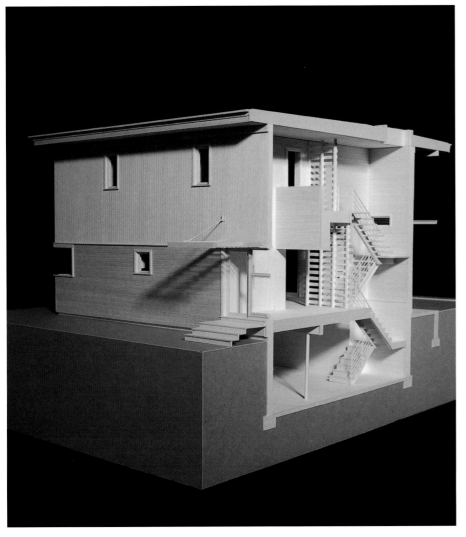

East-West Section

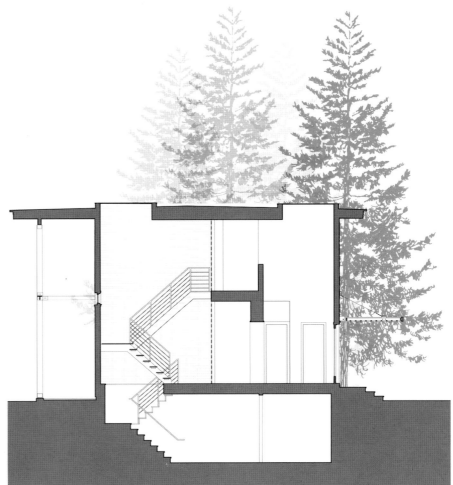

West Elevation

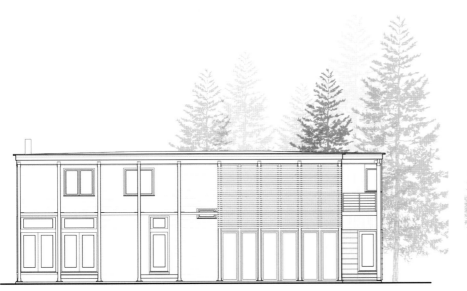

East Elevation

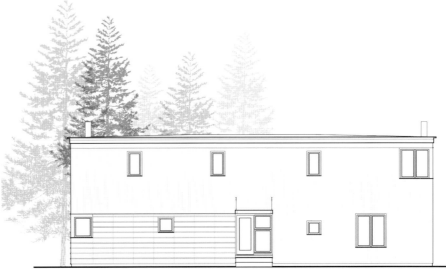

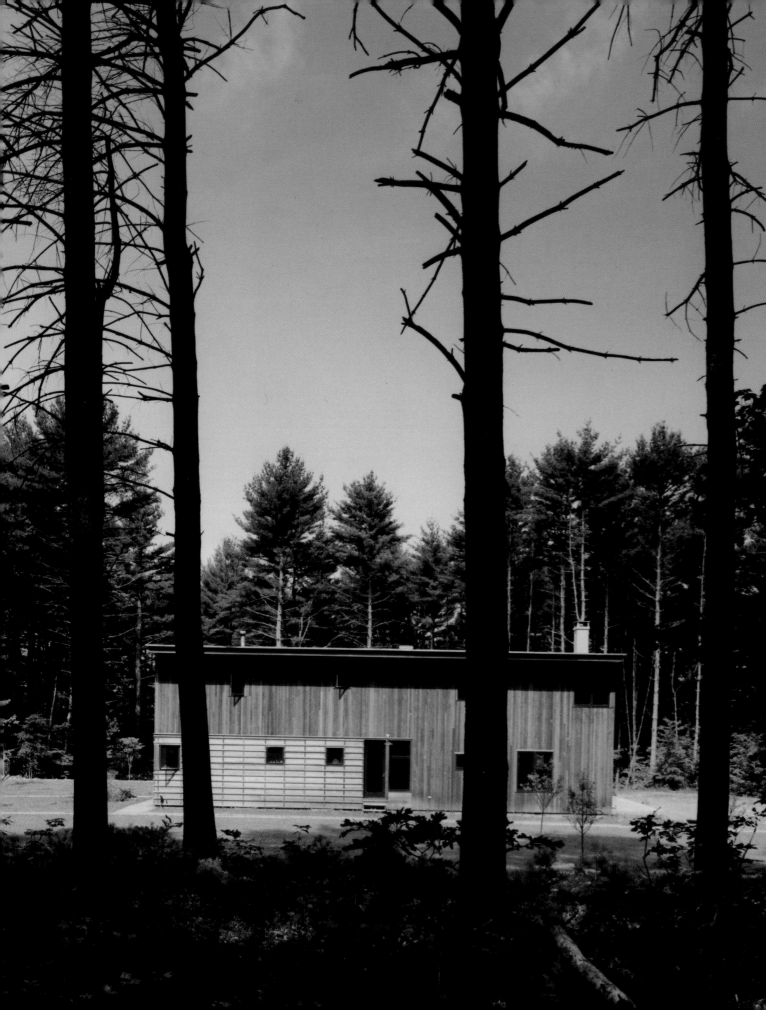

Left: The east facade is dense, punctuated with a composition of windows.

Right: The west facade is primarily formed of attenuated fir columns, defining a two-story porch that establishes a direct relationship with the surrounding trees. Part of that framework is wrapped in cedar slats to provide dappled sunshade overhead, yet remains open for the lower views through the forest.

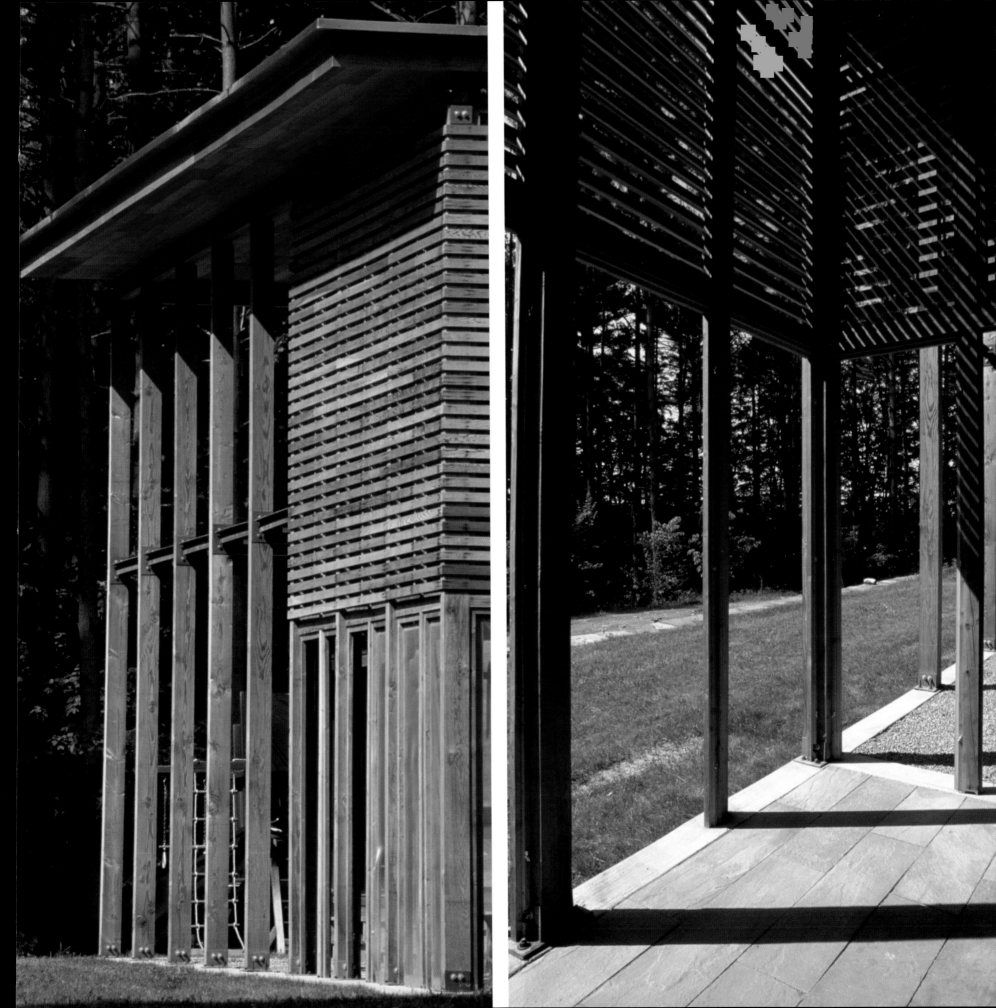

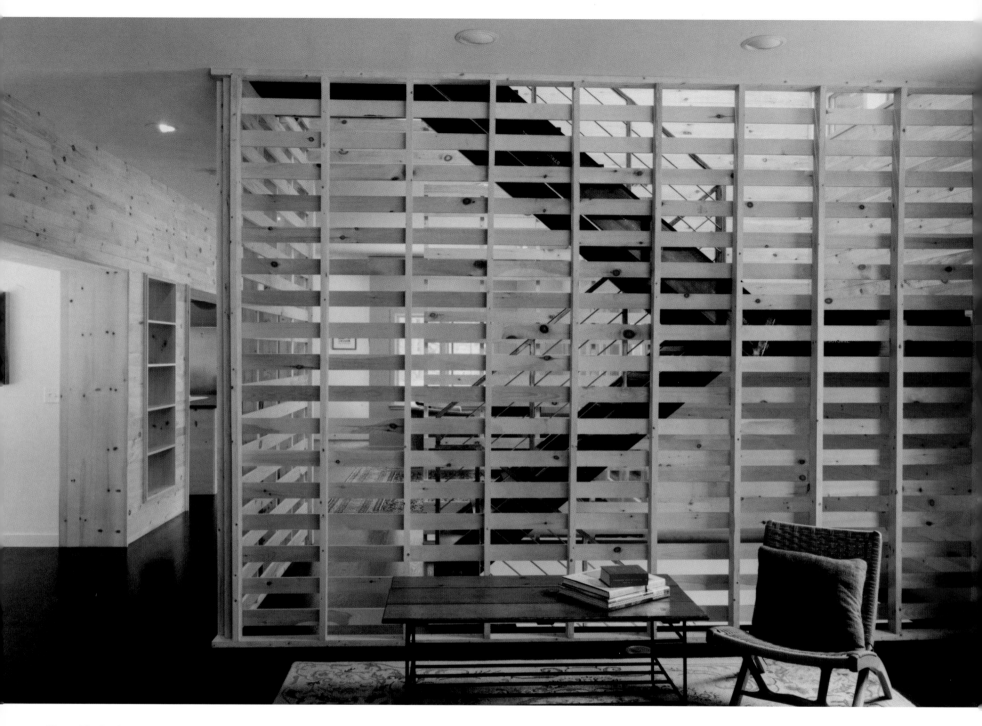

Above: The lattice wall encloses the staircase and separates the living room from the family room.

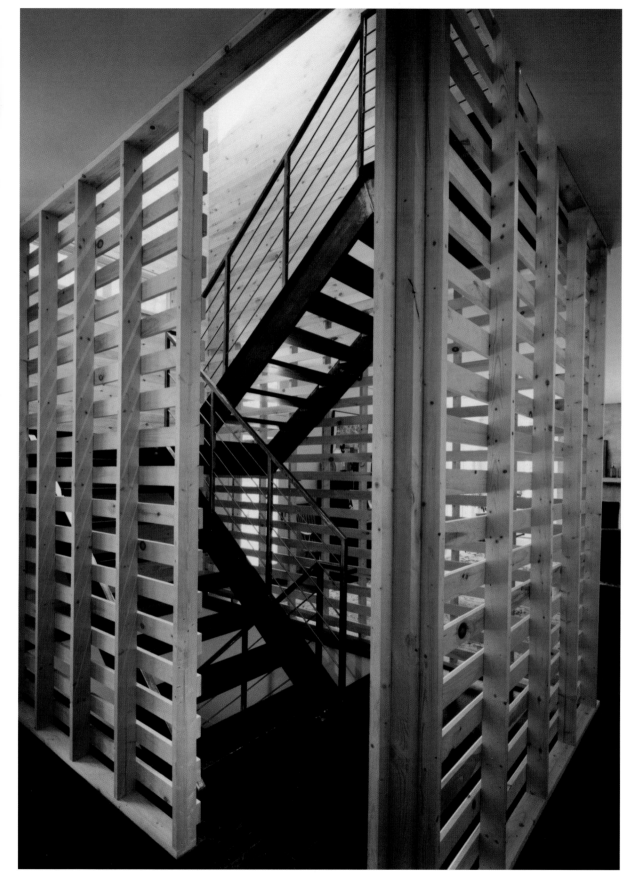

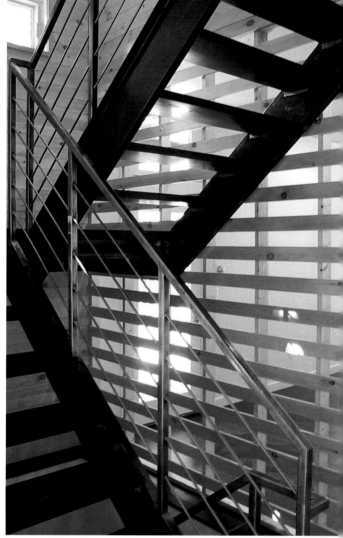

Left: The stairway within the lattice work

Above: Detail of the steel stairway

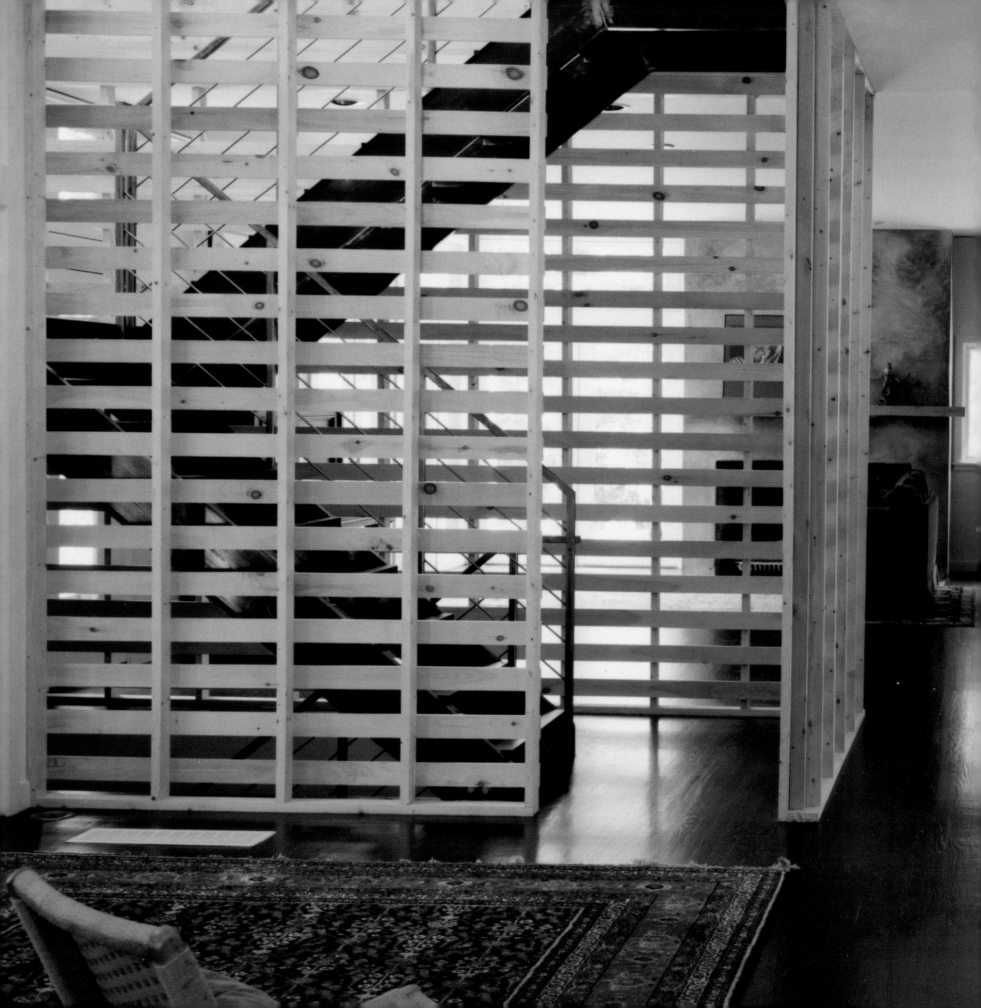

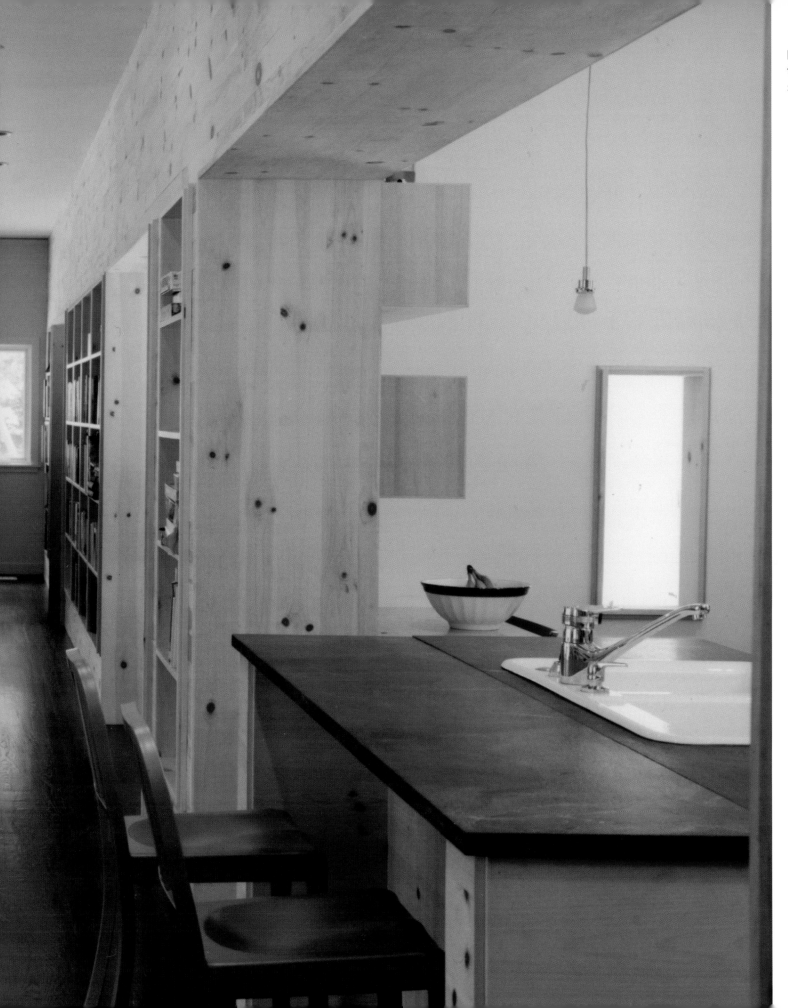

Left: The wooden wall divides the living spaces and provides storage.

LOFT COURTYARD

An Urban Oasis

place: **VENICE, CALIFORNIA** | architects: **STEVEN EHRLICH ARCHITECTS**

photography: **BENNY CHAN**

PROJECT DESCRIPTION

Located in a densely populated California costal town, this 3,600-square-foot residence utilizes the oasis of an interior courtyard with a reflecting pool between two structures at each end of the long, narrow lot. Steel I-beams frame roll-up glass doors on the two facades that face the courtyard and the front facade. This open axis provides an invigorating level of open space, with an uninterrupted flow from the ground floor living and dining rooms in the front, across the courtyard, and up a flight of steps into a rear studio through another roll-up door. The amphitheaterlike steps that rise from the courtyard further enhance this procession of space. The raised platform not only provides an additional vantage point to enjoy the exterior, but it also moderates the site's 5-foot rise in grade from front to back that allows for a two-car garage in the alley. When all three roll-up doors are opened, the house transforms itself into a pavilion of connected courts and spaces.

KEEPING COSTS DOWN

The design of this house centers on the dynamic flow of space and making the most of less materials and space. Materials throughout the house are durable and honest, and create a straightforward, almost loftlike effect. Exposed painted structural steel reveals the interior tectonics of the space, and precut concrete "hardy board" panels provide a durable, low-cost interior and exterior cladding material in this salt-air climate. The easy flow of space is enhanced by the use of off-the-shelf steel grills for stair treads and galleries that seem to float in the lofty void at the center of the house. The polished concrete flooring provides not only the structural slab of the house, but also serves as the finished material. The open-floor plan allows ocean breezes to enter the house, eliminating the need for air conditioning. Utilizing the slope of the site, the garage is tucked into the slope, minimizing the intrusion of cars onsite.

PRIMARY BUILDING MATERIALS

Precut "hardy board" panels were used for interior and exterior cladding. Exposed structural steel and finished concrete complete the industrial loft look of the house.

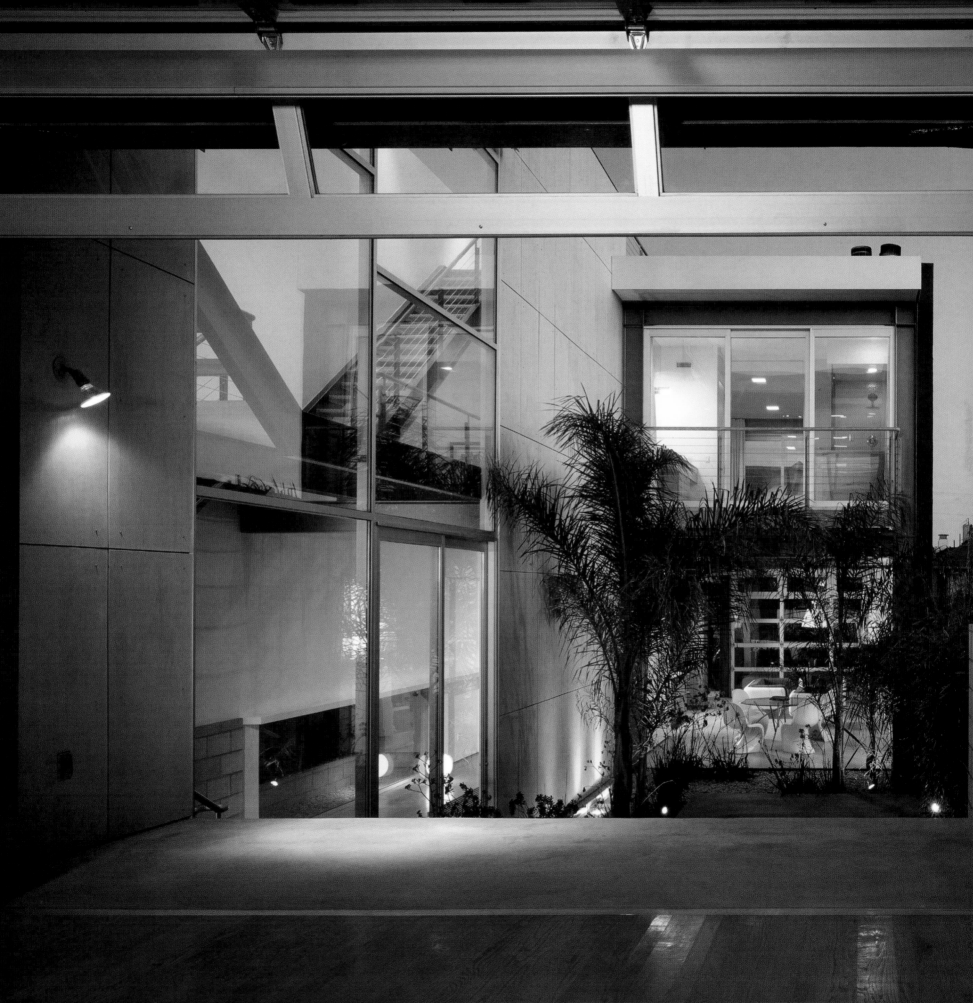

Roof Plan

Second-floor Plan

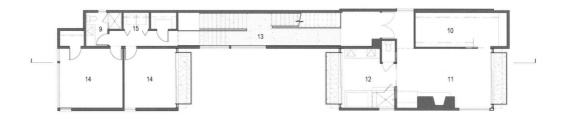

First-floor Plan

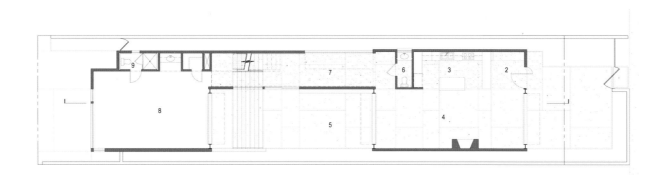

Basement Plan

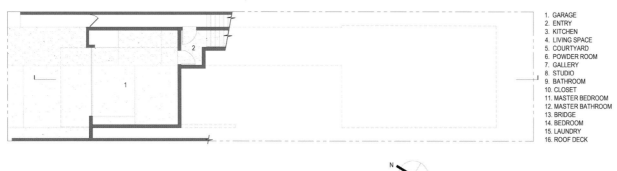

1. GARAGE
2. ENTRY
3. KITCHEN
4. LIVING SPACE
5. COURTYARD
6. POWDER ROOM
7. GALLERY
8. STUDIO
9. BATHROOM
10. CLOSET
11. MASTER BEDROOM
12. MASTER BATHROOM
13. BRIDGE
14. BEDROOM
15. LAUNDRY
16. ROOF DECK

East Elevation

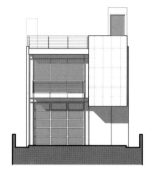

West Elevation

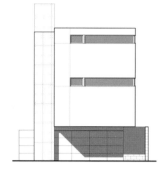

North Elevation

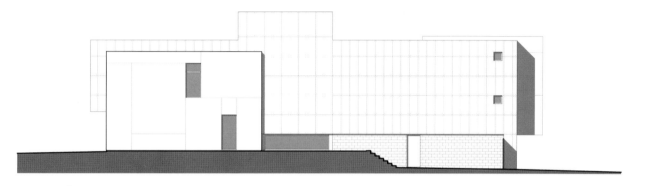

South Elevation

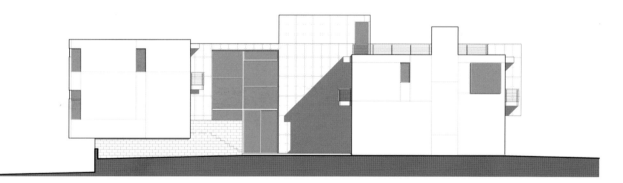

North-South Section

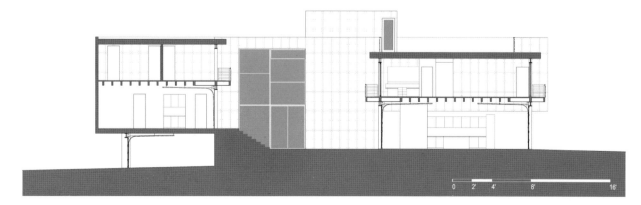

0 2' 4' 8' 16'

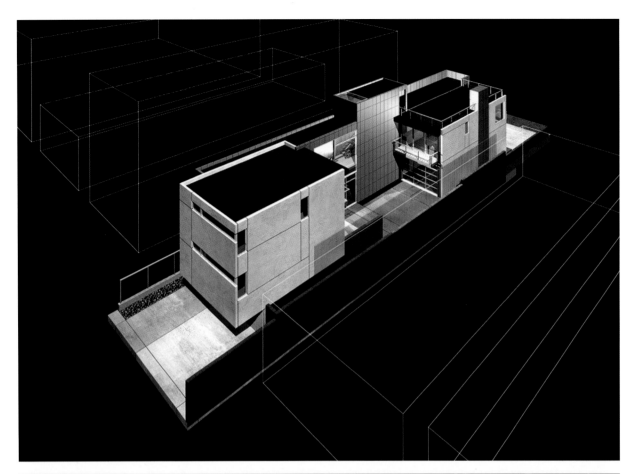

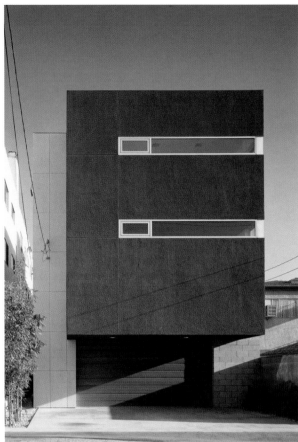

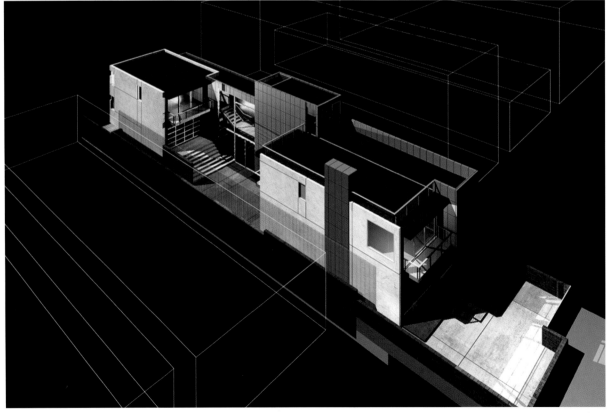

Above Left and Below:
Computer models

Above: West elevation with the
"hardy board" panels in place

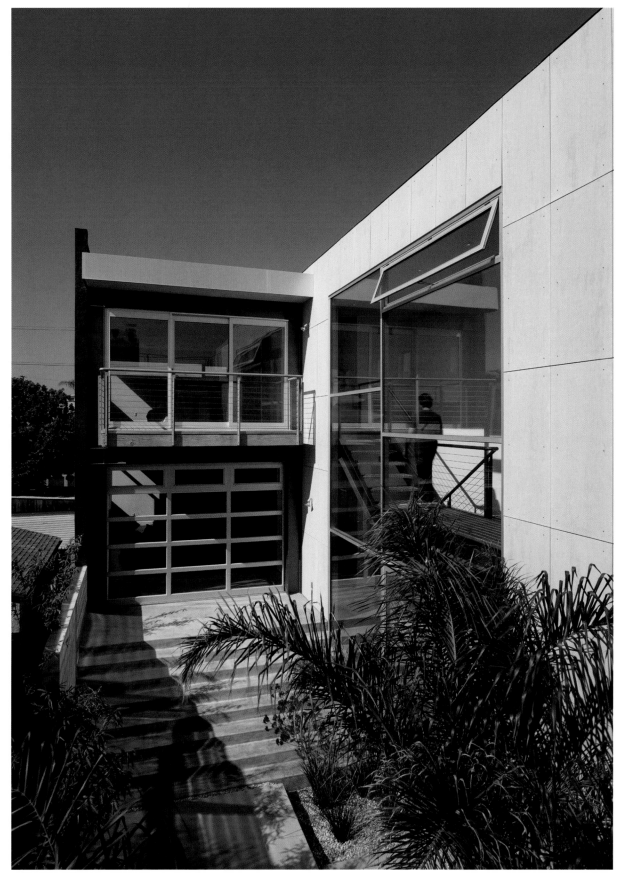

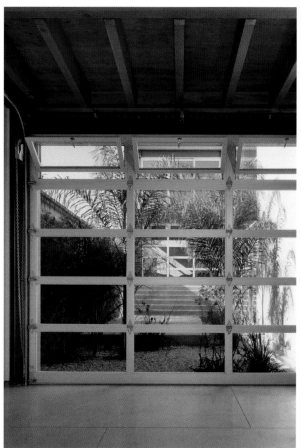

Left: View of the courtyard and guest house, with the service spine that runs along the eastern perimeter of the house. The roll-up garage doors provide an inexpensive yet dramatic way of easily opening up large sections of the house to take advantage of ocean breezes.

Above: View of the guest house from the main house, where the flooring consists of finished concrete

Right: The entry through a floor-to-ceiling pivot door. Inside, the major structural components of the house are left exposed including the exposed ceiling beams, steel columns, and concrete slab floors.

Far Right: A view to the living room from the courtyard; when the garage doors are opened at either end, it becomes at one with the exterior

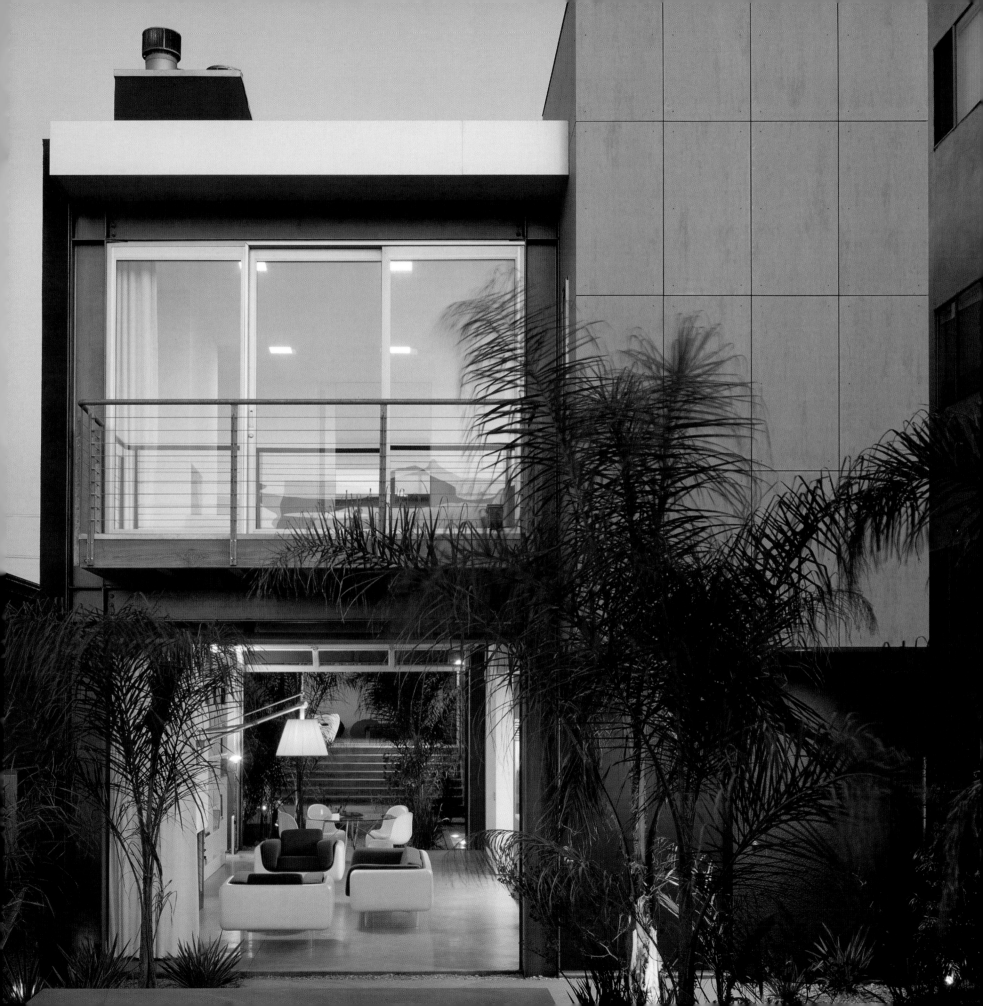

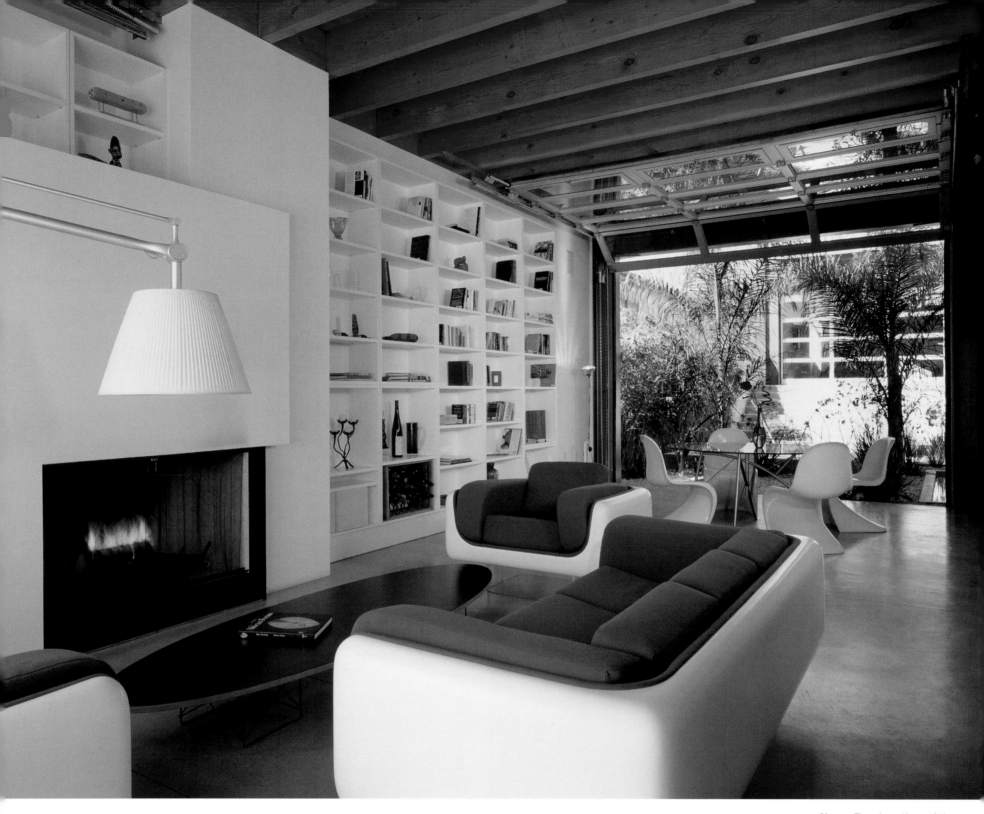

Above: The clean lines of the modern furniture provide a welcome contrast with the raw, exposed building materials. When in the open position, the glazing of the garage doors reflect the garden, and in effect, bring it inside.

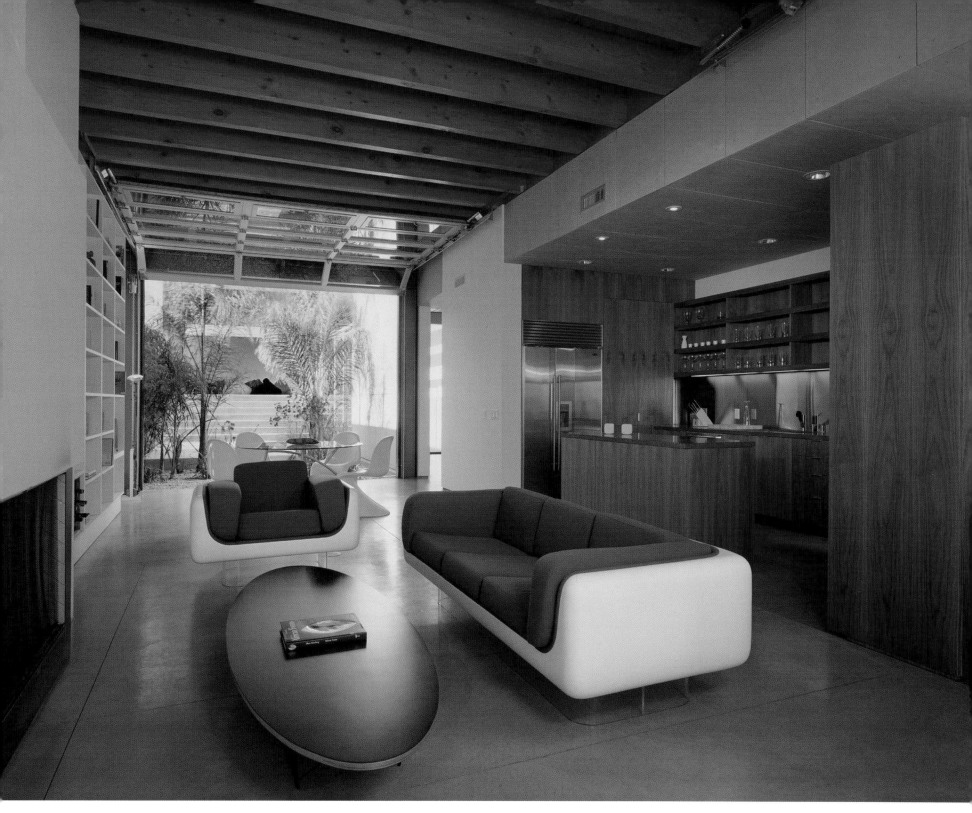

Above: The carefully crafted all-wood kitchen is treated like a fine piece of furniture, recessed into the wall.

Above, Above Left, and Right: Interior views of the service spine connecting the guest house and main house. To keep costs down, "off the shelf" steel treads were used for the stairs and catwalk.

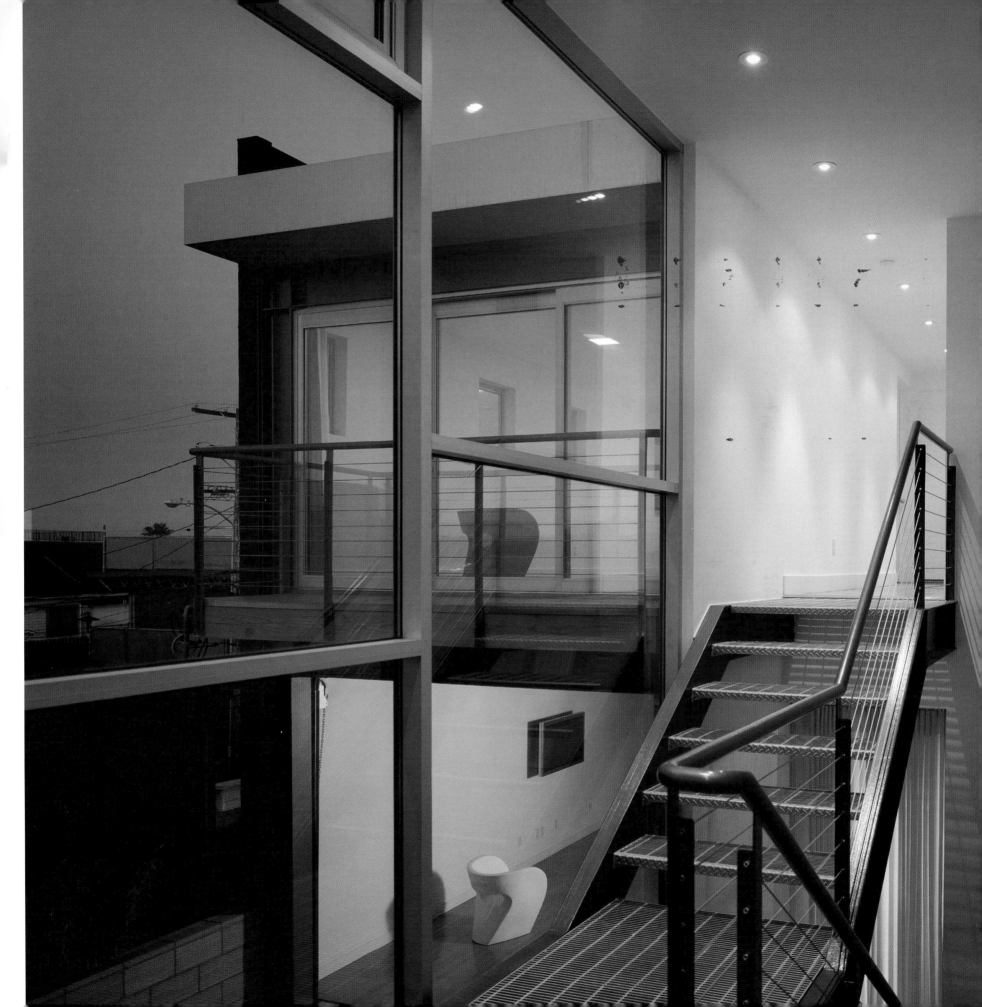

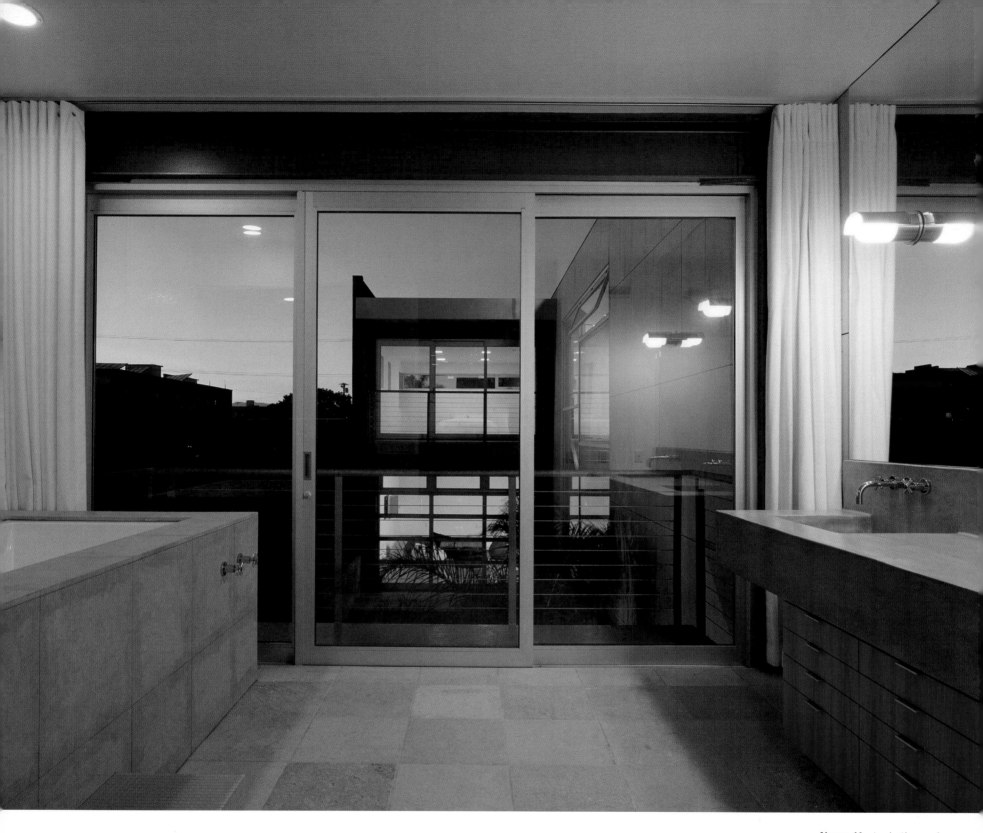

Above: Master bathroom has its own private balcony overlooking the courtyard

Right: The roof deck is enhanced with a prefabricated outdoor fireplace

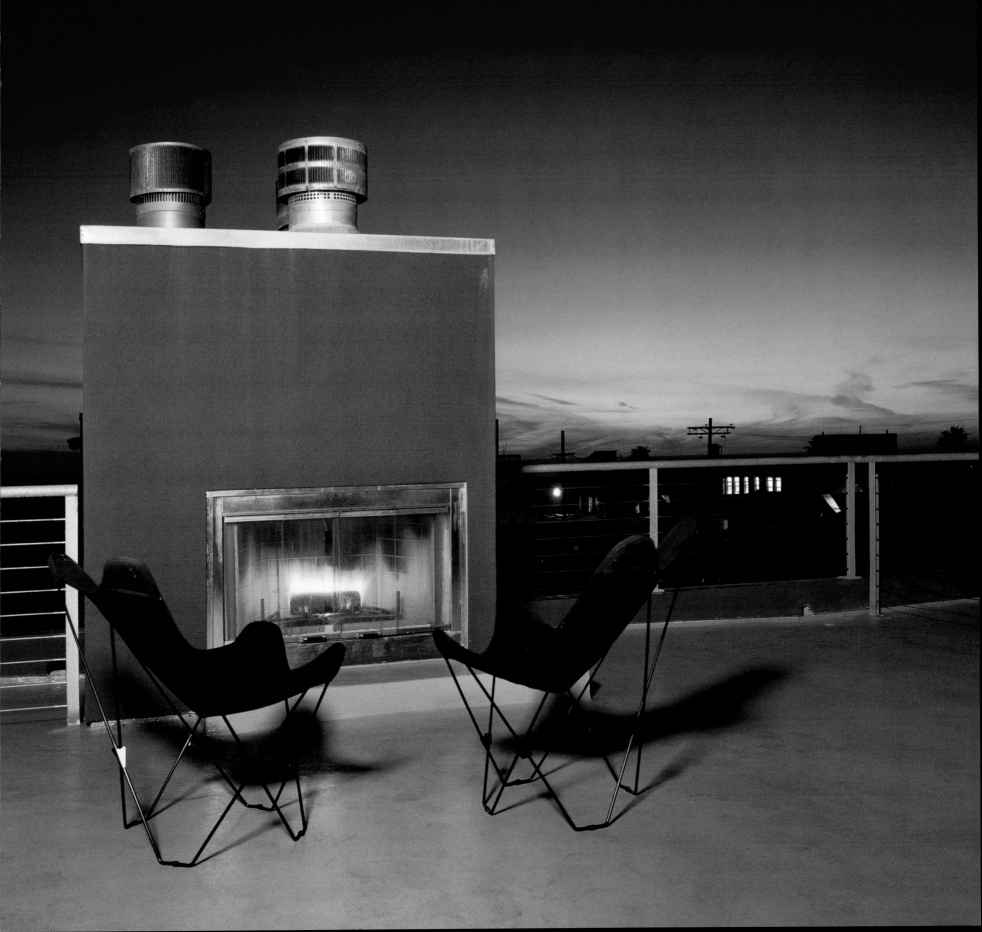

COMANO
A Design for the Weekend Builder

place: **COMANO ISLAND, WASHINGTON** | architects: **VANDEVENTER + CARLANDER ARCHITECTS**

photography: **STEVE KEATING**

PROJECT DESCRIPTION

With only 352 square feet on the main floor and a 112-square-foot loft, this home encompasses all the domestic requirements of structures many times larger. The design of this cabin was premised on a number of existing conditions, including an existing foundation and garden just to the south of the foundation. The architects were asked to design the cabin to embrace the views to the west, to promote connection to the garden, and to screen uphill neighbors. Finally, the clients wanted all of this contained in a design that could be easily built and finished by themselves.

KEEPING COSTS DOWN

In order to keep the construction requirements at a basic level, the design is based on wood-framed walls developed on a 4-foot module. This plan module was then developed vertically using the same dimensional parameters. As a result, the walls are 12 feet tall. All openings were then located based on the construction module. The two large pairs of double doors are 8 feet by 8 feet and located on the 4-foot module. Smaller secondary openings are located along panel edges to simplify framing and siding. This use of the 4-foot module minimizes material waste and promotes efficient construction. The metal-clad garden wall was framed like a typical fence, using pressure-treated posts set in concrete.

PRIMARY BUILDING MATERIALS

For the exterior, fiber cement panels were used on the basic box. Metal panels were used on the garden wall and roof. Inside, a stained concrete slab is the main floor material, while cherry strip flooring was used in the loft. Prefinished maple and cherry plywood was used for all interior wall and ceiling surfaces.

Loft Plan

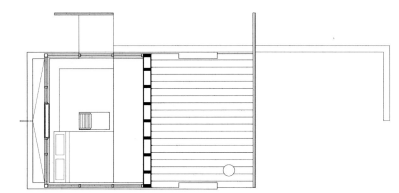

Axonometric

Ground-floor Plan

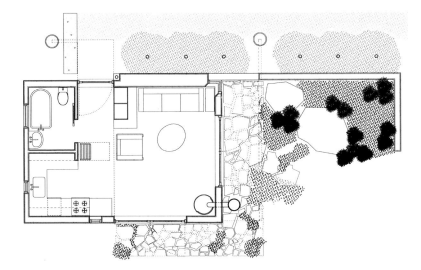

South Elevation

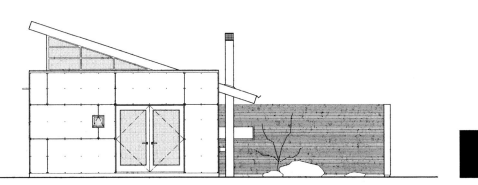

Section

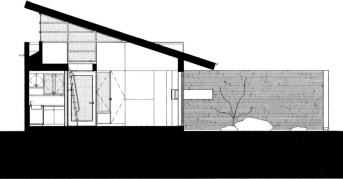

North Elevation

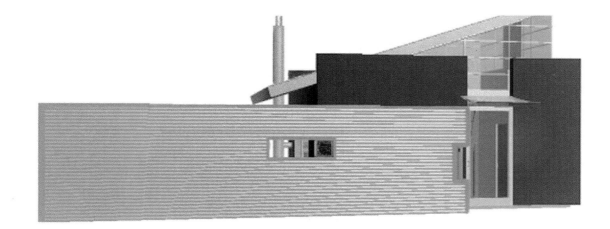

West Elevation

South Elevation

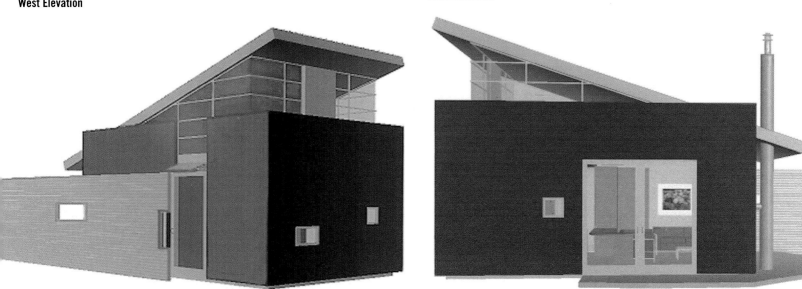

East Elevation

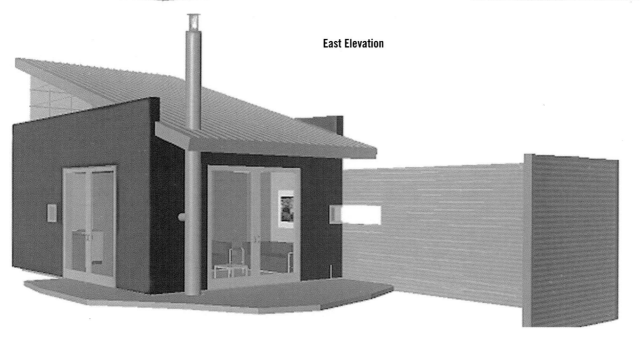

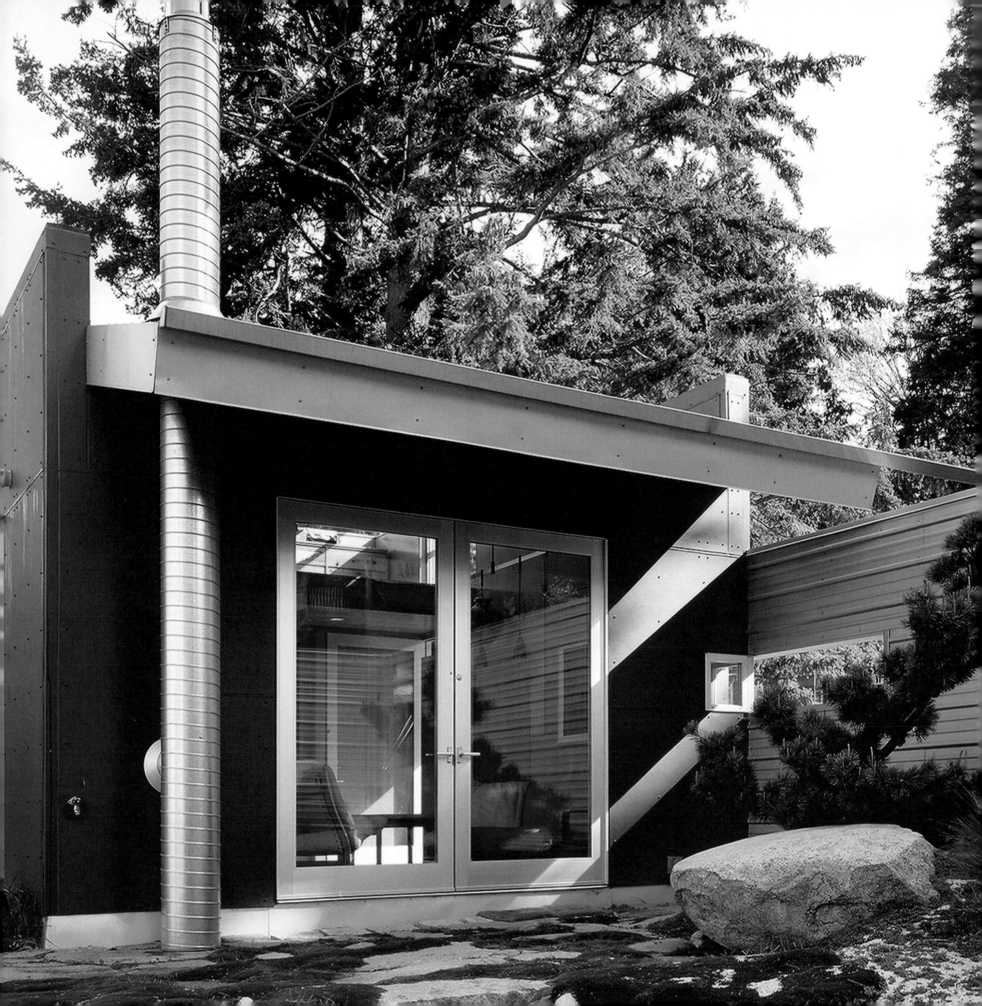

Left: View of the house from the patio

Right: The metal-clad garden wall was detailed like a fence for easy construction.

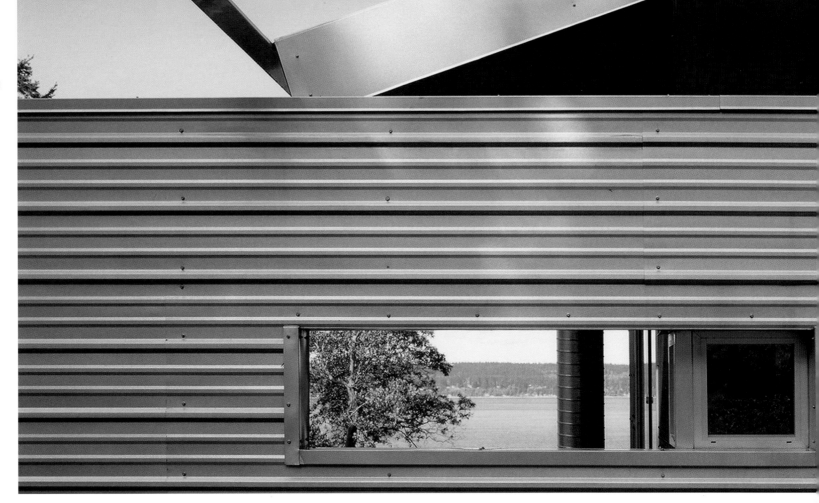

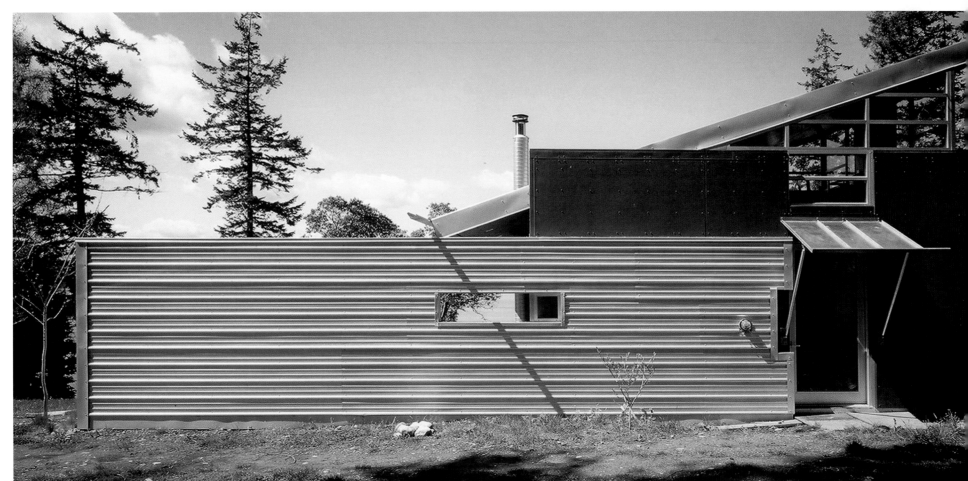

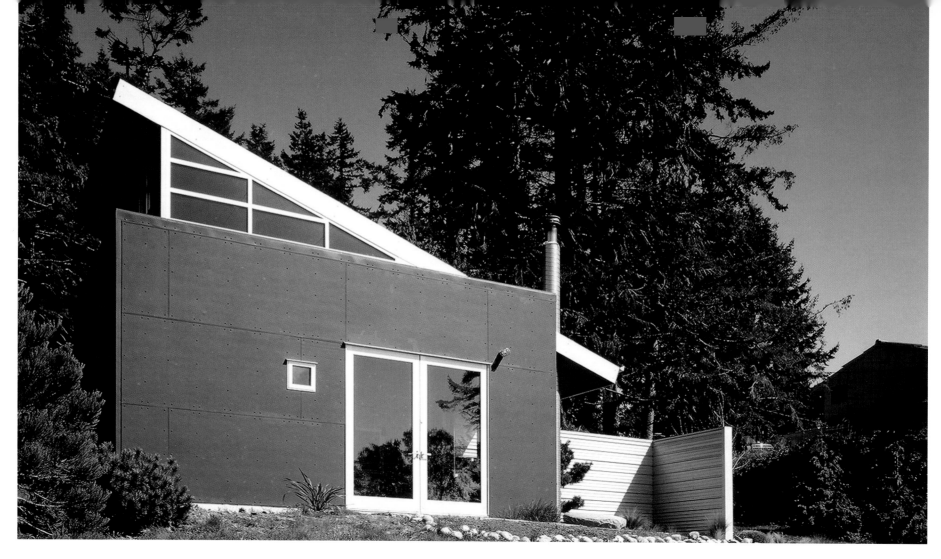

Above and Left: The house was oriented to take advantage of the water views.

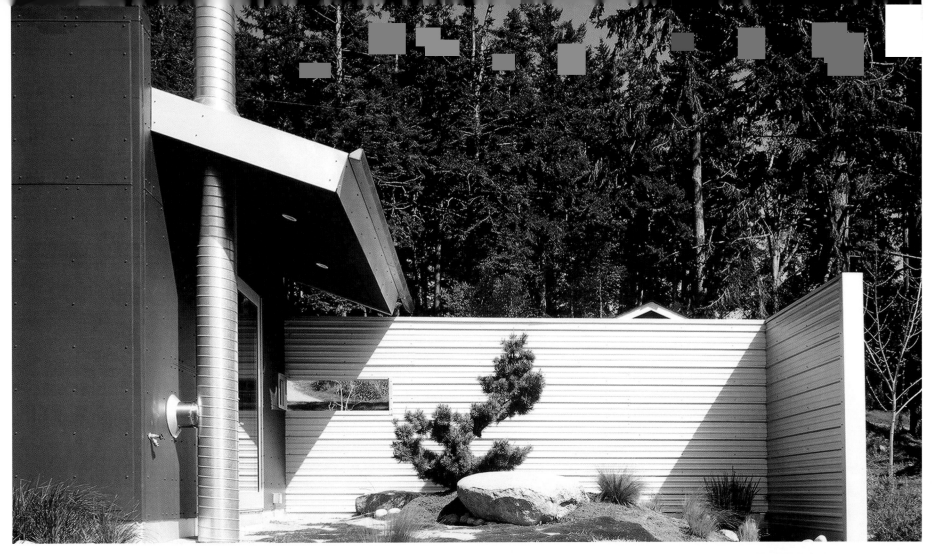

Above: The garden wall was carefully positioned to screen neighboring properties.

Right: Window detail

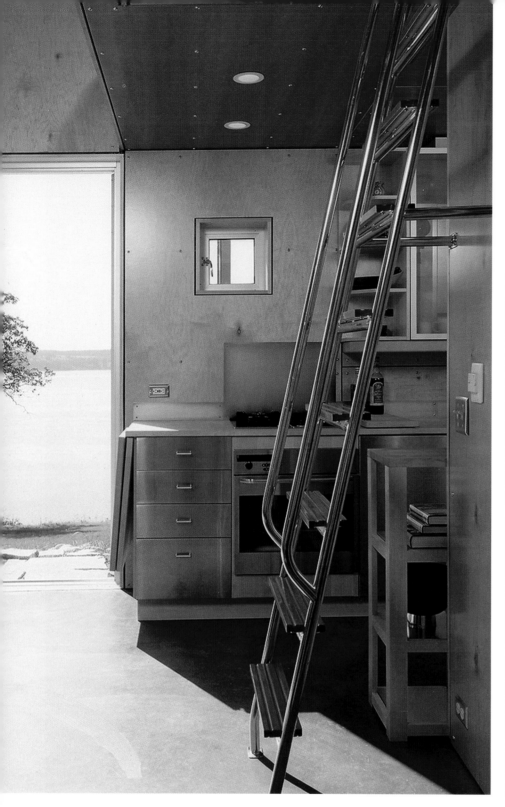

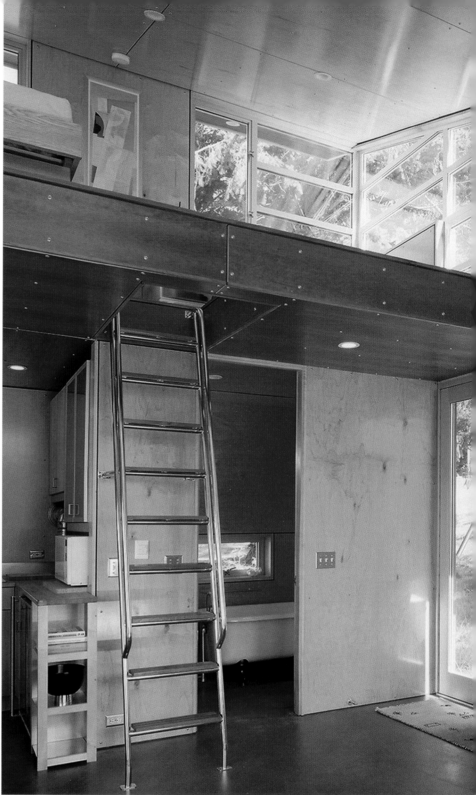

Above and Right: Wall and ceiling surfaces are covered with prefinished maple and cherry plywood. The total first-floor living area is 352 square feet.

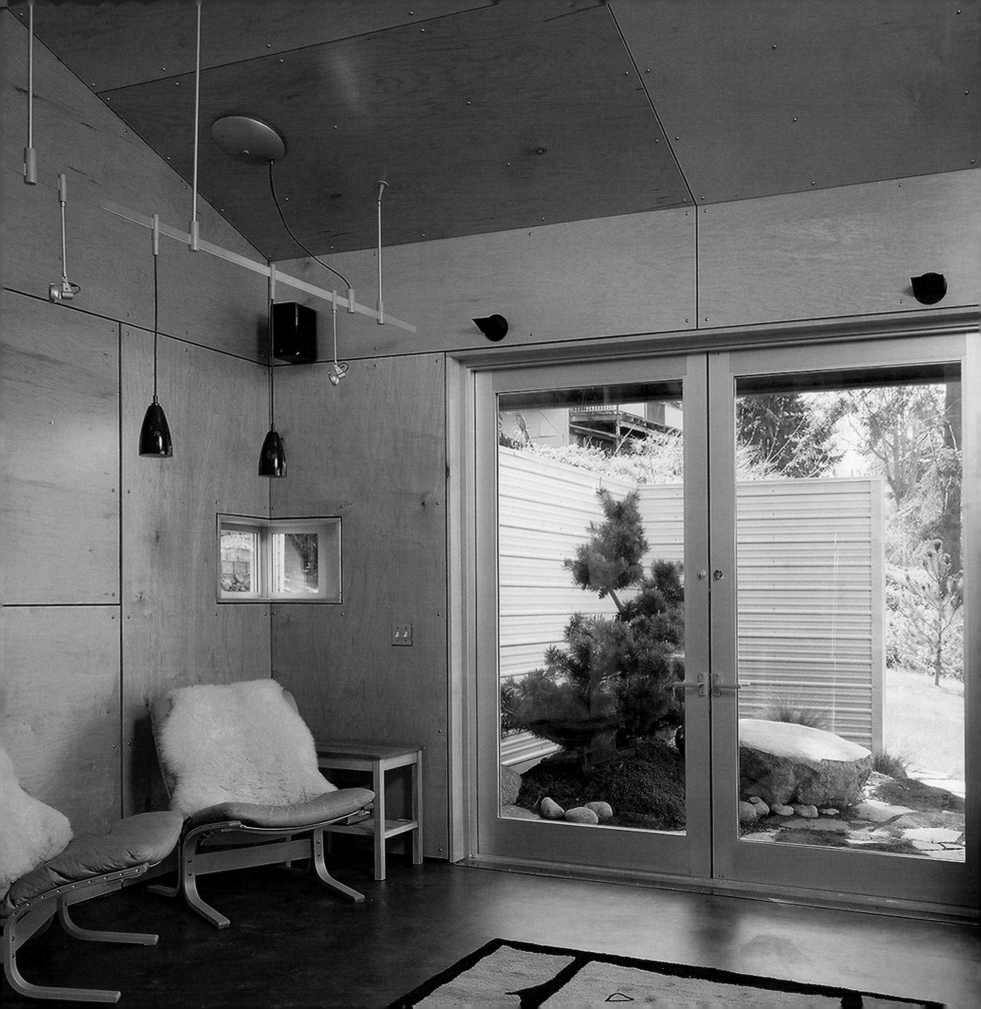

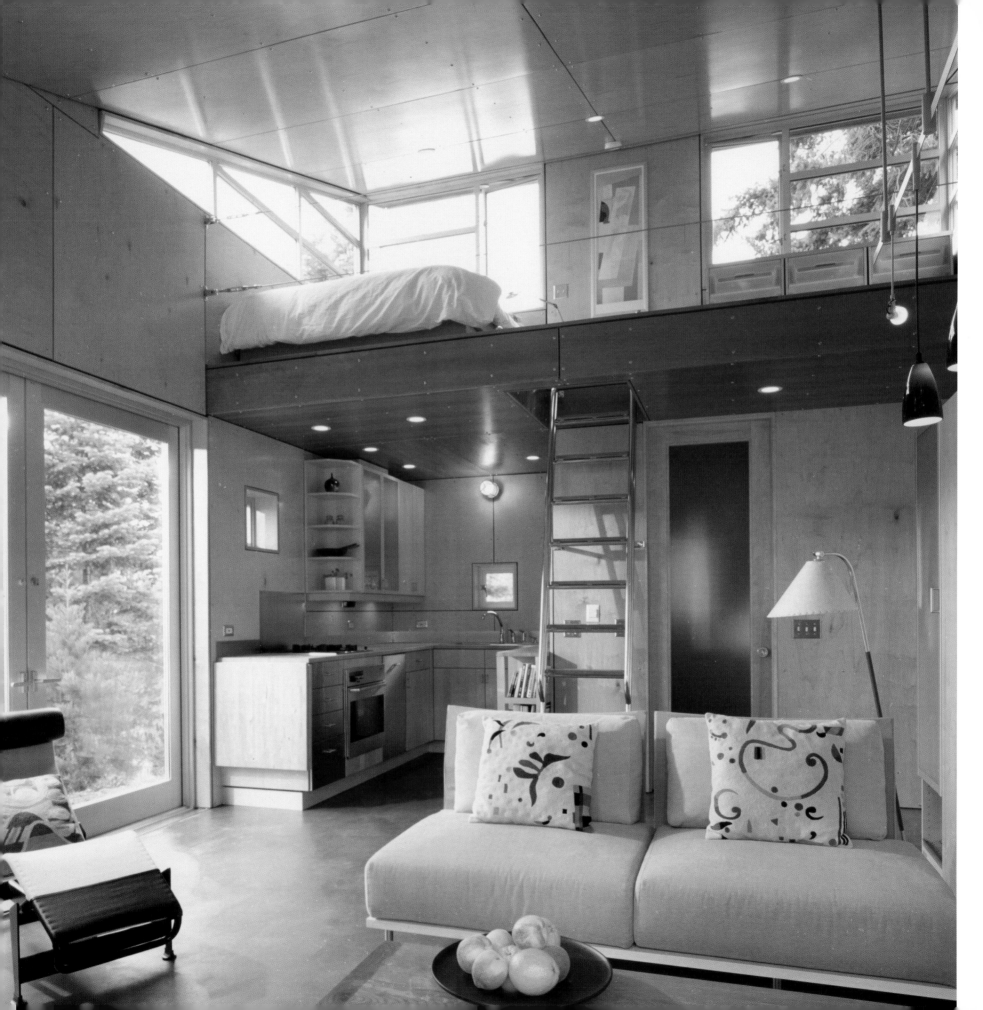

Far Left: The high ceilings and reflective wood surfaces enhance the feeling of spaciousness.

Left: The sleeping loft enjoys views of the water through the clerestory windows.

SCULPTOR'S HOME
Industrial Materials and Processes

place: **SANTA ROSA, CALIFORNIA** | architects: **SANDERS ARCHITECTS**

photography: **SHARON RISEDORPH**

PROJECT DESCRIPTION

This single-family residence was a collaboration among the clients and the architects. The clients are both artists, he a sculptor and she a quilter. The first floor of the house provides studio space. In the front entry foyer is a curved rusted steel sculptural wall that is 22 feet tall. Opposite is a curving steel stairway. Lighting in this entry is entirely by daylight, coming through slit windows in the skin. Some are vertical, some horizontal, one is a skylight, and another is a glass block aperture. One horizontal window frames a fragment of the long view from the top of the stairs. All the openings contribute to a space in which fragments of light track through the space as the sun moves around the house. If the house is perceived from the outside as a horizontal, lengthwise mass with the inference of a long view, the first experience of its interior is the opposite: an inward-focused vertical space for the viewing of art.

KEEPING COSTS DOWN

The steel frame for the house was premanufactured off site and assembled onsite in about three days. Its lightness and strength comes from the folding of thin-gauge steel sheets into C-shaped beams and columns. For a 4,500-square-foot house like this, one would normally budget about $15 per square foot for a traditional steel frame, or about $70,000. This frame cost $28,000. An inexpensive roofing system was used for the cladding on the outside of the house. It's called "Clip-Rib" because one panel is installed with a set of screws that the next one snaps over, and it is maintenance-free. The first floor is concrete cast on metal joists. Commercial aluminum storefront window systems were used and assembled onsite. The upper floor is prefinished bamboo, a common and inexpensive flooring that is also environmentally sustainable.

PRIMARY BUILDING MATERIALS

The house is supported by a prefabricated steel frame normally used in industrial warehouses. The exterior is clad in a standing-seam metal roof system. Curved steel was used for the entry foyer. The interior staircase is steel, and the floors are concrete and bamboo.

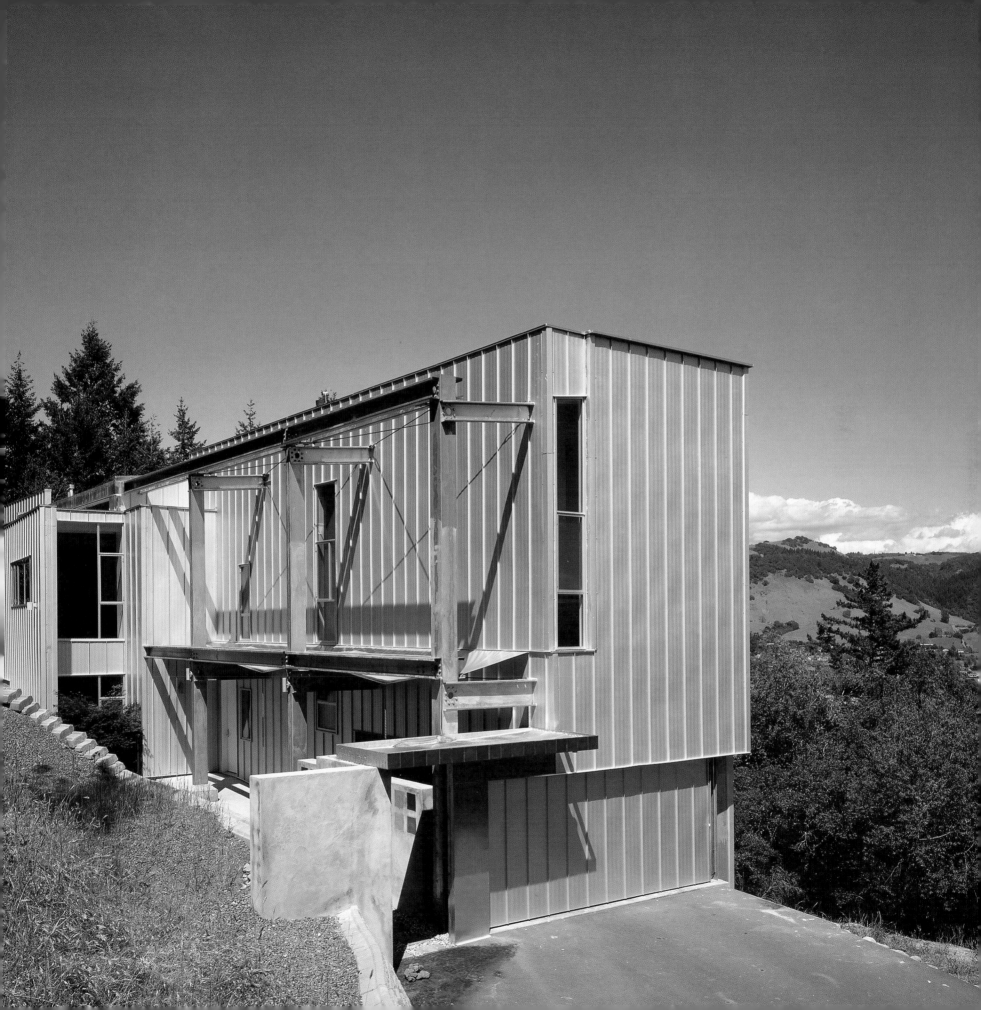

Ground-floor Plan

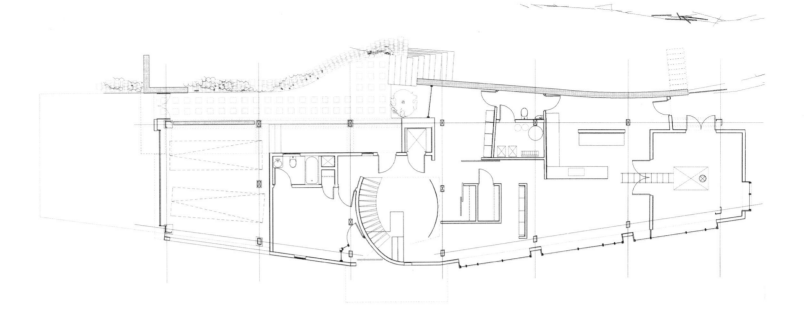

West Elevation

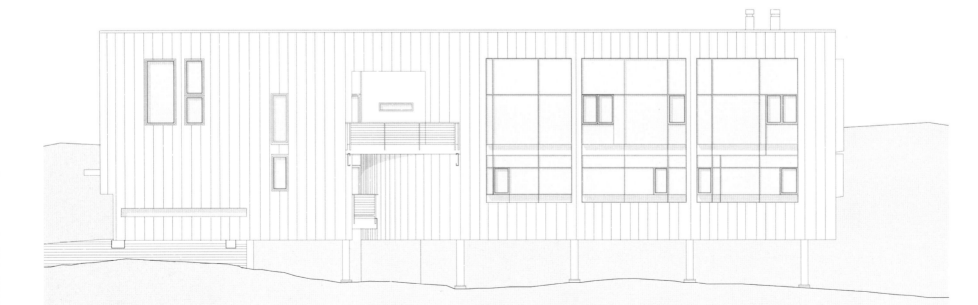

First-floor Plan

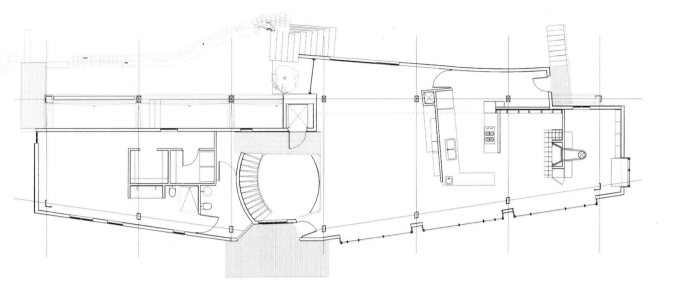

Conceptual Sketch

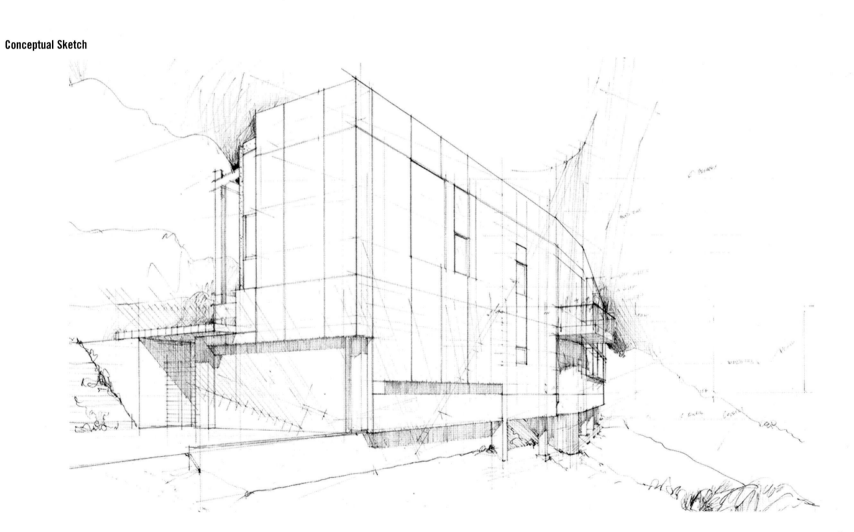

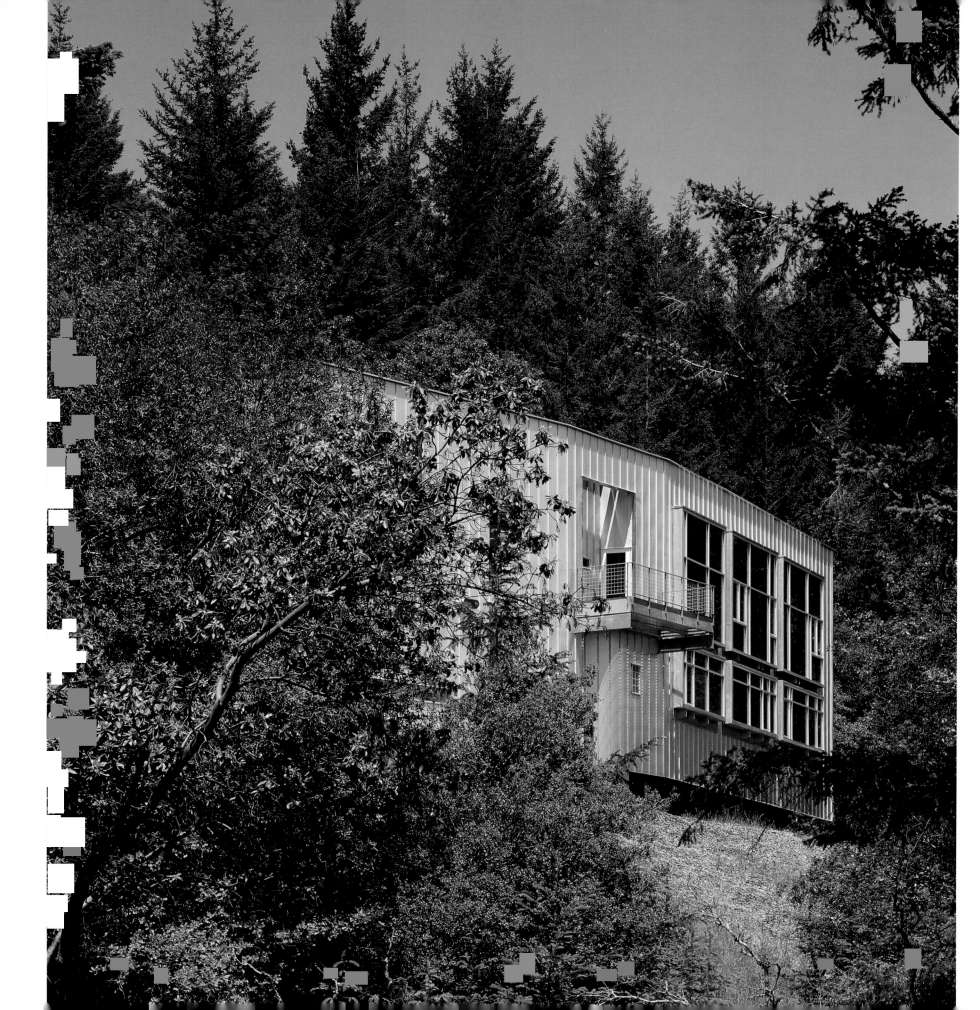

Left and Below: Built around a steel frame, the house's cladding is maintenance-free metal siding and commercial-grade aluminum windows.

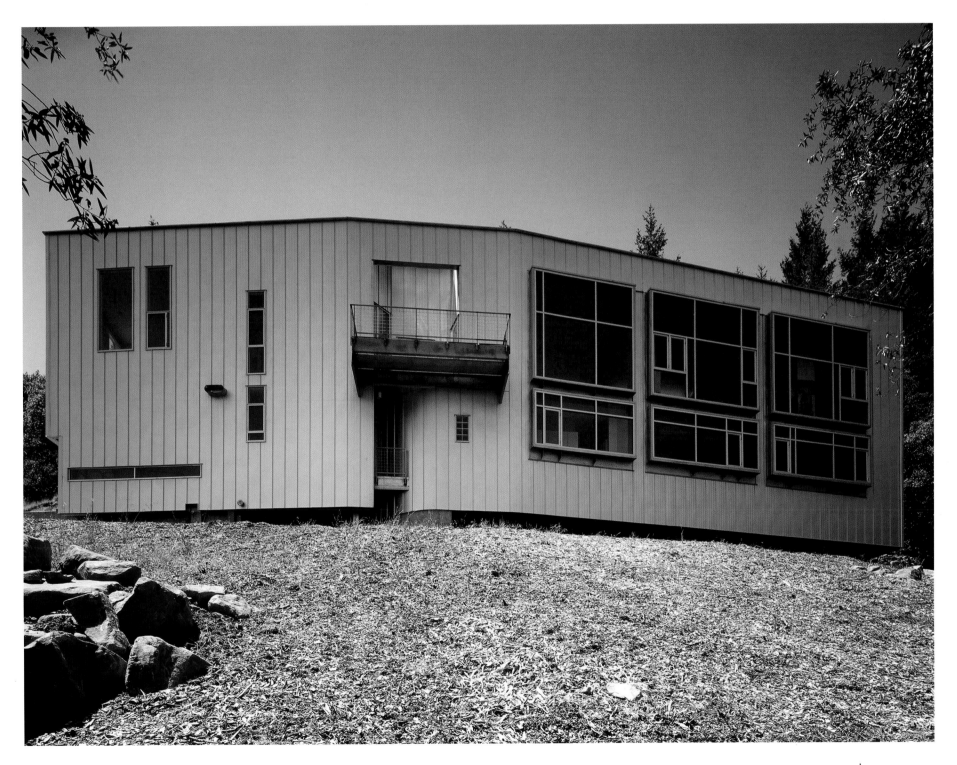

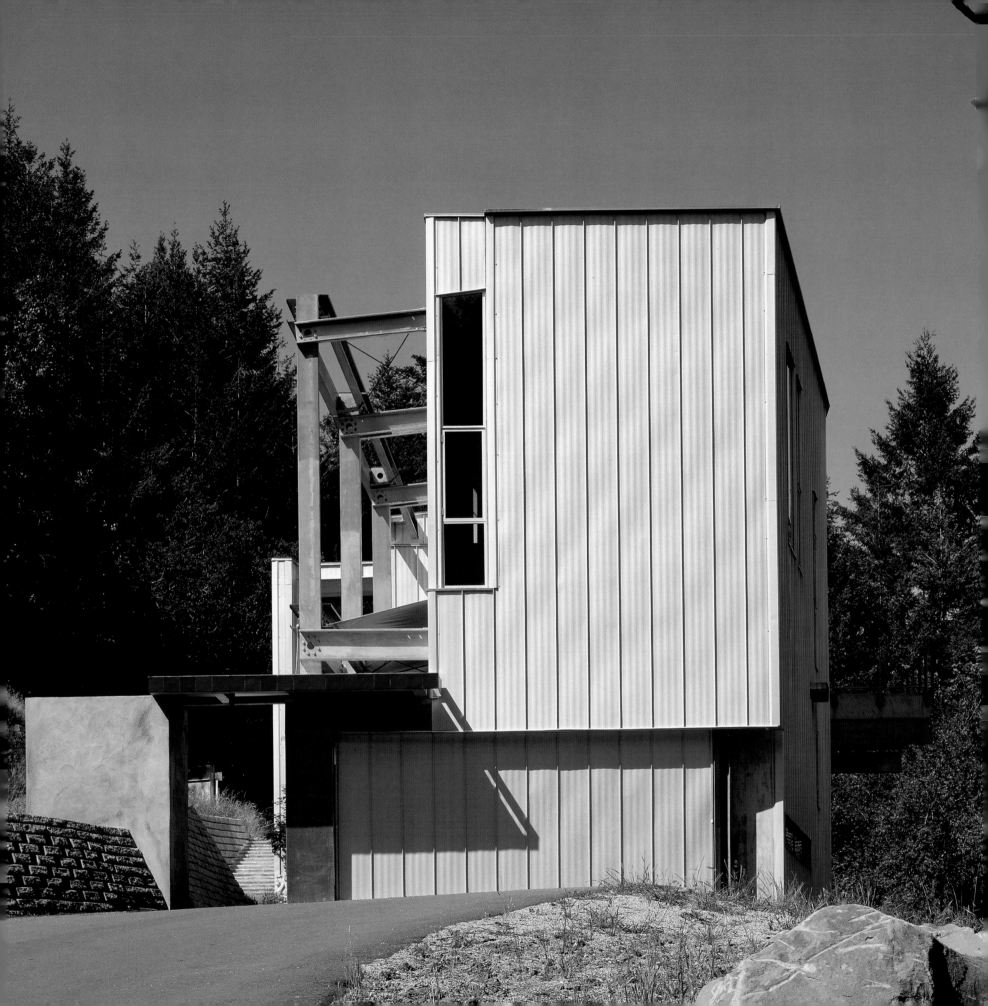

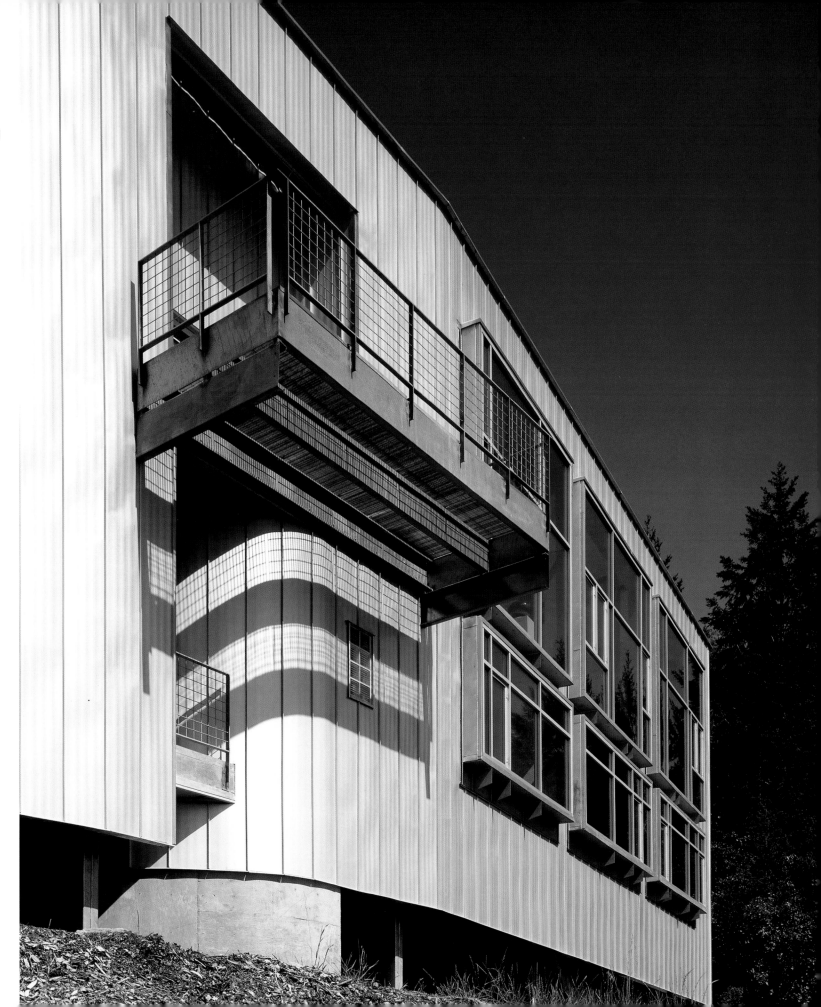

Left: The prefabricated steel framing is exposed at the entry.

Right: The steel balcony's design reflects the industrial spirit of the building.

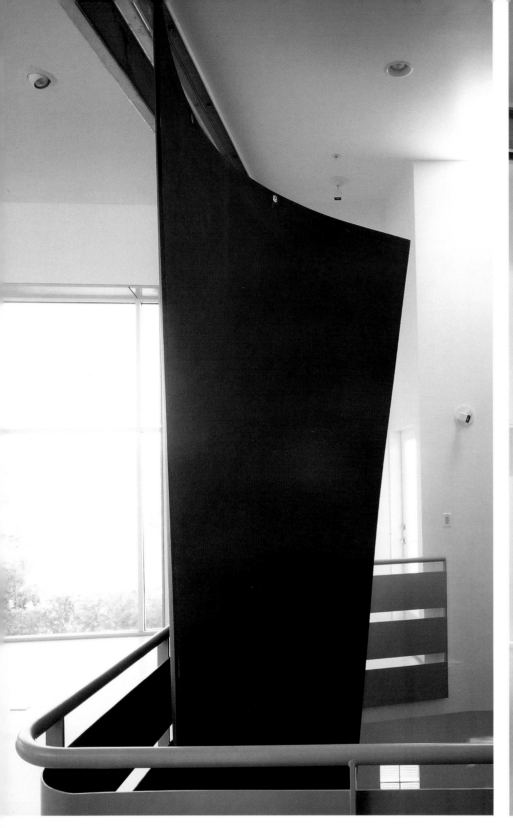

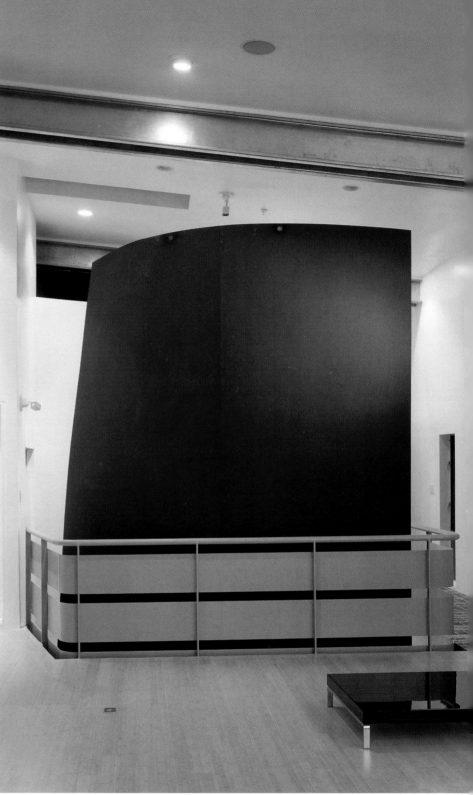

Above Left and Above: The entry foyer is defined by a massive 22-foot-tall rusted steel wall.

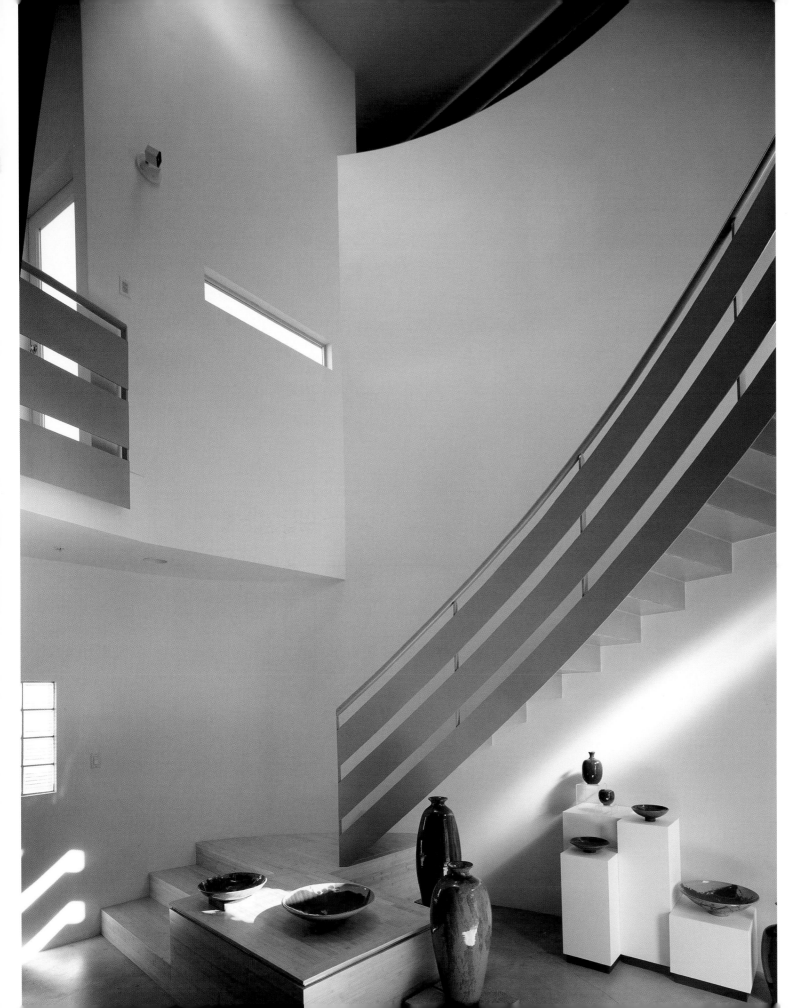

Left: The curving steel stairway is opposite the steel wall. This tall, vertical space is a reflection of the sculptural qualities of the vertical pots created by the owner, which are on display in the space and visible at the base of the stairs.

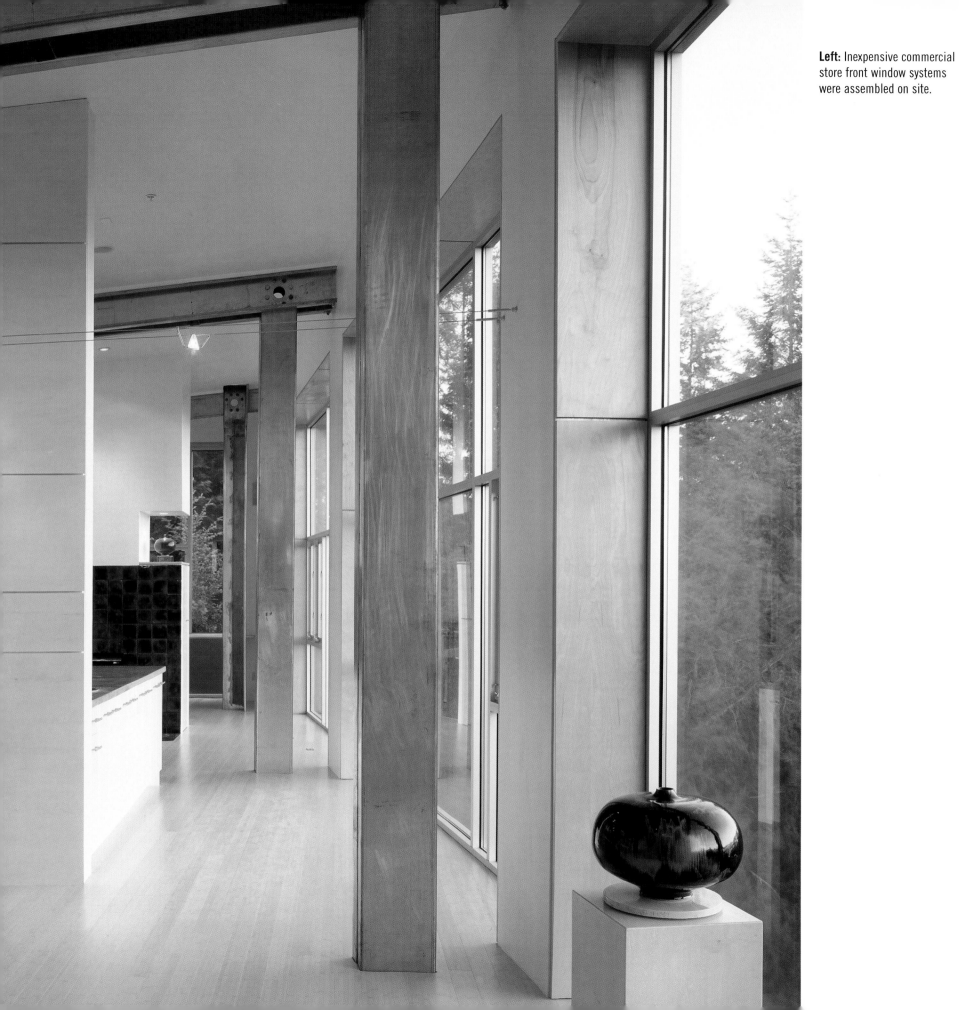

Left: Inexpensive commercial store front window systems were assembled on site.

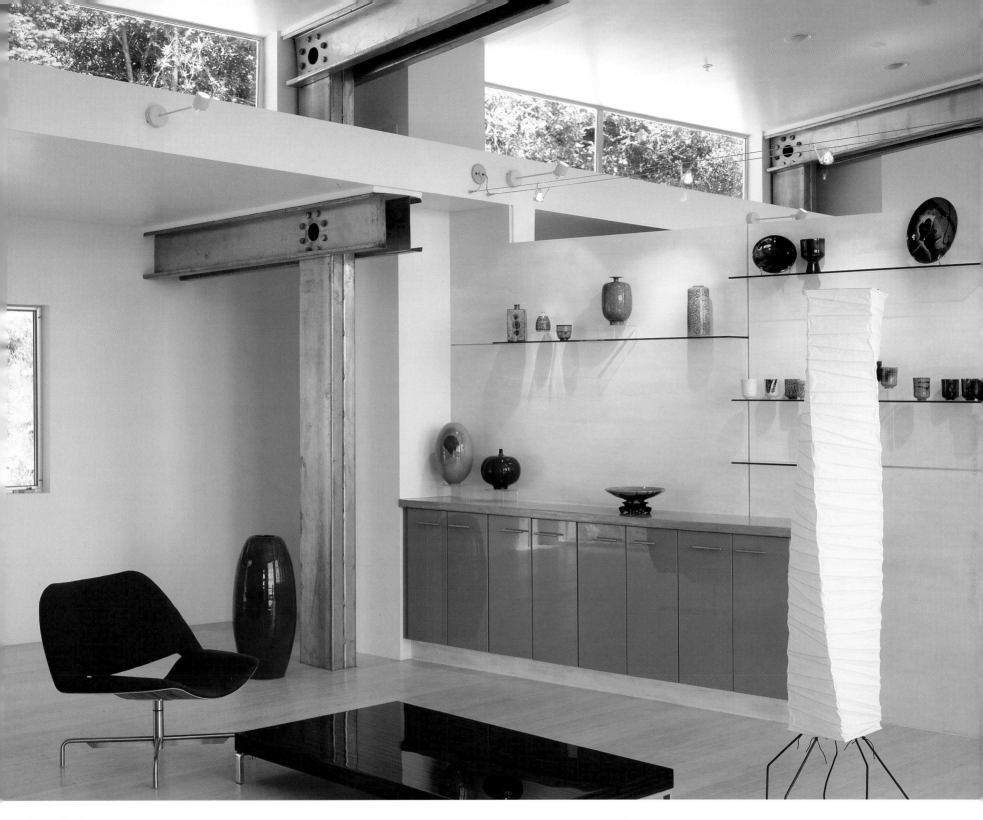

Above: The house was designed to provide a showcase for the clients' art.

WINDY RIDGE

A Village on a Mountain

place: **NEW CREEK, WEST VIRGINIA** | architects: **ROBERT M. GURNEY ARCHITECT**

photography: **HOACHLANDER DAVIS PHOTOGRAPHY**

PROJECT DESCRIPTION

An existing house on a dramatic 53-acre mountaintop site was renovated, and additional spaces were added to nearly double its size to 4,200 square feet. The new compound is conceived as a village stretched across the site with interconnected spaces designed around the existing house and rotated toward optimal views. A four-story observation tower provides panoramic views. The six interconnected buildings that make up the compound are painted in different colors and clad in different materials.

KEEPING COSTS DOWN

Each building is designed with shed roofs for ease of construction and to simplify water drainage during storms. The black walnut flooring that is used throughout the house and the locust ceiling in the living room were taken from the original site. The existing 2,240-square-foot house was renovated at a far lower cost because it had been torn down and a new structure was built in its place.

PRIMARY BUILDING MATERIALS

Wood framing was used for the new structure. A variety of exterior claddings, including board and batten, clapboard, and corrugated metal, distinguish one volume from the other.

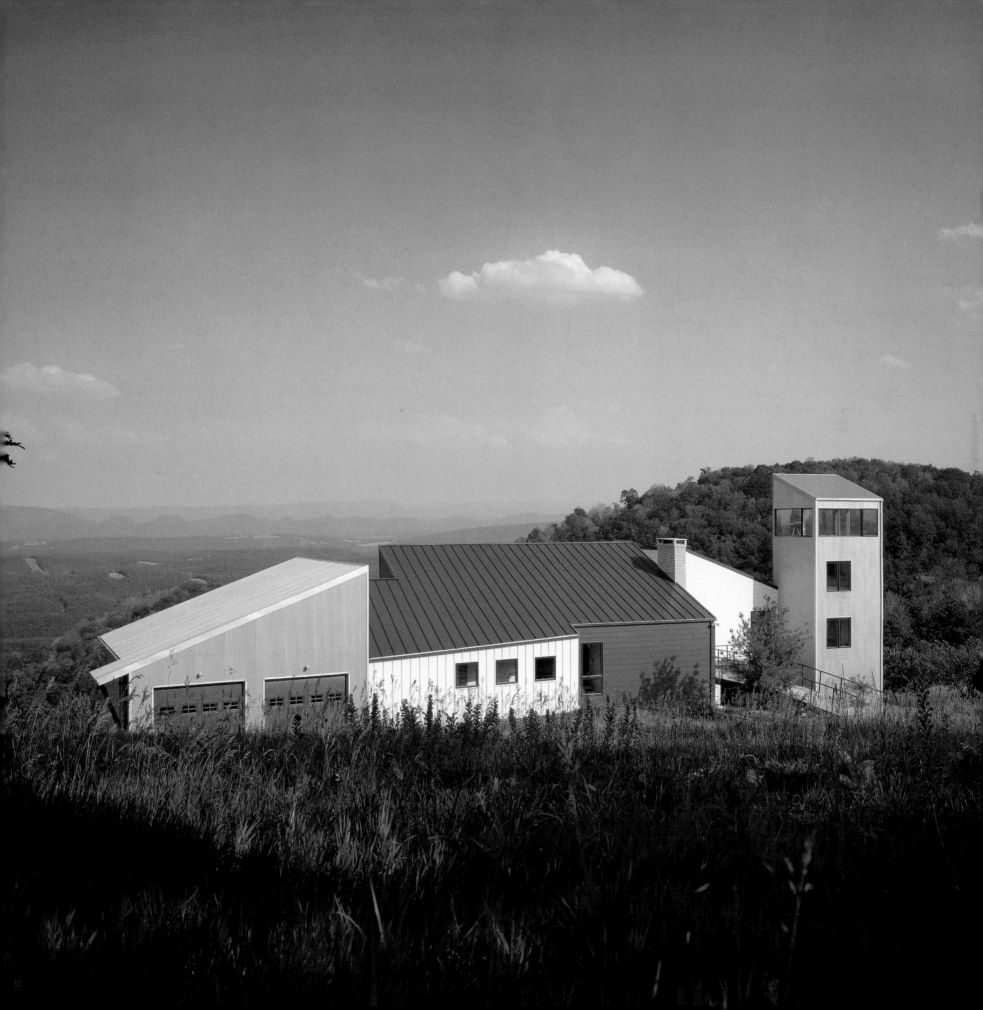

First-floor Plan

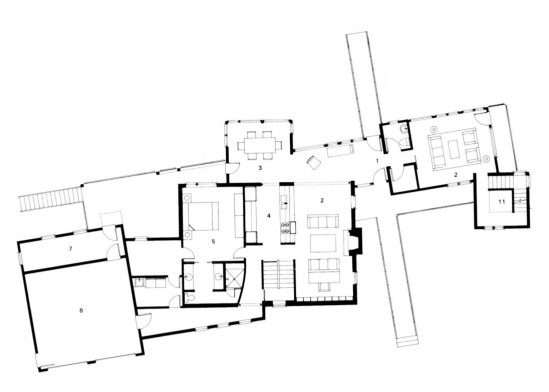

Site Plan

Ground-floor Plan

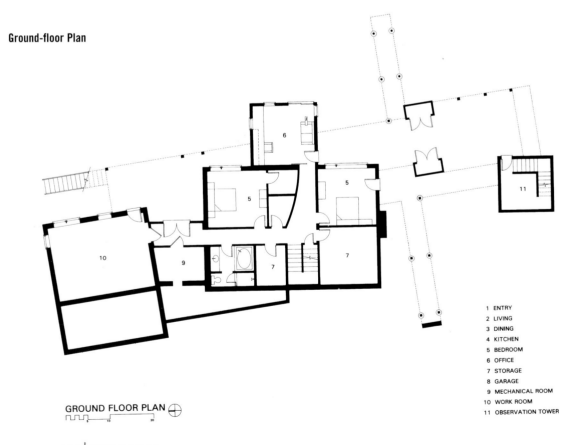

1 ENTRY
2 LIVING
3 DINING
4 KITCHEN
5 BEDROOM
6 OFFICE
7 STORAGE
8 GARAGE
9 MECHANICAL ROOM
10 WORK ROOM
11 OBSERVATION TOWER

GROUND FLOOR PLAN

West Elevation

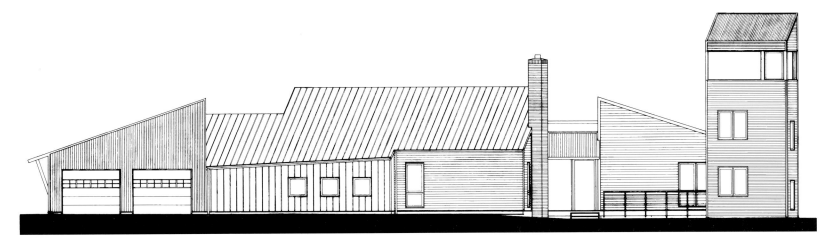

East Elevation

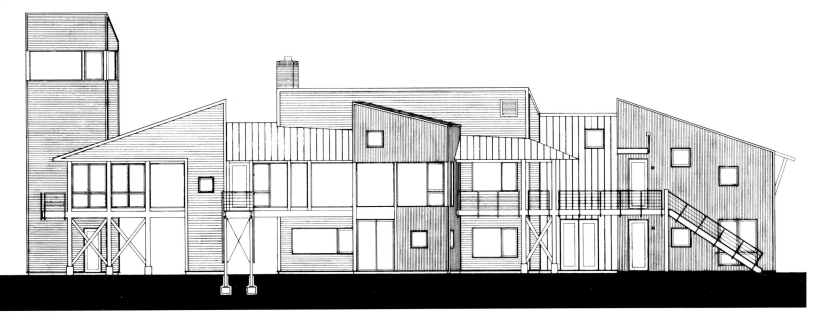

South Elevation

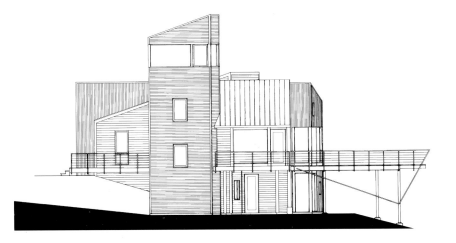

North Elevation

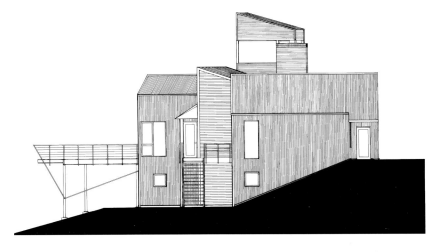

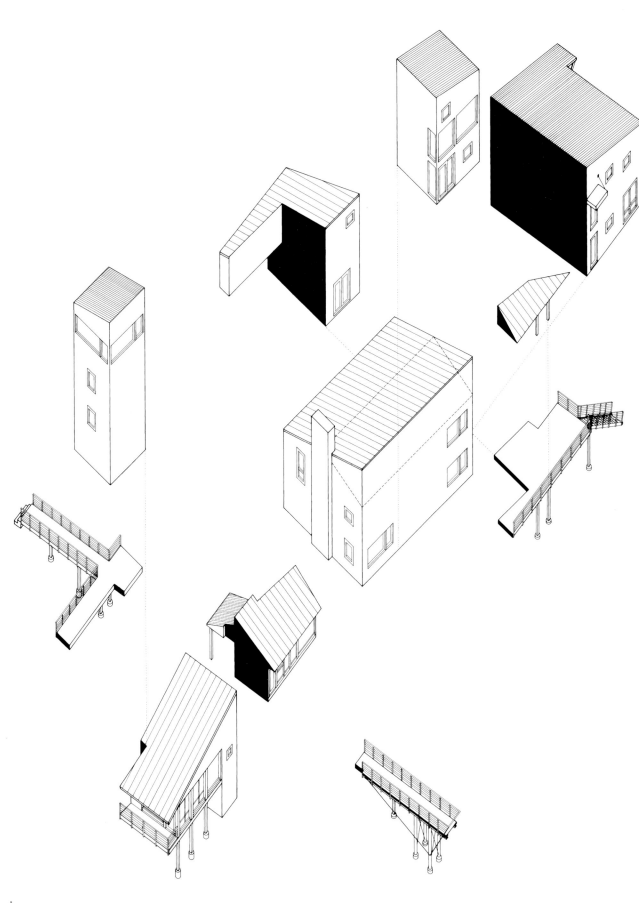

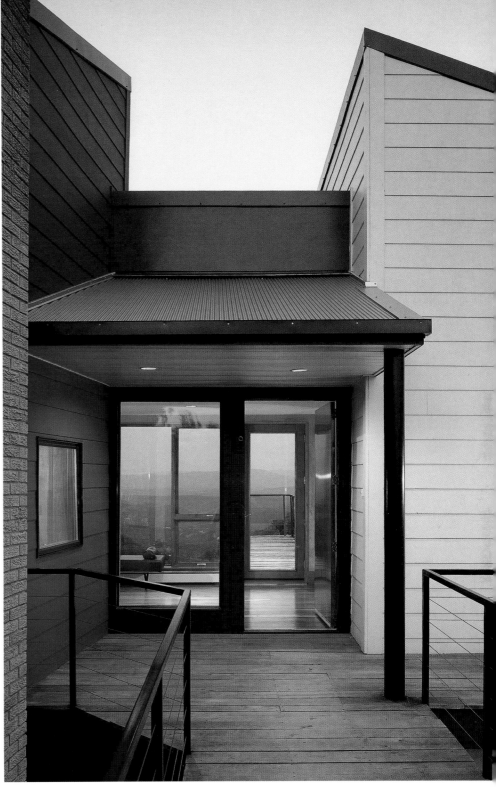

Left: Common shed roofs reduce construction costs and provide excellent drainage during storms.

Above: A narrow, 25-foot platform serves as an axis through the entry to an apple orchard in the rear below.

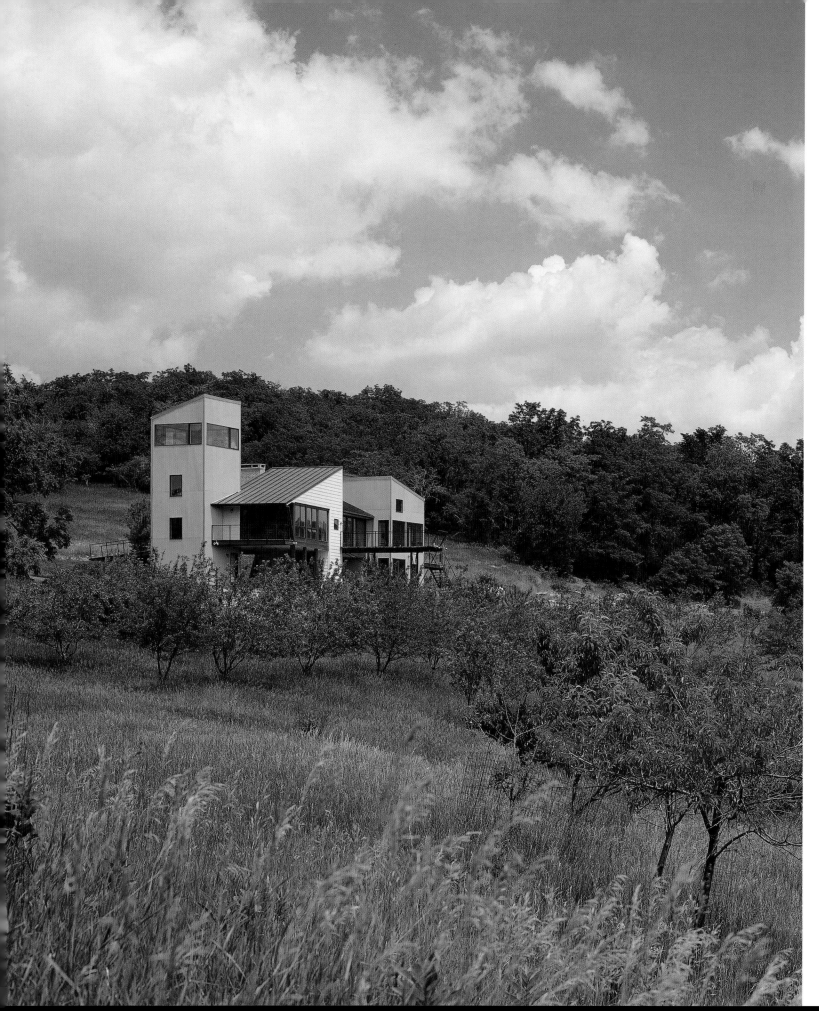

Left: The four-story observation tower provides views over the valley.

Right: From a distance, the cluster of buildings resembles a small hilltop village.

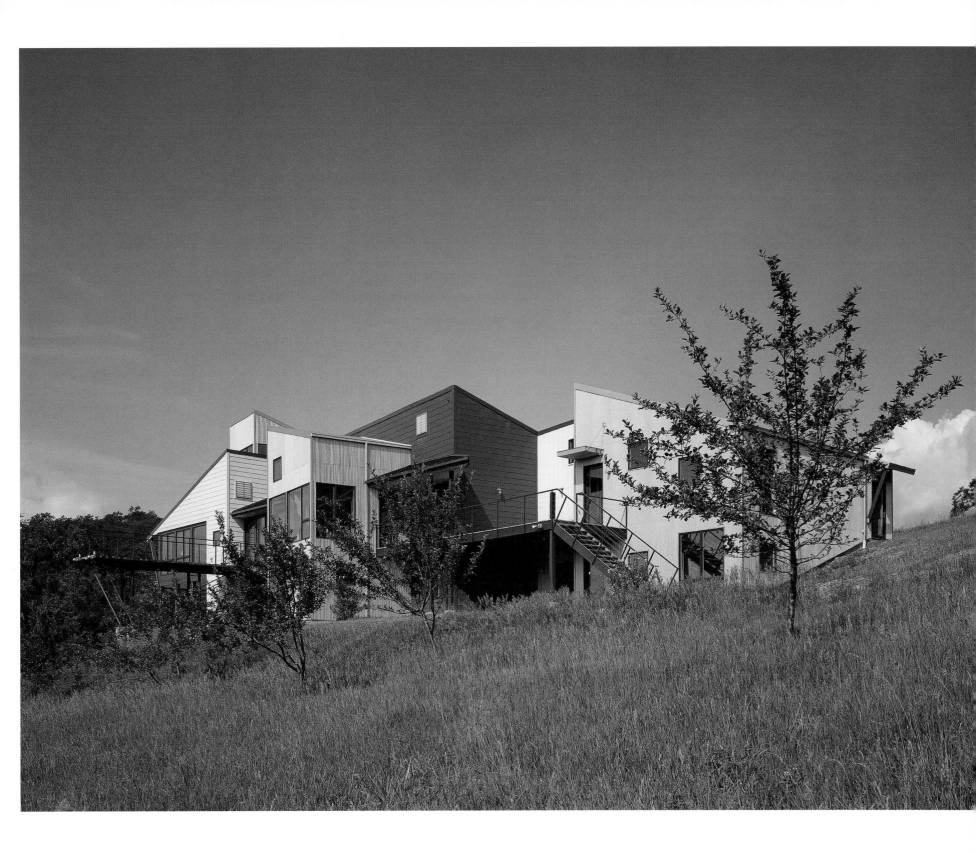

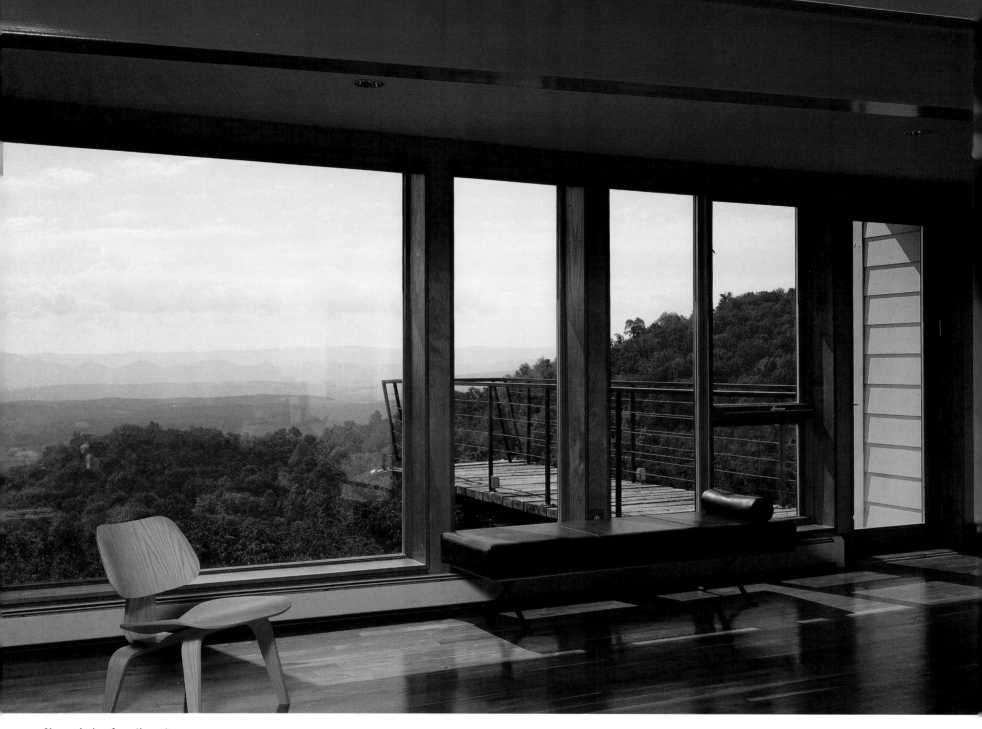

Above: A view from the entry corridor to the observation bridge above the apple orchard

Right: The newly constructed living area opens onto the valley.

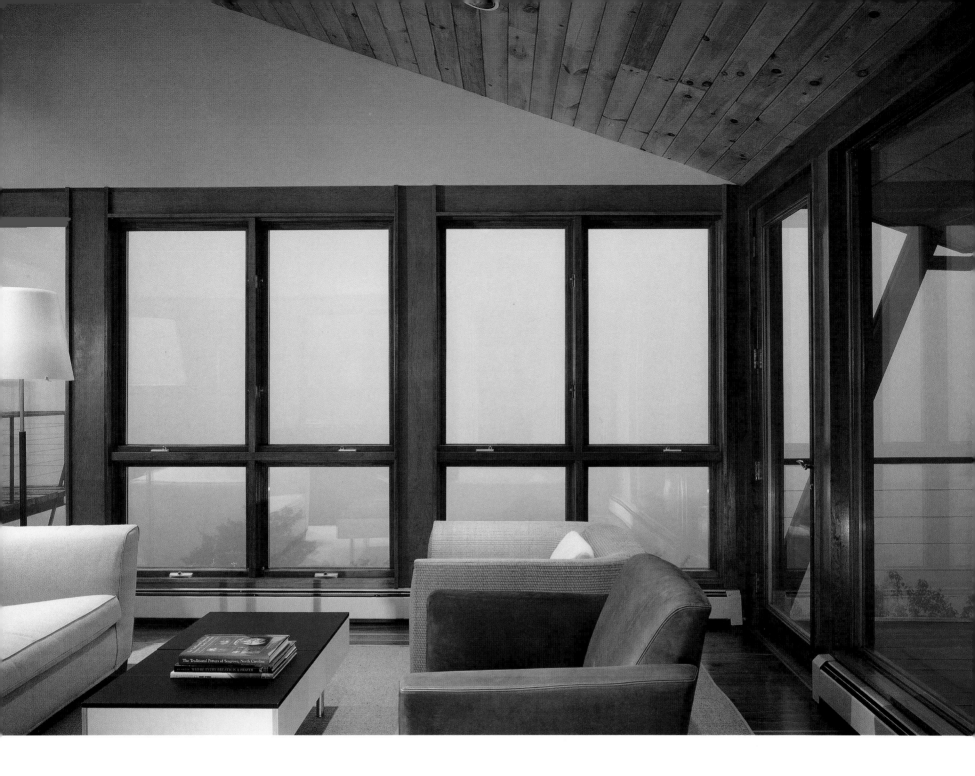

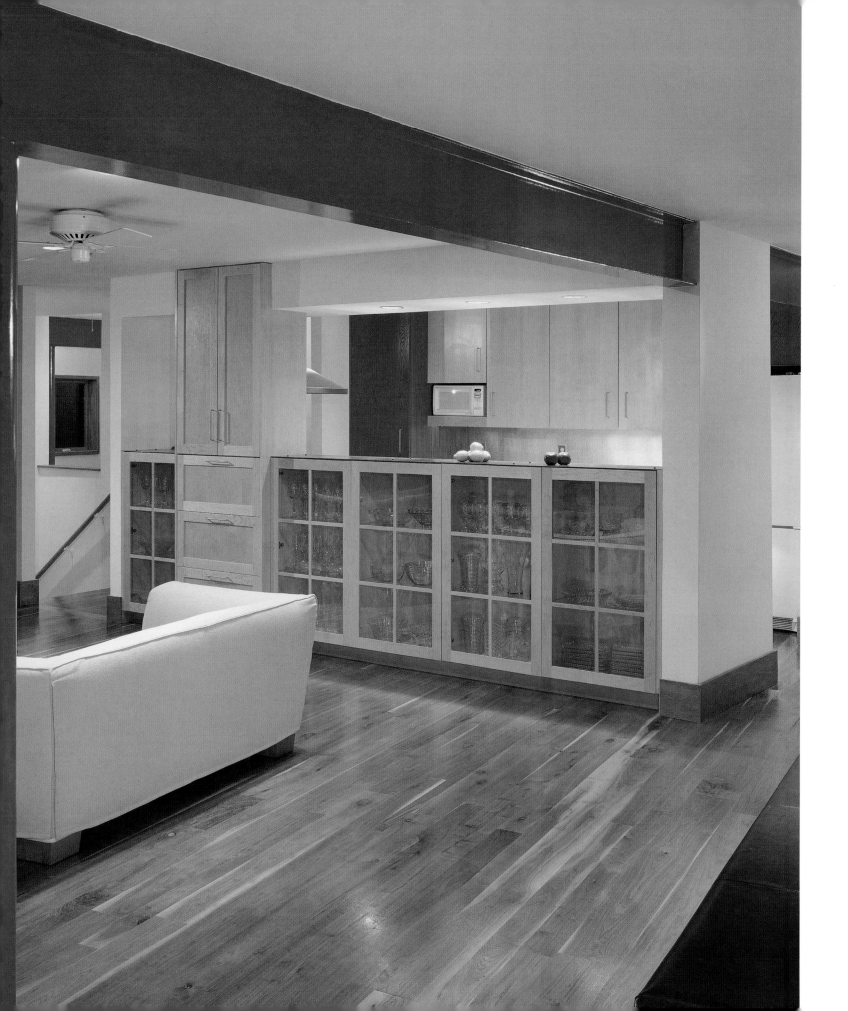

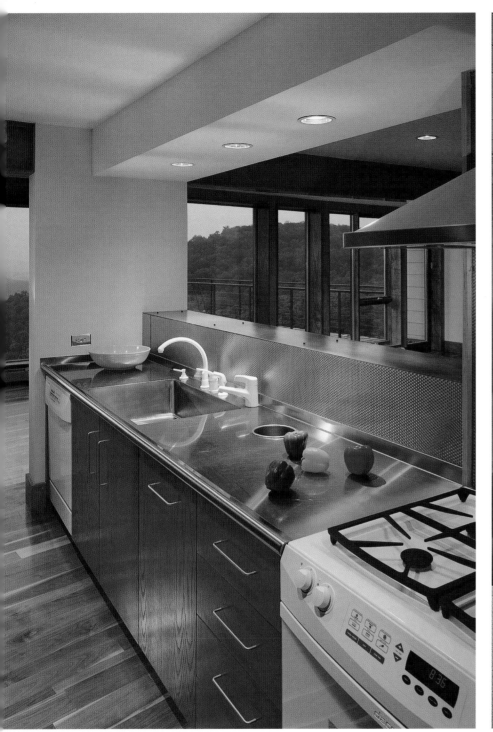

Above and Left: Within the existing house, the main living room was opened to the kitchen.

Above Right: The stairway to the observation tower; the exterior metal cladding of the tower continues into the interior of the house.

HOUSE AND STUDIO

Live/Work Texas Style

> place: **TEXAS** | architects: **MELL LAWRENCE ARCHITECTS**

photography: **HESTER + HARDAWAY PHOTOGRAPHERS**

PROJECT DESCRIPTION

A dramatic two story enclosed porch separates a studio for the husband's graphic design business from the main house. Inside the house, the two story volume continues, enclosing an open living, dining, and kitchen area. Large, commercial grade aluminum windows maximize of a creek at the bottom of the sloping site. A 48-foot Ipe and steel shelf that doubles as a bench runs underneath these windows for the entire length of the house, connecting the living and dining space with the master bedroom at the eastern end. The kitchen bay was pushed out to allow more natural light and sight-lines to visitors approaching the house. Additional sleeping areas are located on this level as well as in a loft above the living area.

KEEPING COSTS DOWN

Exterior materials were chosen for cost considerations as well as aesthetics—they reference the rural vernacular architecture of this region. Galvanized corrugated metal was used for siding as well as roofing, creating a dominant, silver-grey palette that both reflects the natural environment and retreats into it. The wood framing of the screened porch warms this palette and connects the house to its woodland landscape.

PRIMARY BUILDING MATERIALS

The exterior of this house is essentially all low-maintenance metal with galvanized corrugated metal roof and siding and aluminum-framed windows. The kitchen features a custom-built Ipe, Lueders limestone and steel island, Lueders stone counters and custom built painted medium density fiberboard cabinets. The porch is framed in Douglas fir with exposed Douglas fir beams and an interior support column.

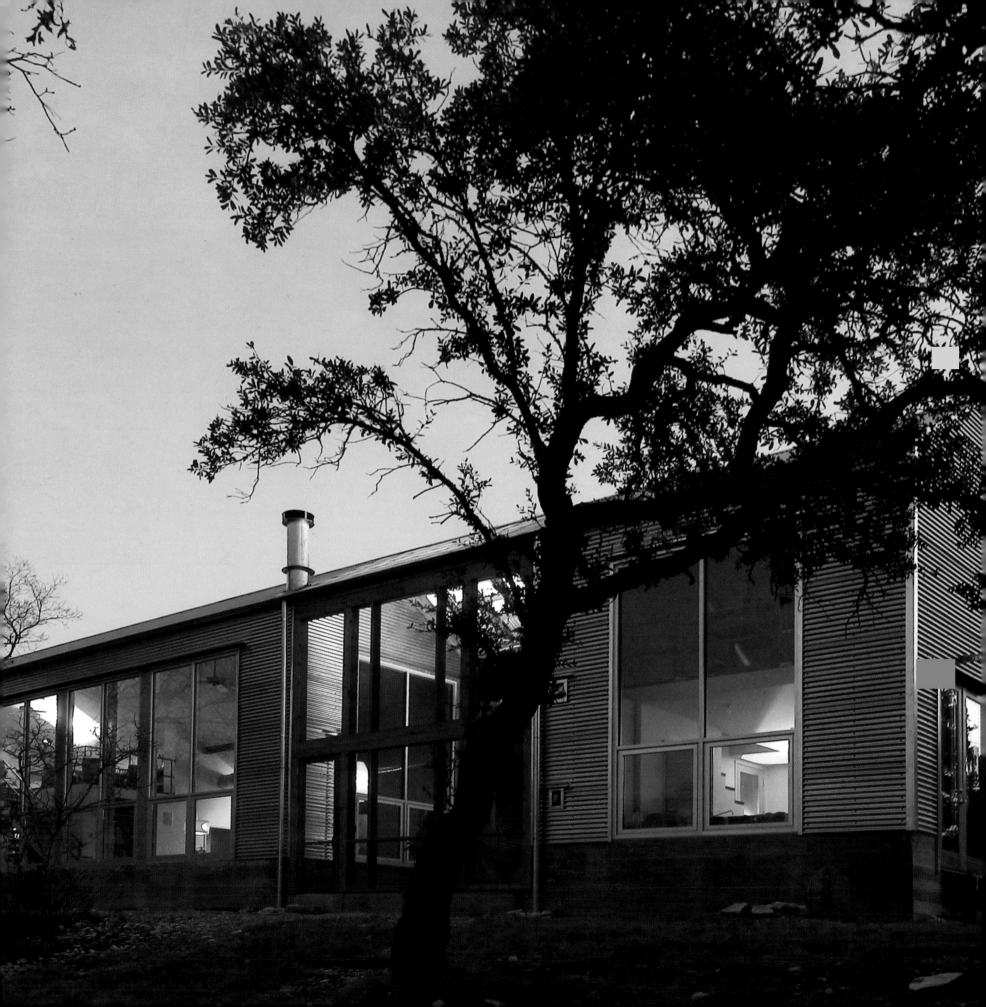

Site Plan

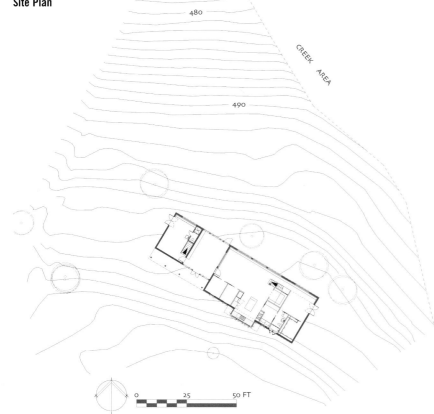

480

CREEK AREA

490

0 25 50 FT

Second-floor Plan

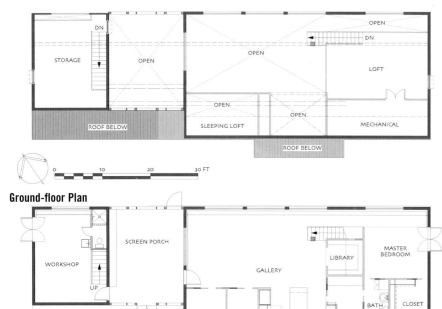

DN

STORAGE

OPEN

ROOF BELOW

OPEN

DN

OPEN

LOFT

OPEN

OPEN

SLEEPING LOFT

MECHANICAL

ROOF BELOW

0 10 20 30 FT

Ground-floor Plan

WORKSHOP

SCREEN PORCH

UP

GALLERY

LIBRARY

MASTER BEDROOM

SLEEPING BERTH

KITCHEN

BATH

LAUND.

CLOSET

0 10 20 30 FT

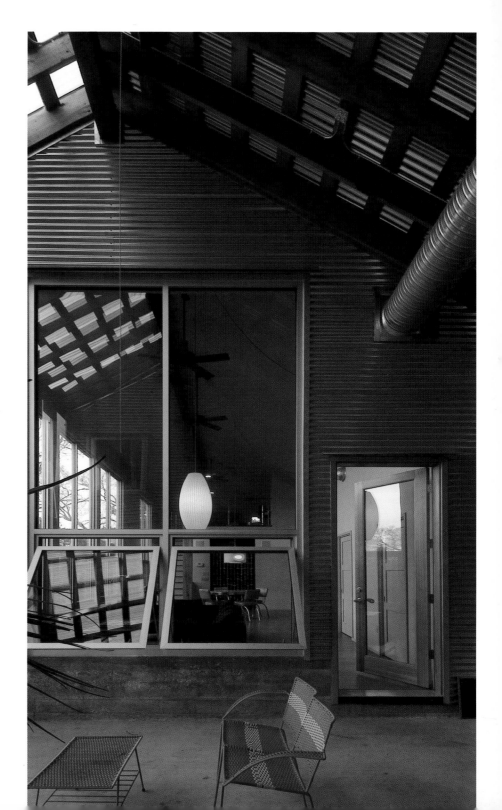

Below: The two story volume of the porch continues into the main house, with a view of the living area.

Right: The master bedroom has direct access to the outside.

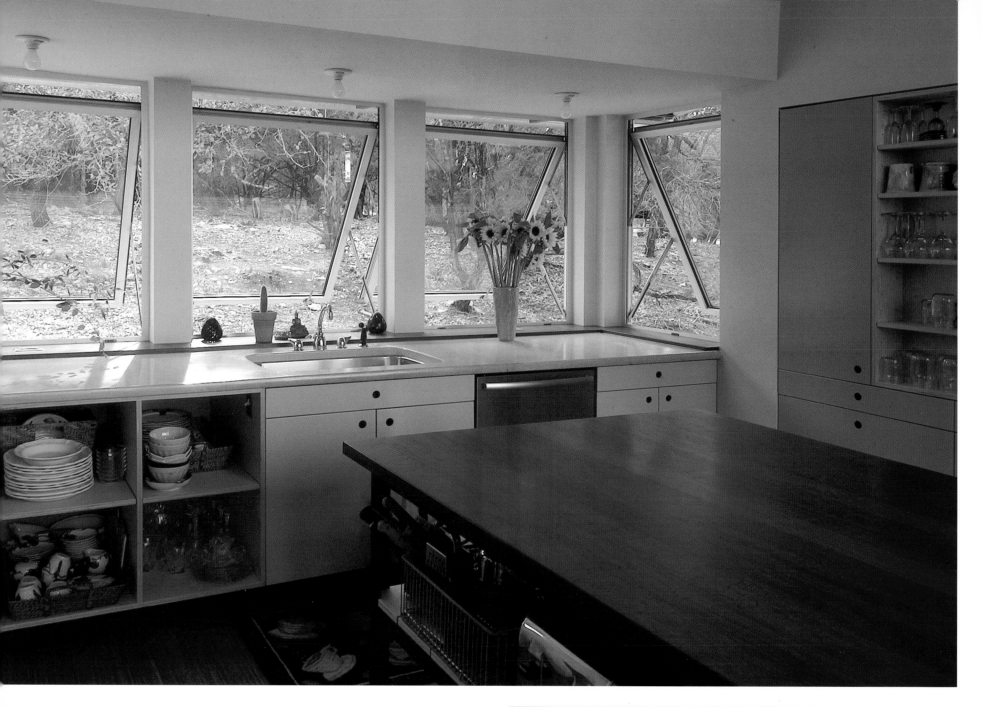

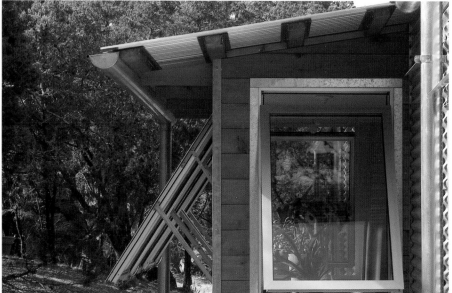

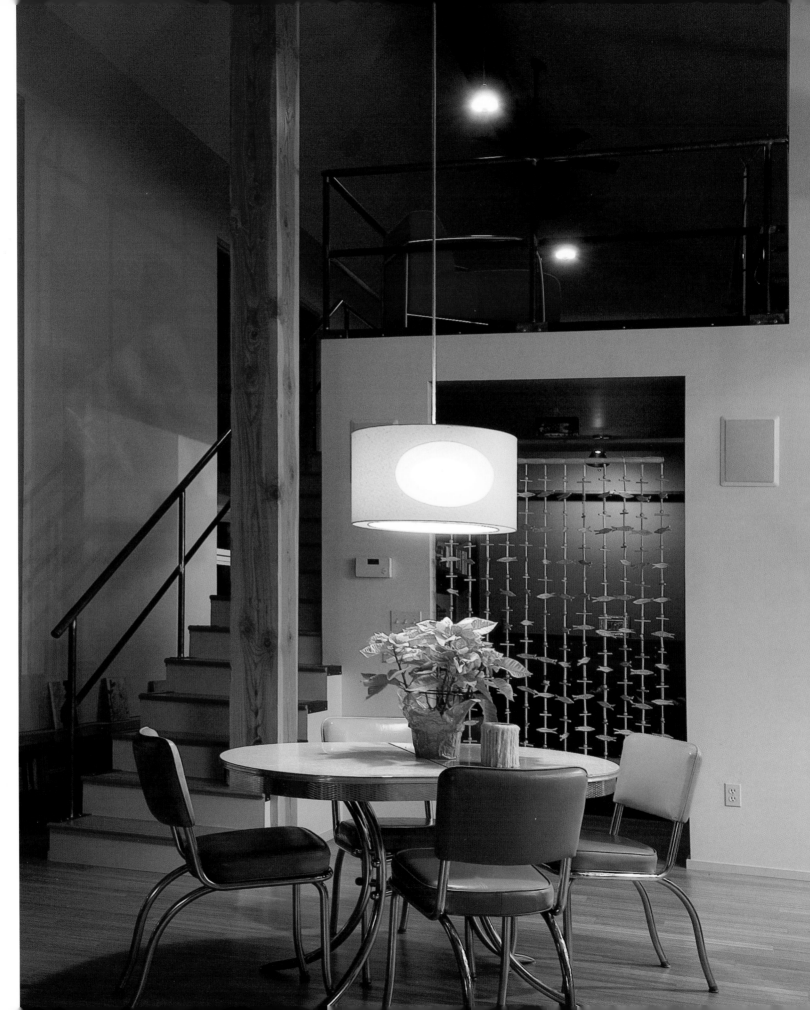

Left and Below Left: A bay was created for the kitchen to bring in more light.

Right: The dining area with a view of the loft and the entry beyond the dining table

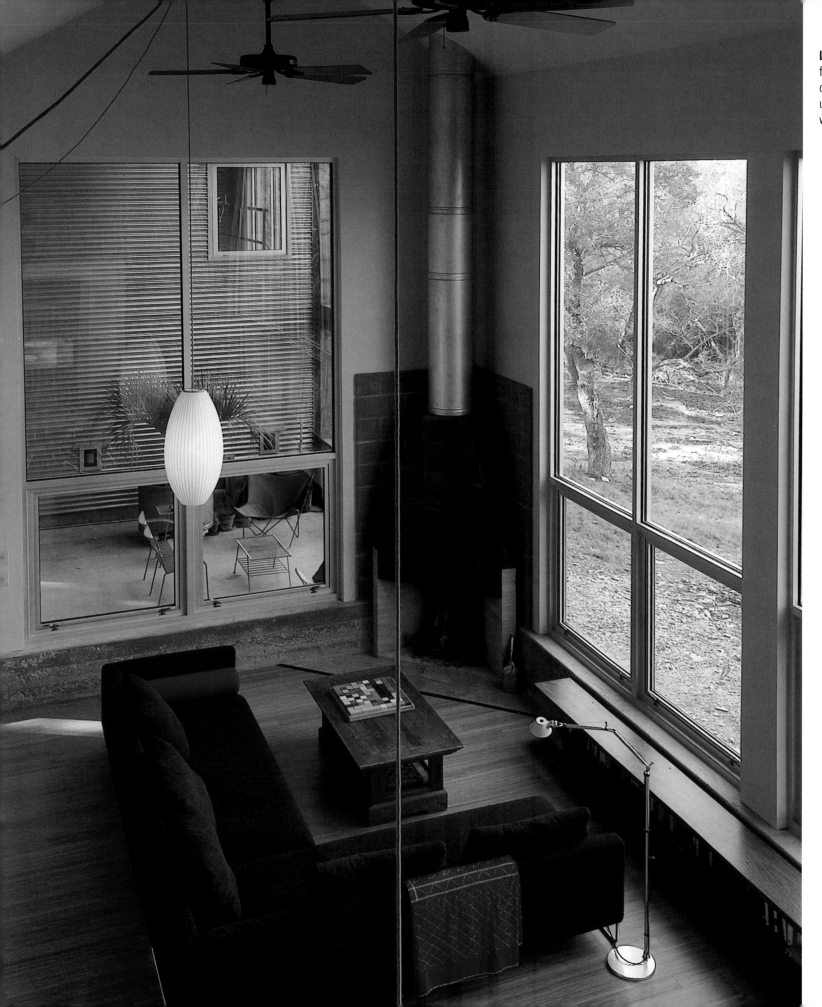

Left: The living area as seen from the loft; a shelf that doubles as seating runs under the commercial-grade windows.

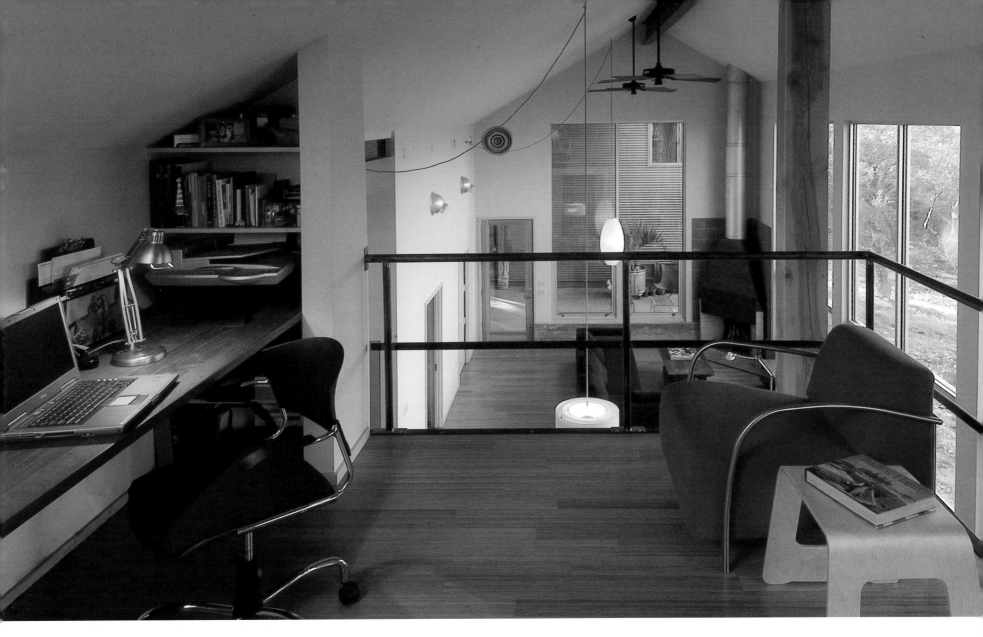

Above: The loft serves as a home office with views across the living room to the porch and studio beyond.

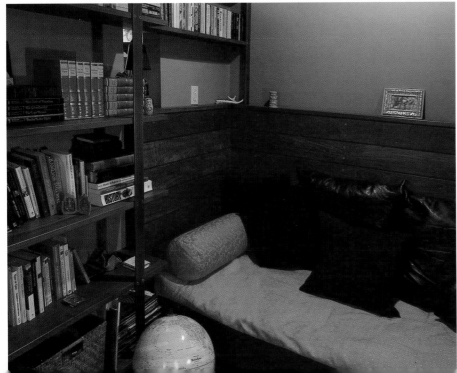

Left: The library provides a cozy retreat from the more open communal living area.

HORSEPEN

A Minimalist House for One

place: **RICHMOND, VIRGINIA** | architects: **WATERSHED**

photography: **JEFF SAXMAN**

PROJECT DESCRIPTION

The client acquired a piece of property that was technically not buildable due to a local flood plain setback. However, he was able to get a front setback variance that allowed just enough depth to construct a 1,120-square-foot home. The site has a small hillside on the north edge along a busy arterial. Entry is via a stair/ramp bridge structure to the upper level—a large open space containing the entry and the kitchen, dining, and living areas. The lower level consists of a sitting room, master bedroom, and bath with storage, laundry, and mechanical spaces.

KEEPING COSTS DOWN

The corner storefront window system maximizes the view across a side street to the only greenspace in the neighborhood. Shifting the plan to that view was not feasible given site restraints, and keeping the rectangular design was necessary given the budget. Thus, the corner window maximizes the view exposure and helps expand the apparent size of the interior space. The owner took charge of most interior finishes and bought all of the fixtures, including plumbing, lighting, and casework, for under $10,000.

PRIMARY BUILDING MATERIALS

Exterior materials are aluminum-clad windows, aluminum storefront, painted cement board siding and trim, asphalt shingles, parged CMU foundation, wood deck and ramp structures, and I-inch galvanized chain-link guardrails.

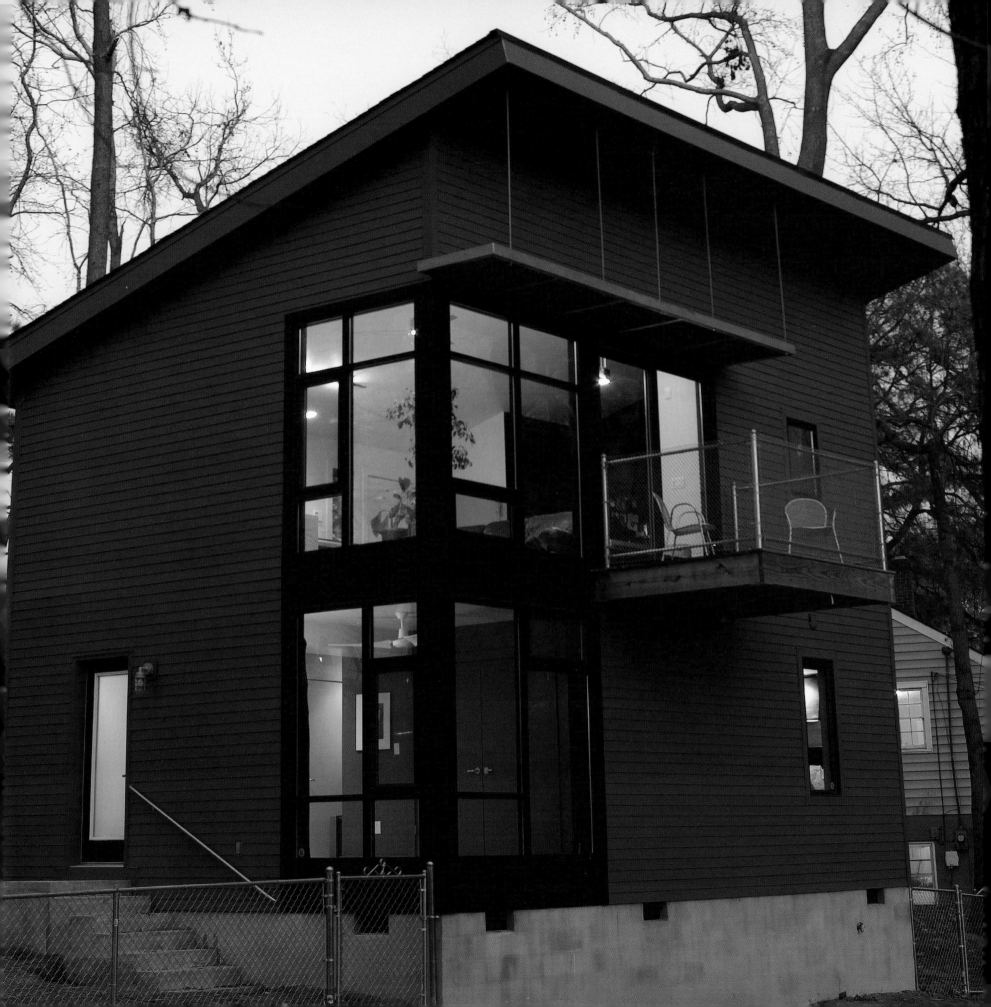

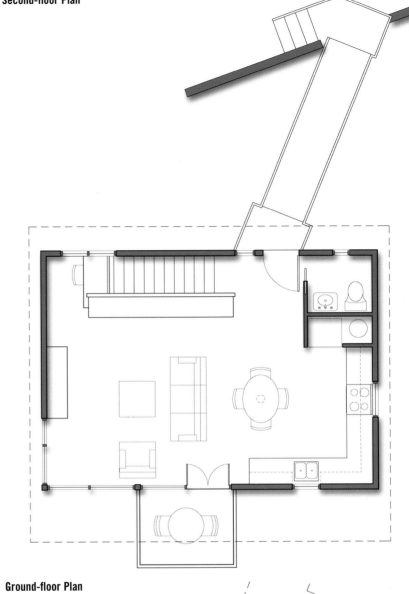

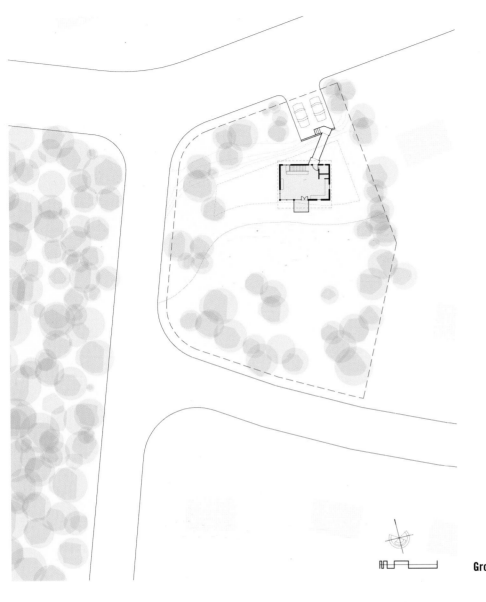

Ground-floor Plan

North Elevation

South Elevation

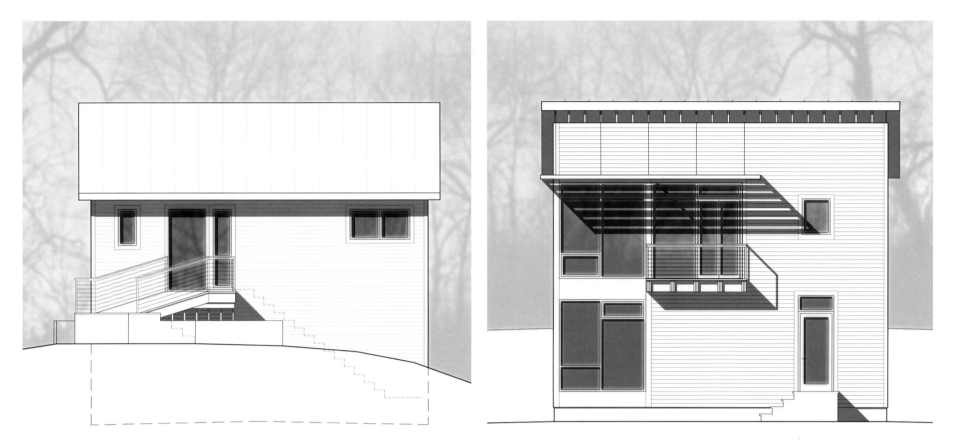

West Elevation

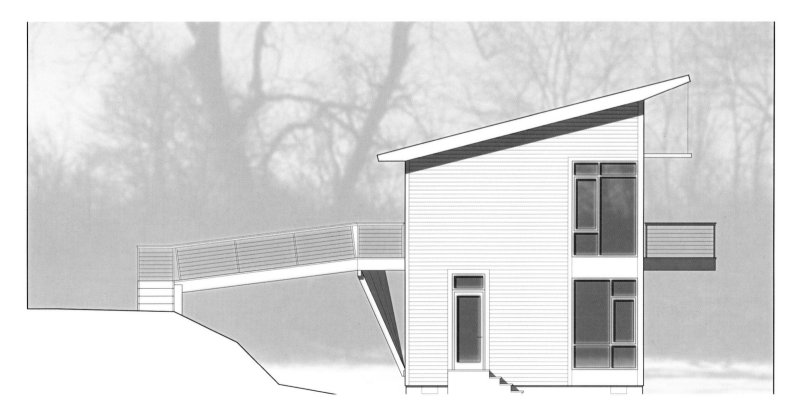

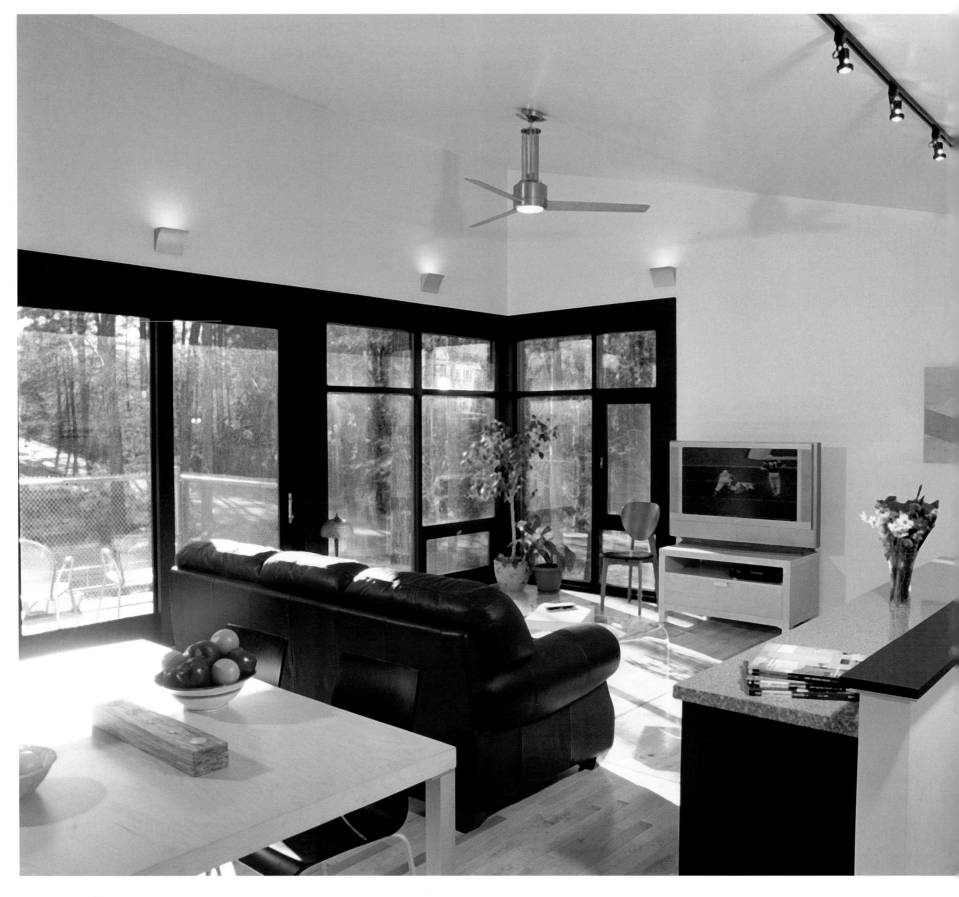

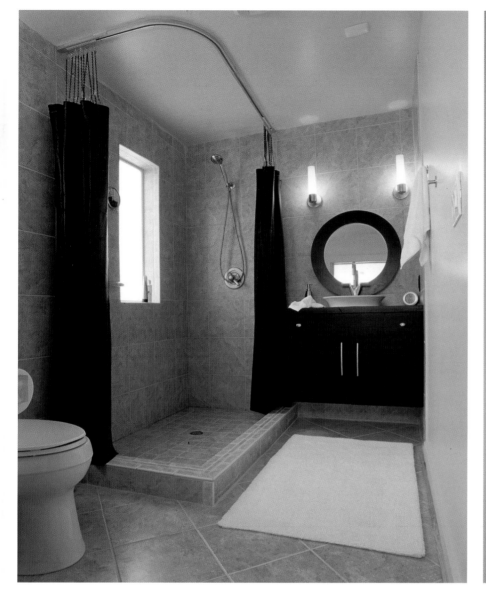

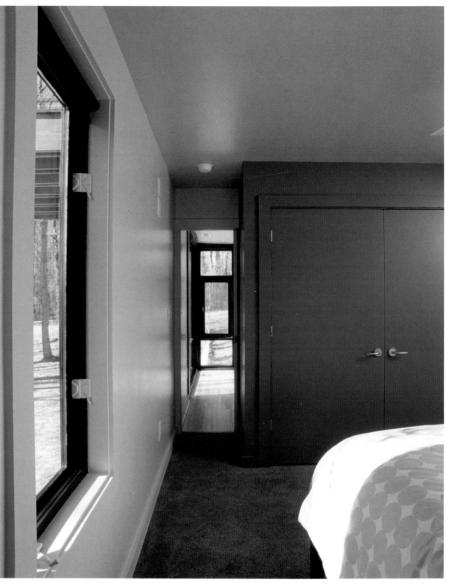

Left: The upper level contains all of the public spaces. The corner window expands the view as well as the sense of interior space.

Above and Above Right: The master bathroom and bedroom are located on the lower level.